Collins

CW01431081

2025 GUIDE to the **NIGHT SKY**

Radmila Topalovic, Storm Dunlop and Wil Tirion

Published by Collins
An imprint of HarperCollins Publishers
Westerhill Road, Bishopbriggs
Glasgow G64 2QT

HarperCollins Publishers
Macken House,
39/40 Mayor Street Upper,
Dublin 1, D01 C9W8, Ireland
www.harpercollins.co.uk

In association with
Royal Museums Greenwich, the group name for the National Maritime Museum,
Royal Observatory Greenwich, Queen's House and *Cutty Sark* 2015
www.rmg.co.uk

© HarperCollins Publishers 2024
Text and illustrations © Radmila Topalovic, Storm Dunlop and Wil Tirion
Photographs © see acknowledgements page 110

Collins® is a registered trademark of HarperCollins Publishers Ltd

All rights reserved. No part of this publication may be reproduced, stored in a retrieval system, or transmitted, in any form or by any means, electronic, mechanical, photocopying, recording or otherwise without the prior written permission of the publisher and copyright owners.

The contents of this publication are believed correct at the time of printing.
Nevertheless the publisher can accept no responsibility for errors or omissions,
changes in the detail given or for any expense or loss thereby caused.

HarperCollins does not warrant that any website mentioned in this title will be provided uninterrupted, that any website will be error free, that defects will be corrected, or that the website or the server that makes it available are free of viruses or bugs. For full terms and conditions please refer to the site terms provided on the website.

A catalogue record for this book is available from the British Library

ISBN 978-0-00-868816-5

10 9 8 7 6 5 4 3 2 1

Printed and bound in Italy by Rotolito S.p.A.

If you would like to comment on any aspect of this book, please contact us at the above address or online.
e-mail: collins.reference@harpercollins.co.uk

This book contains FSC™ certified paper and other controlled sources to ensure responsible forest management.

For more information visit: www.harpercollins.co.uk/green

Contents

4 Introduction

The Constellations

10 The Northern Circumpolar Constellations
12 The Winter Constellations
13 The Spring Constellations
14 The Summer Constellations
15 The Autumn Constellations

The Moon and the Planets

16 The Moon
18 Map of the Moon
20 Eclipses
22 The Planets
26 Minor Planets
28 Comets

30 Introduction to the Month-by-Month Guide

Month-by-Month Guide

34 January
40 February
46 March
52 April
58 May
64 June
70 July
76 August
82 September
88 October
94 November
100 December

106 Dark Sky Sites
108 Glossary and Tables
110 Acknowledgements
111 Further Information

Introduction

The aim of this Guide is to help people find their way around the night sky at any time of the year, by showing how the stars that are visible change from month to month and by highlighting various events that occur during 2025. The objects and events described may be observed with the naked eye, or nothing more complicated than a pair of binoculars.

The conditions for observing naturally vary over the course of the year. During the summer, twilight may persist throughout the night and make it difficult to see the faintest stars. There are three recognized stages of twilight: civil twilight, when the Sun is less than 6° below the horizon; nautical twilight, when the Sun is between 6° and 12° below the horizon; and astronomical twilight, when the Sun is between 12° and 18° below the horizon. Full darkness occurs only when the Sun is more than 18° below the horizon. During nautical twilight, only the very brightest stars are visible. During astronomical twilight, the faintest stars visible to the naked eye may be seen directly overhead, but are lost at lower altitudes. As the diagram shows, full darkness never occurs during June and most of July

at the latitude of London, and at Edinburgh nautical twilight persists throughout the whole night, so at that latitude only the very brightest stars are visible.

Another factor that affects the visibility of objects is the amount of moonlight in the sky. At Full Moon, it may be very difficult to see some of the fainter stars and objects, and even when the Moon is at a smaller phase it may seriously interfere with visibility if it is near the stars or planets in which you are interested. A full lunar calendar is given for each month and may be used to see when nights are likely to be darkest and best for observation.

The celestial sphere

All the objects in the sky (including the Sun, Moon and stars) appear to lie at some indeterminate distance on a large sphere, centred on the Earth. This *celestial sphere* has various reference points and features that are related to those of the Earth. If the Earth's rotational axis is extended, for example, it points to the North and South Celestial Poles, which are thus in line with the North and South Poles on Earth. Similarly, the *celestial*

The duration of twilight throughout the year at London and Edinburgh.

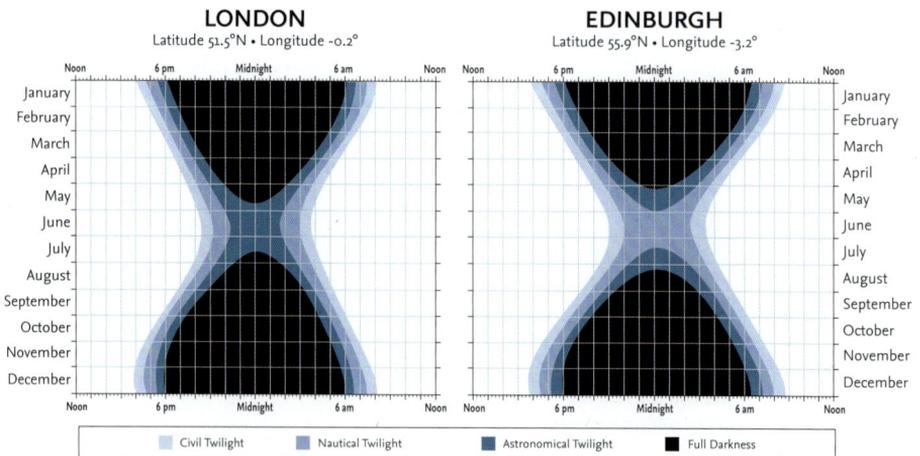

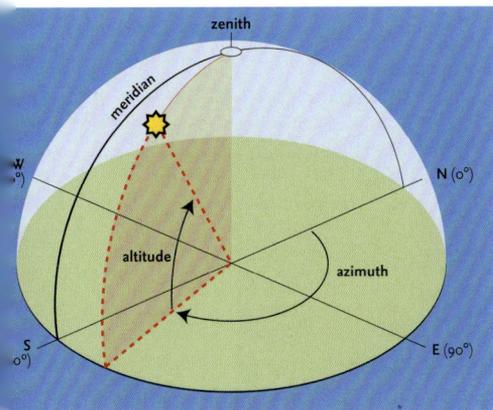

Measuring altitude and azimuth on the celestial sphere.

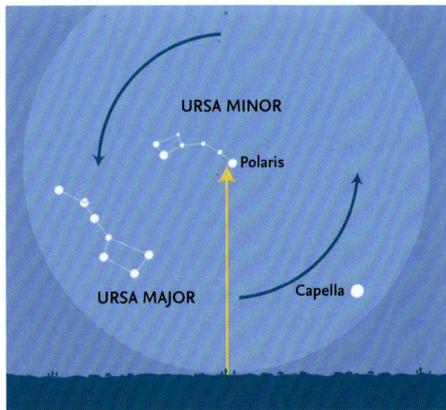

The altitude of the North Celestial Pole equals the observer's latitude.

equator lies in the same plane as the Earth's equator, and divides the sky into northern and southern hemispheres. Because this Guide is written for use in Britain and Ireland, the area of the sky that it describes includes the whole of the northern celestial hemisphere and those portions of the southern that become visible at different times of the year. Stars in the far south, however, remain invisible throughout the year, and are not included.

It is useful to know some of the special terms for various parts of the sky. As seen by an observer, half of the celestial sphere is invisible at any point in time; these objects will be below the horizon. The point directly overhead is known as the **zenith**, and the (invisible) one below one's feet as the **nadir**. The line running from the north point on the horizon, up through the zenith and then down to the south point is the **meridian**. This is an important invisible line in the sky, because objects are highest in the sky, and thus easiest to see, when they cross the meridian in the south. Objects are said to **transit** when they cross this line in the sky.

In this book, reference is frequently made in the text and in the diagrams to the **standard compass points** around the horizon. The position of any object in the sky may be described by its **altitude** (measured in degrees above the horizon), and its **azimuth** (measured

in degrees from north 0° , through east 90° , south 180° and west 270°). Experienced amateurs and professional astronomers also use another system of specifying locations on the celestial sphere, but here the simpler method will suffice.

The celestial sphere appears to rotate about an invisible axis, running between the North and South Celestial Poles. The location (i.e. the altitude) of the Celestial Poles depends entirely on the observer's position on Earth or, more specifically, their latitude. The charts in this book are produced for the latitude of 50°N , so the North Celestial Pole (NCP) is 50° above the northern horizon. The fact that the NCP is fixed relative to the horizon means that all the stars within 50° of the pole are always above the horizon and may, therefore, always be seen at night, regardless of the time of year. This northern circumpolar region is an ideal place to begin learning the sky, and ways to identify the circumpolar stars and constellations will be described shortly.

The ecliptic and the zodiac

Another important line on the celestial sphere is the Sun's apparent path against the background stars – in reality the result of the Earth's orbit around the Sun. This is known as the **ecliptic**. The point where the Sun, apparently moving along the ecliptic, crosses

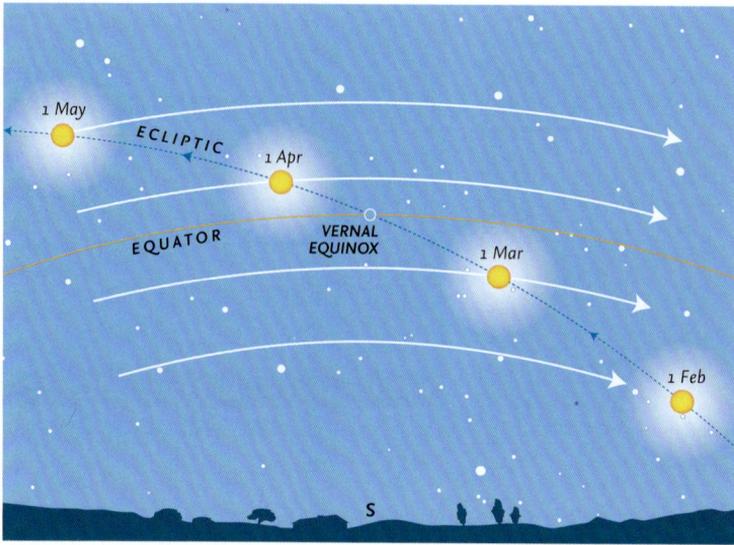

The Sun crossing the celestial equator in spring.

the celestial equator from south to north is known as the vernal (or spring) equinox, which occurs on 20 March. At this time (and at the autumnal equinox, on 22 or 23 September, when the Sun crosses the celestial equator from north to south) day and night are almost exactly equal in length. (There is a slight difference, but that need not concern us here.) The vernal equinox is currently located in the constellation of Pisces, and is important in astronomy because it defines the zero point for a system of celestial coordinates, which is, however, not used in this Guide.

The Moon and planets are to be found in a band of sky that extends 8° on either side of the ecliptic. This is because the orbits of the Moon and planets are inclined at various angles to the ecliptic (i.e. to the plane of the Earth's orbit). This band of sky is known as the zodiac and, when originally devised, consisted of twelve **constellations**, all of which were considered to be exactly 30° wide. When the constellation boundaries were formally established by the International Astronomical Union in 1930, the exact extent of most constellations was altered and, nowadays, the ecliptic passes through thirteen constellations.

Because of the boundary changes, the Moon and planets may actually pass through several other constellations that are adjacent to the original twelve.

The constellations

Since ancient times, the celestial sphere has been divided into various constellations, most dating back to antiquity and usually associated with certain myths or legendary people and animals. Nowadays, the boundaries of the constellations have been fixed by international agreement and their names (in Latin) are largely derived from Greek or Roman originals. Some of the names of the most prominent stars are of Greek or Roman origin, but many are derived from Arabic names. Many bright stars have no individual names and, for many years, stars were identified by terms such as 'the star in Hercules' right foot'. A more sensible scheme was introduced by the German astronomer Johannes Bayer in the early seventeenth century. Following his scheme – which is still used today – most of the brightest stars are identified by a Greek letter followed by the genitive form of the constellation's Latin name. An example is

the Pole Star, also known as Polaris and α Ursae Minoris (abbreviated α UMi). The Greek alphabet is shown on page 109 with a list of all the constellations that may be seen from latitude 50°N , together with abbreviations, their genitive forms and English names. Other naming schemes exist for fainter stars, but are not used in this book.

Asterisms

Apart from the constellations (88 of which cover the whole sky), certain groups of stars, which may form a part of a larger constellation or cross several constellations, are readily recognizable and have been given individual names. These groups are known as **asterisms**, and the most famous (and well-known) is the 'Plough', the common name for the seven brightest stars in the constellation of **Ursa Major**, the Great Bear. The names and details of some asterisms mentioned in this book are given in the list on page 110.

Magnitudes

The brightness of a star, planet or other body is frequently given in magnitudes (mag.). This is a mathematically defined scale where larger numbers indicate a fainter object. The scale extends beyond the zero point to negative numbers for very bright objects. (Sirius, the brightest star in the sky is mag. -1.4 .) Most observers are able to see stars as faint as about mag. 6, under very clear skies.

The Moon

Although the daily rotation of the Earth carries the sky from east to west, the Moon gradually moves eastwards by approximately its diameter (about half a degree) in an hour. Normally, in its orbit around the Earth, the Moon passes above or below the direct line between the Earth and the Sun (at New Moon) or outside the area obscured by the Earth's shadow (at Full Moon). Occasionally, however, the three bodies are more-or-less perfectly aligned to give an **eclipse**: a solar eclipse at New Moon or a lunar eclipse at Full Moon. Depending on the exact circumstances, a solar eclipse may be

merely partial (when the Moon does not cover the whole of the Sun's disk); annular (when the Moon is too far from Earth in its orbit to appear large enough to hide the whole of the Sun); or total. Total and annular eclipses are visible from very restricted areas of the Earth, but partial eclipses are normally visible over a wider area.

Somewhat similarly, at a lunar eclipse, the Moon may pass through the outer zone of the Earth's shadow, the **penumbra** (in a penumbral eclipse, which is not generally perceptible to the naked eye), so that just part of the Moon is within the darkest part of the Earth's shadow, the **umbra** (in a partial eclipse); or completely within the umbra (in a total eclipse). Unlike solar eclipses, lunar eclipses are visible from large areas of the Earth.

Occasionally, as it moves across the sky, the Moon passes between the Earth and individual planets or distant stars, giving rise to an **occultation**. As with solar eclipses, such occultations are visible from restricted areas of the world.

The planets

The planets are always moving against the background stars, therefore they are treated in some detail in the monthly pages and information is given regarding when they are close to other planets, the Moon or any of five bright stars that lie near the ecliptic. Such events are known as **appulses** or, more frequently, as **conjunctions**. (There are technical differences in the way these terms are defined – and should be used – in astronomy, but these need not concern us here.) The positions of the planets are shown for every month on a special chart of the ecliptic.

The term conjunction is also used when a planet is either directly behind or in front of the Sun, as seen from Earth. (Under normal circumstances it will then be invisible.) The conditions of most favourable visibility depend on whether the planet is one of the two known as **inferior planets** – planets that orbit the Sun within the Earth's orbit (Mercury and Venus) –

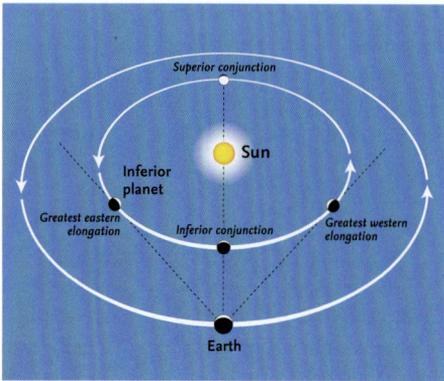

Inferior planet.

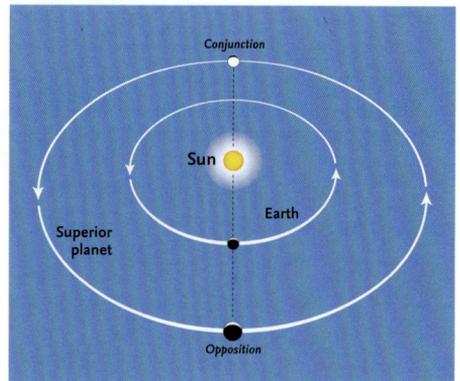

Superior planet.

or one of the five **superior planets** – planets that orbit the Sun beyond the Earth. Of the latter, three (Mars, Jupiter and Saturn) are covered in detail. Occasionally, details of the fainter superior planets, Uranus and Neptune, are included, and special charts are given for them on page 25.

The inferior planets are most readily seen at eastern or western elongation, when their angular distance from the Sun (separation from the Sun in degrees) is greatest. Superior planets are best seen at **opposition**, when they are directly opposite the Sun in the sky, and cross the meridian at local midnight.

It is often useful to be able to estimate angles on the sky, and approximate values may be obtained by holding one hand at arm's length. The various angles are shown in the diagram, together with the separations of the various stars in the Plough.

Meteors

At some time or other, nearly everyone has seen a meteor – a 'shooting star' – as it flashed across the sky. The particles that cause meteors – known technically as 'meteoroids' – normally range in size from that of a grain of sand (or even smaller) to the size of a pea. Fireballs or bolides are very bright meteors that are caused by objects up to a metre in size. On any night of the year there are occasional meteors, known as sporadics, that may travel in any direction.

These occur at a rate that is normally between three and eight per hour. Far more important, however, are meteor showers, which occur at fixed periods of the year, when the Earth encounters a trail of particles left behind by a comet or, very occasionally, by a minor planet (asteroid). Meteors always appear to diverge from a single point on the sky, known as the radiant, and the radiants of major showers are shown on the charts. Meteors that come from a circular area 8° in diameter around the radiant are classed as belonging to the particular shower. All others that do not come from that area are sporadics (or, occasionally from another shower that is active at the same time). A list of the major meteor showers is given on page 31.

Although the positions of the various shower radiants are shown on the charts, looking directly at the radiant is not the most effective way of seeing meteors. They are most likely to be noticed if one is looking about $40\text{--}45^\circ$ away from the radiant position. (This is approximately two hand-spans as shown in the diagram for measuring angles.)

Other objects

Certain other objects may be seen with the naked eye under good conditions. Some were given names in antiquity – Praesepe is one example – but many are known by what are called 'Messier numbers', the numbers in a catalogue of nebulous objects compiled by

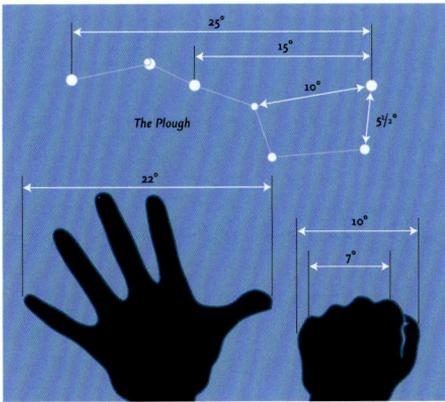

Measuring angles in the sky.

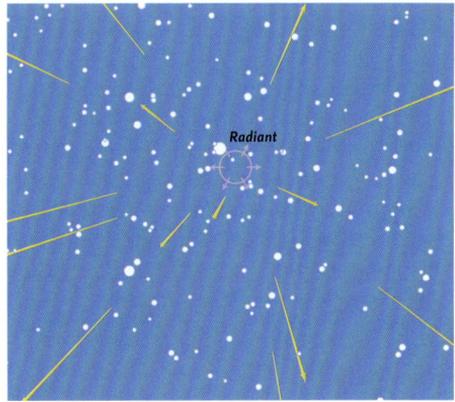

Meteor shower (showing the April Lyrid radiant).

Charles Messier in the late eighteenth century. Some, such as the Andromeda Galaxy, M31, and the Orion Nebula, M42, may be seen by the naked eye, but all those given in the list will benefit from the use of binoculars. Apart from galaxies, such as M31, which contain thousands of millions of stars, there are also two types of cluster: open clusters, such as M45, the Pleiades, which may consist of a few

dozen to some hundreds of stars; and globular clusters, such as M13 in Hercules, which are spherical concentrations of many thousands of stars. One or two gaseous nebulae, consisting of gas illuminated by stars within them, are also visible. The Orion Nebula, M42, is one, and is illuminated by the group of four stars, known as the Trapezium, which may be seen within it by using a good pair of binoculars.

Some interesting objects.

Messier / NGC	Name	Type	Constellation	Maps (months)
—	<i>Hyades</i>	open cluster	Taurus	Sep–Mar
—	<i>Double Cluster</i>	open cluster	Perseus	All year
—	<i>Melotte 111 (Coma Cluster)</i>	open cluster	Coma Berenices	Jan–Aug
M3	—	globular cluster	Canes Venatici	Jan–Sep
M4	—	globular cluster	Scorpius	May–Aug
M8	<i>Lagoon Nebula</i>	gaseous nebula	Sagittarius	Jun–Aug
M11	<i>Wild Duck Cluster</i>	open cluster	Scutum	May–Oct
M13	<i>Hercules Cluster</i>	globular cluster	Hercules	Feb–Nov
M15	—	globular cluster	Pegasus	Jun–Dec
M20	<i>Trifid Nebula</i>	gaseous nebula	Sagittarius	Jun–Aug
M22	—	globular cluster	Sagittarius	Jun–Sep
M27	<i>Dumbbell Nebula</i>	planetary nebula	Vulpecula	May–Dec
M31	<i>Andromeda Galaxy</i>	galaxy	Andromeda	All year
M35	—	open cluster	Gemini	Oct–May
M42	<i>Orion Nebula</i>	gaseous nebula	Orion	Nov–Mar
M44	<i>Praesepe</i>	open cluster	Cancer	Nov–Jun
M45	<i>Pleiades</i>	open cluster	Taurus	Aug–Apr
M57	<i>Ring Nebula</i>	planetary nebula	Lyra	Apr–Dec
M67	—	open cluster	Cancer	Dec–May
NGC 752	—	open cluster	Andromeda	Jul–Mar
NGC 3242	<i>Ghost of Jupiter</i>	planetary nebula	Hydra	Feb–May

The Northern Circumpolar Constellations

The northern circumpolar stars are the key to starting to identify the constellations. For anyone in the northern hemisphere they are visible at any time of the year, and nearly everyone is familiar with the seven stars of the Plough – known as the Big Dipper in North America – an asterism that forms part of the large constellation of **Ursa Major** (the Great Bear).

Ursa Major

Due to the apparent movement of the stars around the Sun, Ursa Major lies in different parts of the evening sky at different periods of the year. The diagram below shows its position at the beginning of the four main seasons. The seven stars of the Plough remain visible throughout the year anywhere north of latitude 40°N. Even at the latitude (50°N) for which the charts in this book are drawn, many of the stars in the southern portion of the constellation of Ursa Major are hidden below the horizon for part of the year or (particularly in late summer) cannot be seen late in the night.

Polaris and Ursa Minor

The two stars **Dubhe** and **Merak** (α and β Ursae

Majoris, respectively), farthest from the ‘tail’ are known as the ‘Pointers’. A line from Merak to Dubhe, extended about five times their separation, leads to the Pole Star, **Polaris**, or α Ursae Minoris. All the stars in the northern sky appear to rotate around it. There are five main stars in the constellation of **Ursa Minor**, and the two farthest from the Pole, **Kochab** and **Pherkad** (β and γ Ursae Minoris, respectively), are known as ‘The Guards’.

Cassiopeia

On the opposite of the North Pole from Ursa Major lies **Cassiopeia**. It is highly distinctive, appearing as five stars forming a letter ‘W’ or ‘M’ depending on its orientation. Provided the sky is reasonably clear of clouds, you will nearly always be able to see either Ursa Major or Cassiopeia, and thus be able to orientate yourself on the sky.

To find Cassiopeia, start with **Alioth** (ϵ Ursae Majoris), the first star in the tail of the Great Bear. A line from this star extended through Polaris points directly towards γ Cassiopeiae, the central star of the five.

Cepheus

Although the constellation of **Cepheus** is fully circumpolar, it is not nearly as well-known as Ursa Major, Ursa Minor or Cassiopeia, partly because its stars are fainter. Its shape is rather like the gable-end of a house. The line from the Pointers through Polaris, if extended, leads to **Errai** (γ Cephei) at the ‘top’ of the ‘gable’. The brightest star, **Alderamin** (α Cephei) lies in the Milky Way region, at the ‘bottom right-hand corner’ of the figure.

Draco

The constellation of **Draco** consists of a quadrilateral of stars, known as the ‘Head of Draco’ (and also the ‘Lozenge’), and a long chain of stars forming the neck and body of the dragon. To find the Head of Draco, locate the two stars **Phecda** and **Megrez** (γ and δ Ursae Majoris) in the Plough, opposite the Pointers.

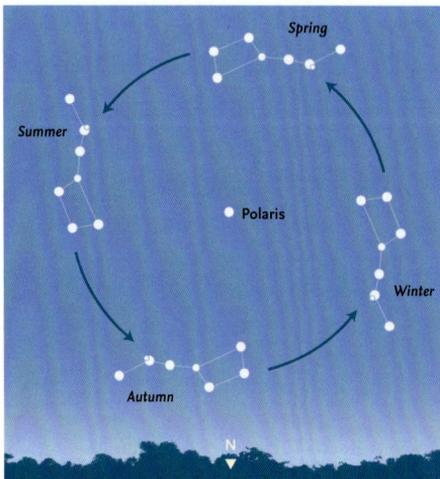

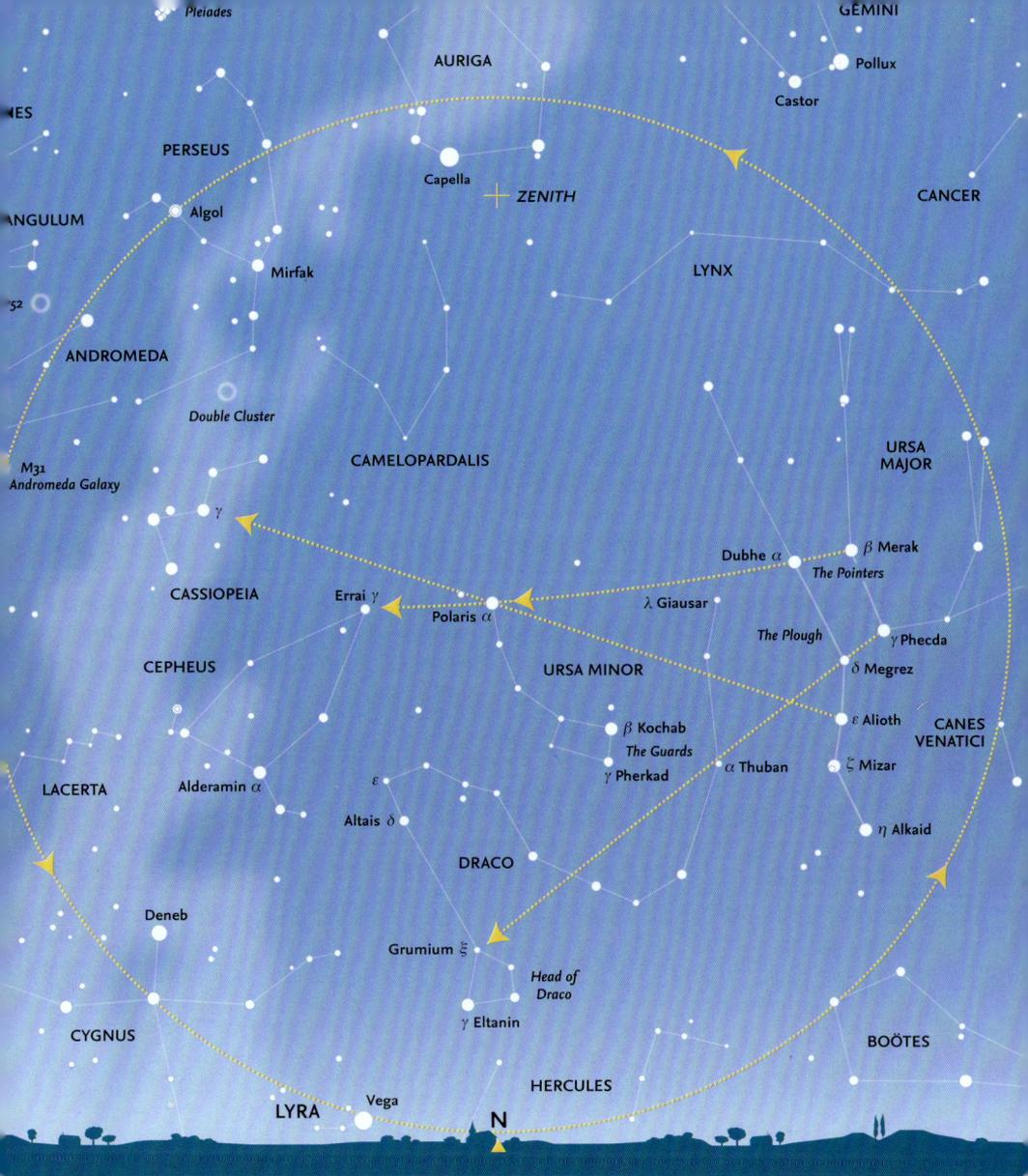

The stars and constellations inside the circle are always above the horizon, seen from our latitude.

Extend a line from Phecda through Megrez by about eight times their separation, right across the sky below the Guards in Ursa Minor, ending at **Grumium** (ξ Draconis) at one corner of the quadrilateral. The brightest star, **Eltanin** (γ Draconis), lies farther to the south. From

the head of Draco, the constellation first runs northwest to **Altair** (δ Draconis) and ϵ Draconis, then doubles back southwards before winding its way through **Thuban** (α Draconis) before ending at **Gausar** (λ Draconis) almost between the Pointers and Polaris.

The Winter Constellations

The winter sky is dominated by several bright stars and distinctive constellations. The most conspicuous constellation is **Orion**, the main body of which has an hour-glass shape. It straddles the celestial equator and is thus visible from anywhere in the world. The three stars that form the 'Belt' of Orion point down towards the southeast and to **Sirius** (α Canis Majoris), the brightest star in the sky. **Mintaka** (δ Orionis), the star at the northeastern end of the Belt, farthest from Sirius, actually lies just slightly south of the celestial equator.

A line from **Bellatrix** (γ Orionis) at the 'top right-hand corner' of Orion, through **Aldebaran** (α Tauri), past the 'V' of the Hyades cluster, points to the distinctive cluster of bright blue stars known as the **Pleiades**, or the 'Seven Sisters'. Aldebaran is one of the five bright stars that may sometimes be occulted (hidden) by the Moon. If carried right across the sky,

another line from Bellatrix, through **Betelgeuse**, (α Orionis) points to the constellation of **Leo**, a prominent constellation in the spring sky.

Six bright stars in six different constellations: **Capella** (α Aurigae), **Aldebaran** (α Tauri), **Rigel** (β Orionis), **Sirius** (α Canis Majoris), **Procyon** (α Canis Minoris) and **Pollux** (β Geminorum) form what is sometimes known as the 'Winter Hexagon'. Pollux is accompanied to the northwest by the slightly fainter star of **Castor** (α Geminorum), the second 'Twin'.

In a counterpart to the famous 'Summer Triangle', an almost perfect equilateral triangle, the 'Winter Triangle', is formed by Betelgeuse (α Orionis), Sirius (α Canis Majoris) and Procyon (α Canis Minoris).

Several of the stars in this region of the sky show distinctive tints: Betelgeuse (α Orionis) is reddish, Aldebaran (α Tauri) is orange and Rigel (β Orionis) is blue-white.

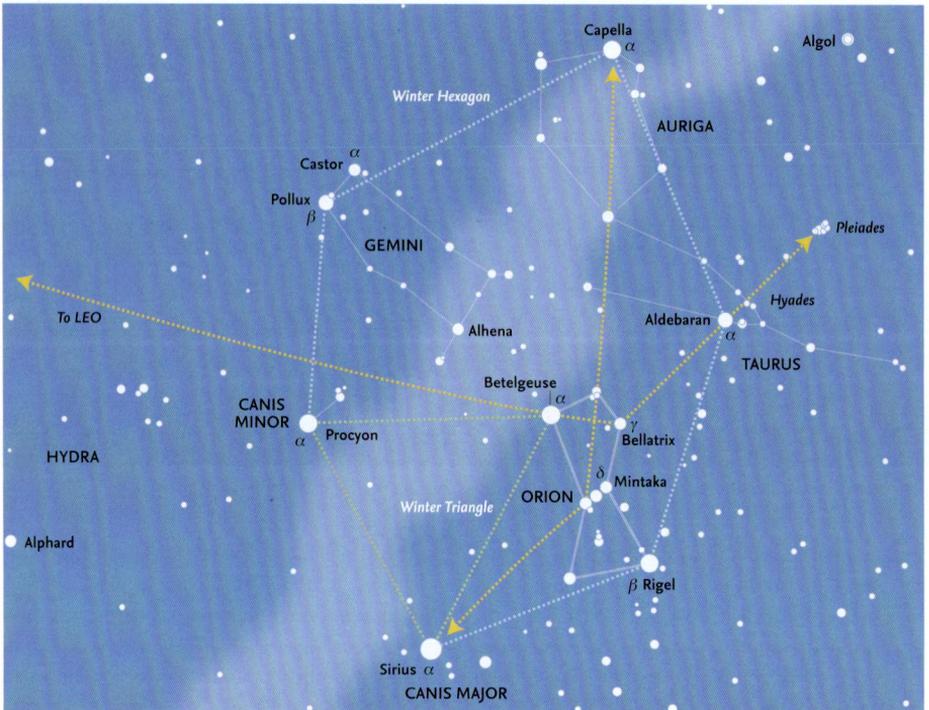

The Spring Constellations

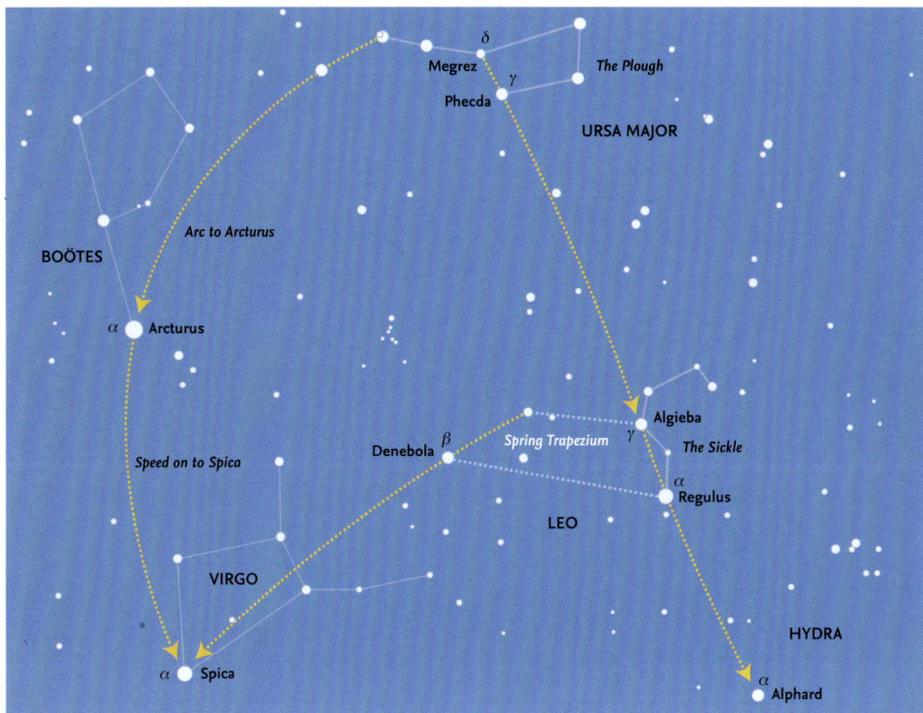

The most prominent constellation in the spring sky is the zodiacal constellation of **Leo**, and its brightest star, **Regulus** (α Leonis), which may be found by extending a line from Megrez and Phecda (δ and γ Ursae Majoris, respectively) – the two stars on the opposite side of the bowl of the Plough from the Pointers – down to the southeast. Regulus forms the ‘dot’ of the ‘backward question mark’ known as ‘the Sickle’. Regulus, like Aldebaran in Taurus is one of the bright stars that lie close to the ecliptic, and that are occasionally occulted by the Moon. The same line from Ursa Major to Regulus, if continued, leads to **Alphard** (α Hydrae), the brightest star in **Hydra**, the largest of the 88 constellations.

The shape formed by the body of Leo is sometimes known as the ‘Spring Trapezium’. At the other end of the constellation from Regulus is **Denebola** (β Leonis), and the line

forming the back of the constellation through Denebola points to the bright star **Spica** (α Virginis) in the constellation of **Virgo**. A saying that helps to locate Spica is well-known to astronomers: ‘Arc to Arcturus and then speed on to Spica.’ This suggests following the arc of the tail of Ursa Major to Arcturus and then on to Spica. **Arcturus** (α Boötis) is actually the brightest star in the northern hemisphere of the sky. (Although other stars, such as Sirius, are brighter, they are all in the southern hemisphere.) Overall, the constellation of **Boötes** is sometimes described as ‘kite-shaped’ or ‘shaped like the letter P’.

Although Spica is the brightest star in the zodiacal constellation of Virgo, the rest of the constellation is not particularly distinct, consisting of a rough quadrilateral of moderately bright stars and some fainter lines of stars extending outwards.

The Summer Constellations

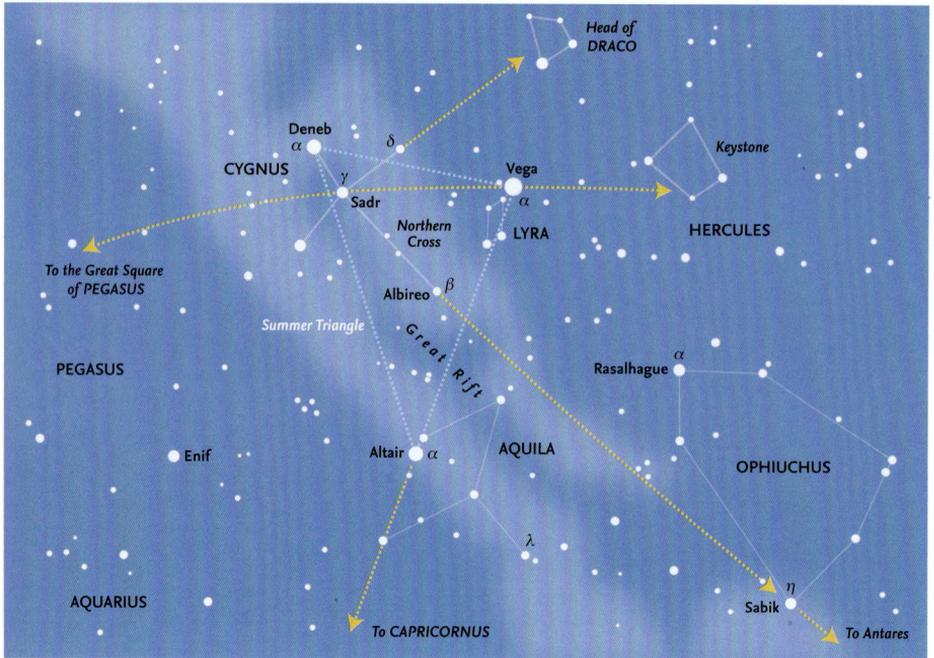

On summer nights, the three bright stars **Deneb** (α Cygni), **Vega** (α Lyrae) and **Altair** (α Aquilae) form the striking ‘Summer Triangle’. The constellations of **Cygnus** (the Swan) and **Aquila** (the Eagle) represent birds ‘flying’ down the length of the Milky Way. This part of the Milky Way contains the **Great Rift**, an elongated dark region where the light from distant stars is obscured by intervening dust. The dark Rift is clearly visible even to the naked eye.

The most prominent stars of Cygnus are sometimes known as the ‘Northern Cross’ (as a counterpart to the ‘Southern Cross’ – the constellation of Crux – in the southern hemisphere). The central line of Cygnus through **Albireo** (β Cygni), extended well to the southwest, points to **Sabik** (η Ophiuchi) in the large, sprawling constellation of **Ophiuchus** (the Serpent Bearer) and beyond to **Antares** (α Scorpii) in the constellation of **Scorpius**. Like Cepheus, the shape of Ophiuchus somewhat resembles the gable-end of a house, and the

brightest star **Rasalhague** (α Ophiuchi) is at the ‘apex’ of the ‘gable’.

A line from the central star of Cygnus, **Sadr** (γ Cygni) through δ Cygni, in the northwestern ‘wing’ points towards the Head of Draco -and is another way of locating that part of the constellation. Another line from Sadr to Vega indicates the central portion, ‘The Keystone’, of the constellation of **Hercules**. An arc through the same stars, in the opposite direction, points towards the constellation of **Pegasus**, and more specifically to the ‘Great Square of Pegasus’.

Aquila is less conspicuous than Cygnus and consists of a diamond shape of stars, representing the body and wings of the eagle, together with a rather faint star, λ Aquilae, marking the ‘head’. **Lyra** (the Lyre) mainly consists of Vega (α Lyrae) and a small quadrilateral of stars to its southeast. Continuation of a line from Vega through Altair indicates the zodiacal constellation of **Capricornus**.

The Autumn Constellations

During the autumn season, the most striking feature is the 'Great Square of Pegasus', an almost perfect rectangle on the sky, forming the main body of the constellation of **Pegasus**. However, the star at the northeastern corner, **Alpheratz**, is actually α Andromedae, and part of the adjacent constellation of **Andromeda**. A line from **Scheat** (β Pegasi) at the northeastern corner of the Square, through **Matar** (η Pegasi), points in the general direction of Cygnus. A crooked line of stars leads from **Markab** (α Pegasi) through **Homam** (ζ Pegasi) and **Biham** (θ Pegasi) to **Enif** (ϵ Pegasi). A line from Markab through the last star in the Square, **Algenib** (γ Pegasi) points in the general direction of the five stars, including **Menkar** (α Ceti), that form the 'tail' of the constellation of **Cetus** (the Whale). A ring of seven stars lying below the southern side of the Great Square is known as 'the Circlet', part of the constellation of **Pisces** (the Fishes).

Extending the line of the western side of the Great Square towards the south leads to the isolated bright star, **Fomalhaut** (α Piscis Austrini), in the Southern Fish. Following the line of the eastern side of the Great Square towards the north leads to Cassiopeia while, in the other direction, it points towards **Diphda** (β Ceti), which is actually the brightest star in Cetus.

Three bright stars leading northeast from Alpheratz form the main body of the constellation of **Andromeda**. Continuation of that line leads towards the constellation of **Perseus** and **Mirfak** (α Persei). Running southwards from Mirfak is a chain of stars, one of which is the famous variable star **Algol** (β Persei). Farther east, an arc of stars leads to the prominent cluster of the **Pleiades**, in the constellation of **Taurus**.

Between Andromeda and Cetus lie the two small constellations of **Triangulum** (the Triangle) and **Aries** (the Ram).

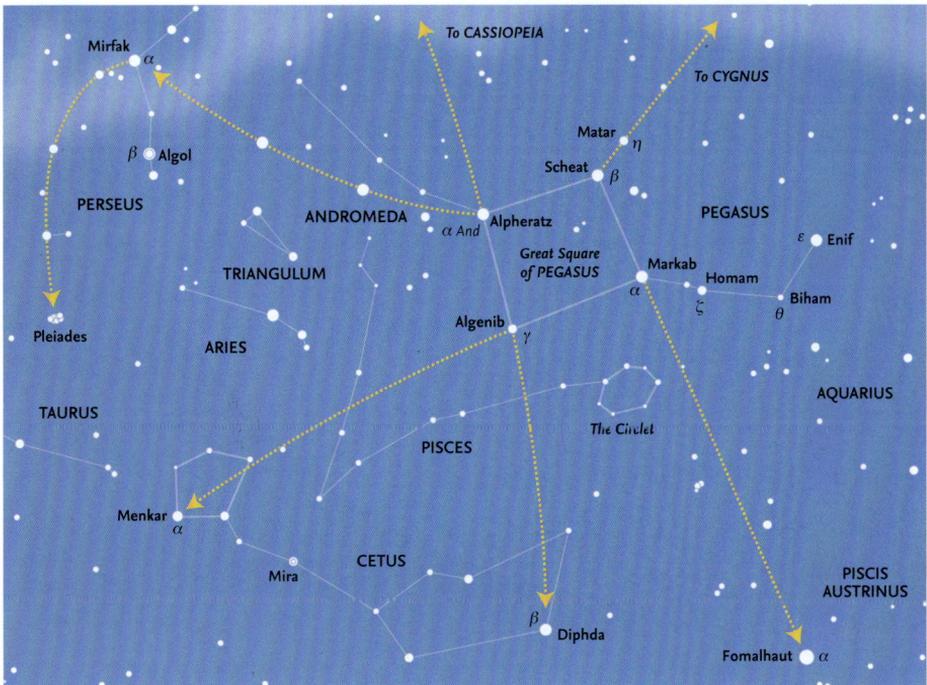

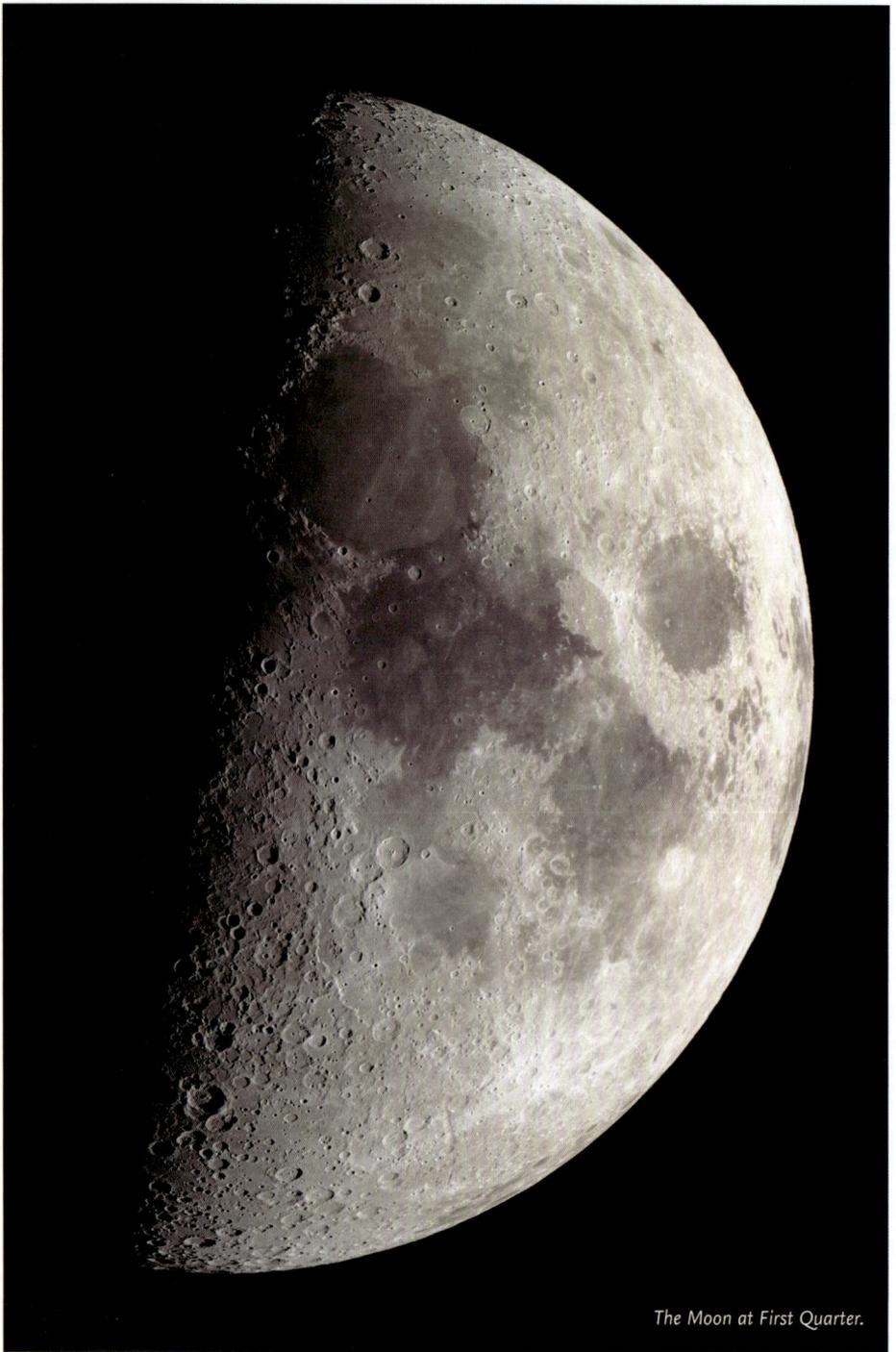

The Moon at First Quarter.

The Moon

The monthly pages include diagrams showing the phase of the Moon for every day of the month, and also indicate the day in the **lunation** (or **age** of the Moon), which begins at New Moon. Although the main features of the surface – the light highlands and the dark maria (seas) – may be seen with the naked eye, far more features may be detected with the use of binoculars or any telescope. The many craters are best seen when they are close to the **terminator** (the boundary between the illuminated and the non-illuminated areas of the surface), when the Sun rises or sets over any particular region of the Moon and the crater walls or central peaks cast strong shadows. Most features become difficult to see at Full Moon, although this is the best time to see the bright ray systems surrounding certain craters. Accompanying the Moon map on the following pages is a list of prominent features, including the days in the lunation when they are normally close to the terminator and thus easiest to see. A few bright features

such as Linné and Proclus, visible when well illuminated, are also listed. One feature, Rupes Recta (the Straight Wall) is readily visible only when it casts a shadow with light from the east, appearing as a light line when illuminated from the opposite direction.

The dates of visibility vary slightly through the effects of **libration**. Because the Moon's orbit is inclined to the Earth's equator and also because it moves in an ellipse, the Moon appears to rock slightly from side to side (and nod up and down). Areas near the **limb** (the edge of the Moon) may vary considerably in their location and visibility. (This is easily noticeable with Mare Crisium and the craters Tycho and Plato.) Another effect is that at crescent phases before and after New Moon, the normally non-illuminated portion of the Moon receives a certain amount of light, reflected from the Earth. This **Earthshine** may enable certain bright features (such as Aristarchus, Kepler and Copernicus) to be detected even though they are not illuminated by sunlight.

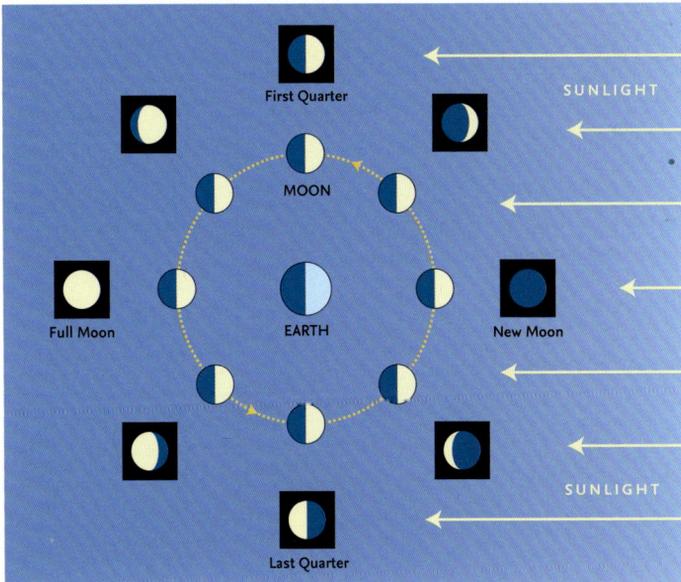

The Moon phases. During its orbit around the Earth, different portions of the side of the Moon that faces us are illuminated by the Sun.

Map of the Moon

Abulfeda	6:20
Agrippa	7:21
Albategnius	7:21
Aliacensis	7:21
Alphonsus	8:22
Anaxagoras	9:23
Anaximenes	11:25
Archimedes	8:22
Aristarchus	11:25
Aristillus	7:21
Aristoteles	6:20
Arzachel	8:22
Atlas	4:18
Autolycus	7:21
Barrow	7:21
Billy	12:26
Birt	8:22
Blancanus	9:23
Bullialdus	9:23
Bürg	5:19
Campanus	10:24
Cassini	7:21
Catharina	6:20
Clavius	9:23
Cleomedes	3:17
Copernicus	9:23
Cyrillus	6:20
Delambre	6:20
Deslandres	8:22
Endymion	3:17
Eratosthenes	8:22
Eudoxus	6:20
Fra Mauro	9:23
Fracastorius	5:19
Franklin	4:18
Gassendi	11:25
Geminus	3:17
Goclenius	4:18
Grimaldi	13-14:27-28
Gutenberg	5:19
Hercules	5:19
Herodotus	11:25
Hipparchus	7:21
Hommel	5:19
Humboldt	3:15
Janssen	4:18
Julius Caesar	6:20
Kepler	10:24
Landsberg	10:24
Langrenus	3:17
Letronne	11:25
Linné	6
Longomontanus	9:23

The numbers indicate the day or days (the age) of the Moon when features are usually best visible.

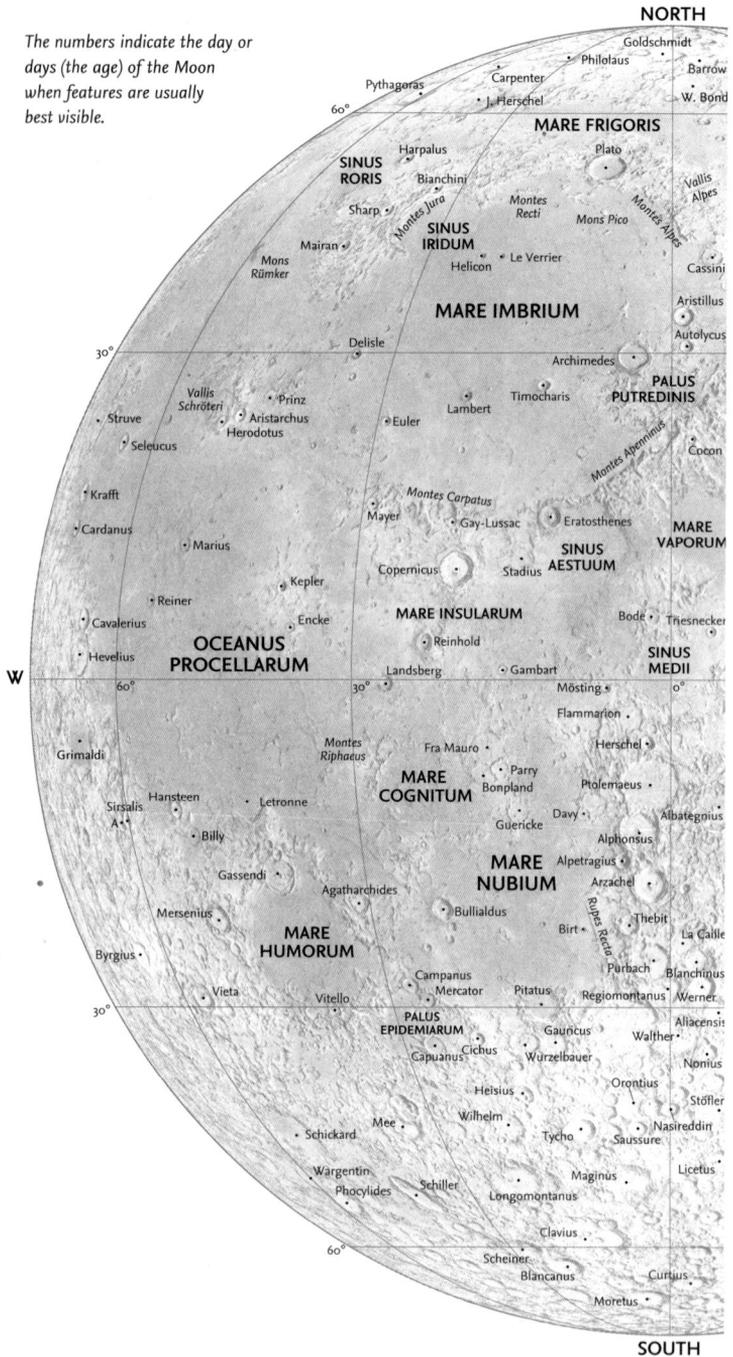

Eclipses in 2025

Lunar eclipses

There are two total lunar eclipses in 2025. The first takes place on 14 March and it will be visible from Western Europe as well as North and South America, West Africa and the Pacific Ocean. The second eclipse occurs on 7 September, this will be visible from Europe, Africa, Asia and Australia. During a total lunar eclipse the Moon moves eastward into the Earth's penumbra, then moves behind the Earth into the darkest region of the Earth's shadow – the umbra – eventually creeping back out into the penumbra and into the sunlight. On 14 March maximum eclipse occurs at 06:59, the Moon will spend a total of 1 hour and 6 minutes immersed in the darkest shadow of the Earth. During this time the Moon is still visible; however, it will appear a reddish-brown colour. This is due to refracted sunlight

which passes through the Earth's atmosphere and bends towards the lunar surface. Blue hues are scattered outwards by the Earth's atmosphere, leaving behind redder light which eventually reaches the Moon. On the evening of 7 September the time of maximum eclipse will be 18:12; the umbral eclipse will last 1 hour 22 minutes.

Solar eclipses

There are two partial solar eclipses in 2025; the first takes place on 29 March with the maximum occurring at 11:03 from London and a duration of 1 hour and 53 minutes. This eclipse will be visible from Europe, northwest Africa and northern Russia. The second partial eclipse occurs on 21 September; this will be visible only from the southern hemisphere.

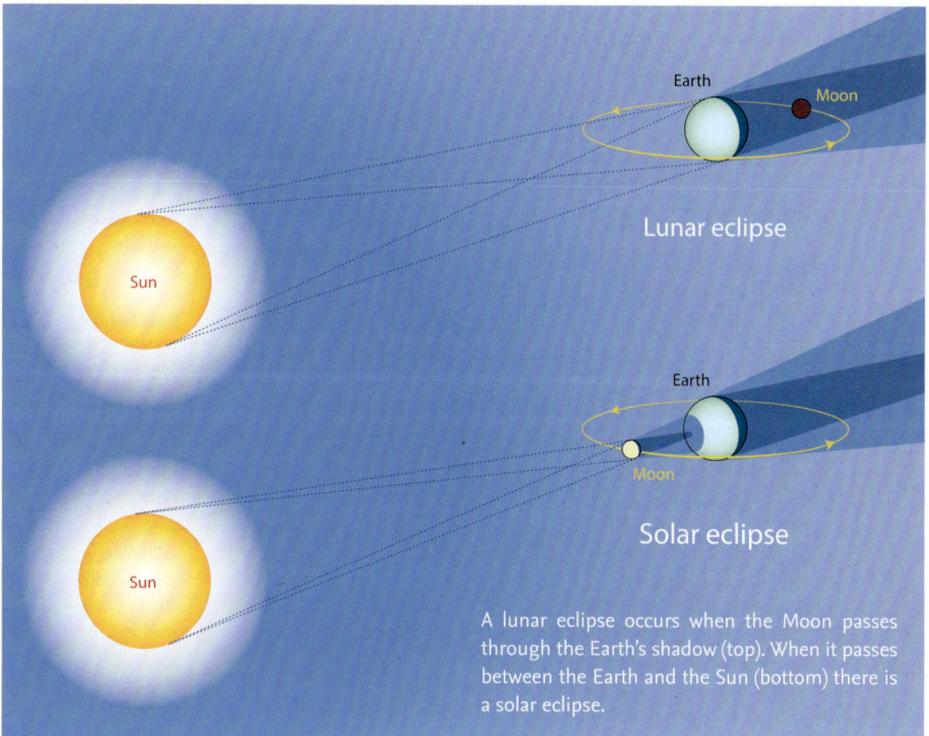

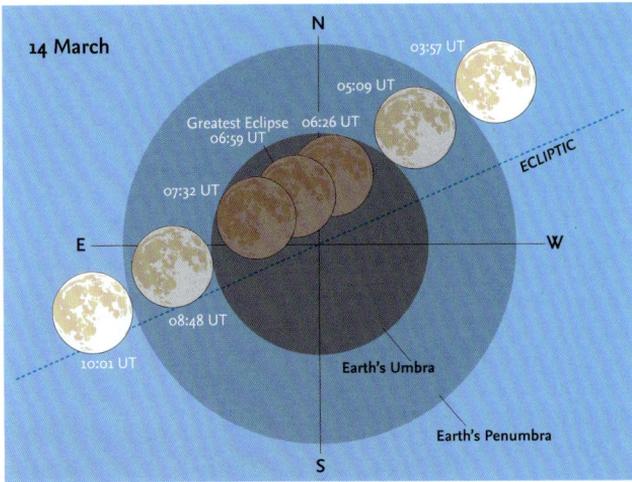

The path of the Moon as it passes through the shadow of the Earth on 14 March. Maximum eclipse occurs at 06:59 UT.

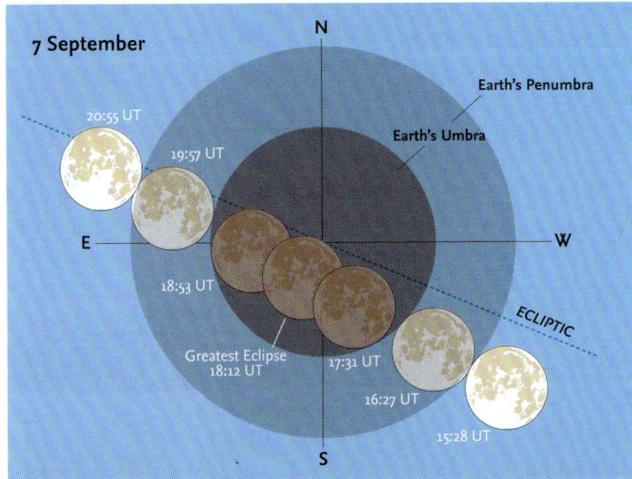

The path of the Moon as it passes through the shadow of the Earth on 7 September. Maximum eclipse occurs at 18:12 UT.

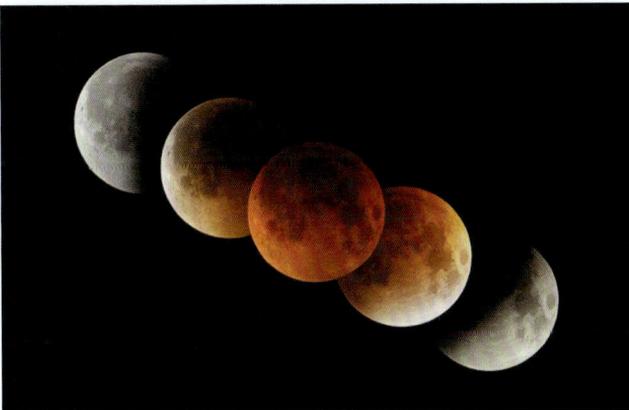

A sequence of five images of the Moon, taken by Akira Fujii, showing the progression of the Moon (from right to left: west to east) through the Earth's shadow.

The Planets in 2025

Mercury and Venus

Mercury reaches greatest eastern elongation three times during 2025 – it will be seen in the early evening on 8 March (with Venus nearby), 4 July and 29 October, although it will be just above the horizon at sunset on this day (with Mars in the same region of the sky). Mercury switches to an appearance at dawn when it is at greatest western elongation on 21 April, 19 August and 7 December, although in April it will be positioned at a low altitude with Venus and Saturn close by. Its magnitude oscillates throughout the year – it will be brightest in May (-2.3) and faintest in November (6.1).

Venus appears as the evening star on 10 January when it is at greatest eastern elongation. Saturn will be visible in the same area and both planets will lie in Aquarius. On 31 May Venus will move to greatest western elongation in Pisces and appear in the morning. On both occasions it will shine brightly at mag. -4.4.

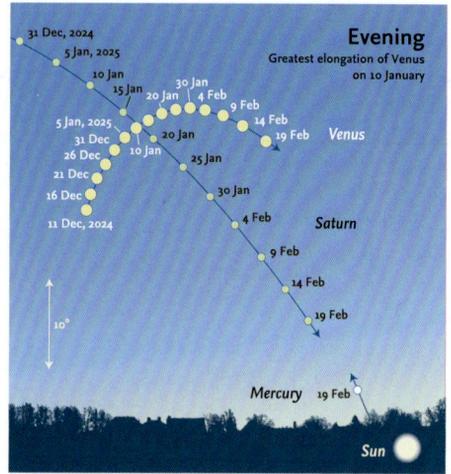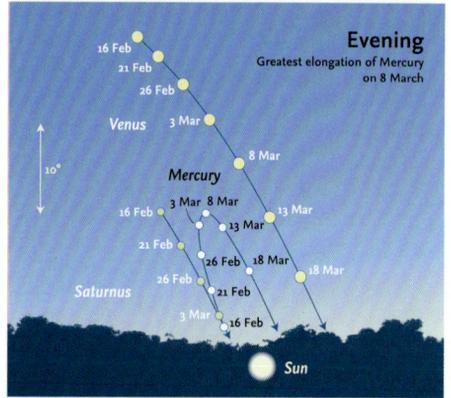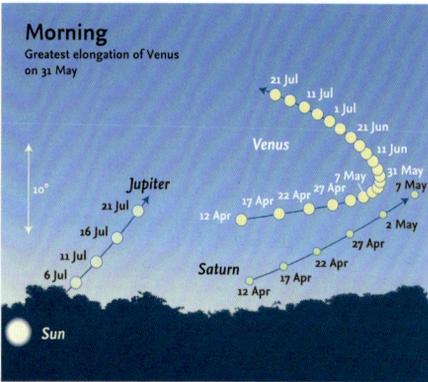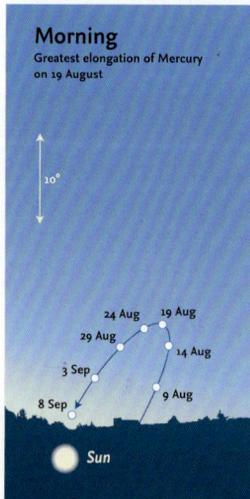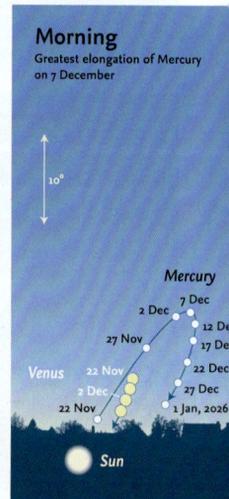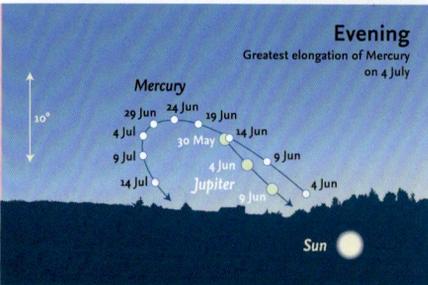

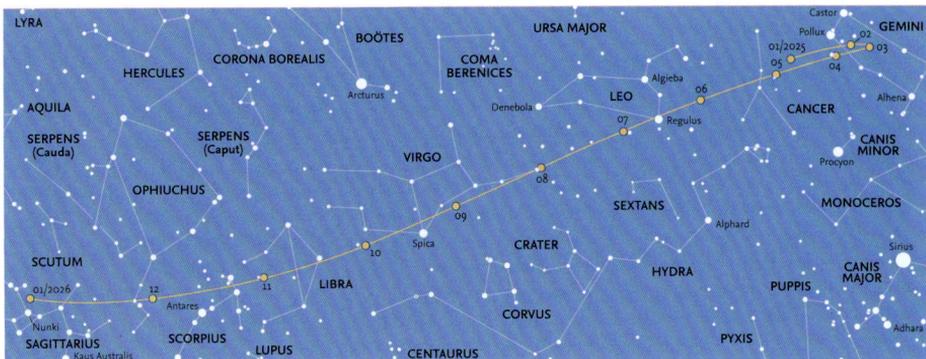

The path of Mars in 2025. In the last months it is caught up by the Sun and disappears in the evening twilight.

Mars

Mars will reach perigee on 12 January and opposition takes place 4 days later due to its elliptical orbit. It will reach a peak magnitude of -1.4 in **Gemini**. As it takes longer to complete its orbit than the Earth, Mars does not come to opposition every year; the last opposition took place in December 2022. Instead, it often remains in the sky for many months at a time, moving slowly along the ecliptic. Oppositions occur during a period of retrograde motion, when the planet appears to move westwards against the pattern of distant stars. Mars began retrograde motion on 6 December 2024 and it will end its westward motion on 24 February, moving eastward until 10 January 2027 when it will appear to move backwards again as the Earth overtakes it in its orbit around the Sun.

As Mars moves away from Earth, its apparent size in the sky will decrease and it will dim to a magnitude of 1.6 in August, slowly appearing brighter towards the end of the year as it reaches magnitude 1.0 . Mars starts in **Cancer**, moves into **Gemini** then back to Cancer in April, it will pass through **Leo** and **Virgo** in the summer, setting

earlier in the evening and appearing closer to the Sun as autumn approaches. Mars will be in **Libra** in October and then it will move through **Scorpius** and **Ophiuchus** all before December.

Because of its eccentric orbit, which carries it at very differing distances from the Sun (and Earth), not all oppositions of Mars are equally favourable for observation. The relative positions of Mars and the Earth are shown below. It will be seen that the opposition of 2018 was very close and thus favourable for observation, and that of 2020 was also reasonably good. By comparison, opposition in 2027 will be at a far greater distance, so the planet will appear much smaller.

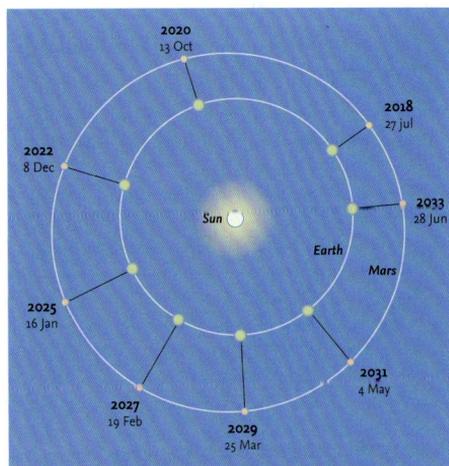

The oppositions of Mars between 2018 and 2033. As the illustration shows, there is an opposition on 16 January 2025.

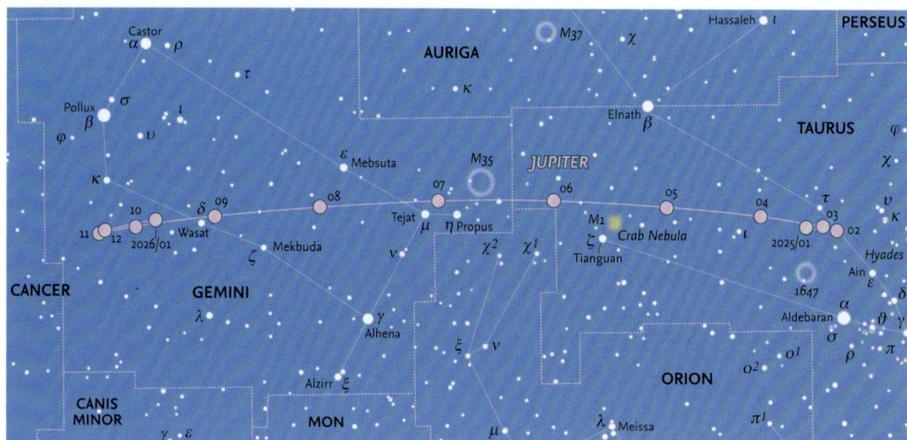

The path of Jupiter in 2025. Jupiter does not come to opposition until 10 January 2026. Background stars are shown down to magnitude 6.5.

Jupiter and Saturn

Jupiter reaches opposition in early December 2024 and begins 2025 in **Taurus** at a magnitude of -2.7. It ends retrograde motion on 4 February 2025. It moves into **Gemini** in June, dimming to mag. -1.9 and will be too close to the Sun to be seen. Jupiter will enter retrograde motion again on 11 November, brightening to -2.7 in December.

Jupiter's four large satellites are readily visible in binoculars. Not all four are visible all the time, they are sometimes hidden behind the planet or invisible in front of it. Io, the

closest to Jupiter, orbits in just under 1.8 days, and Callisto, the farthest away, takes about 16.7 days. In between are Europa (c. 3.6 days) and the largest, Ganymede (c. 7.1 days).

Saturn is in **Aquarius** at the start of the year, it moves into **Pisces** in April, then back into Aquarius in September. On 13 July Saturn will enter retrograde motion in Pisces. It will reach opposition on 21 September and it will shine brightly with a magnitude of 0.6. Saturn will end its retrograde movement on 28 November, gradually getting fainter and dipping to mag. 1.0 in December. On 23 March Saturn's rings will appear edge-on as viewed from Earth but the planet will be too close to the Sun to be visible at this time. It will reappear in the early morning sky from late June onwards, setting earlier towards the end of the year.

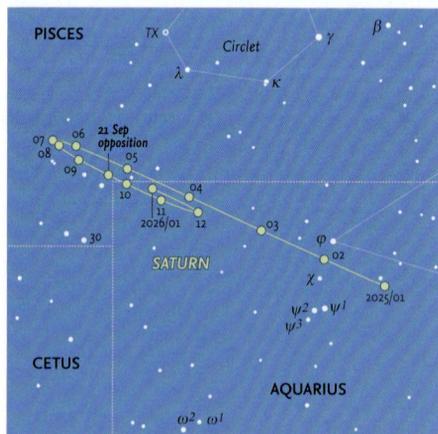

The path of Saturn in 2025. Saturn comes to opposition on 21 September. Background stars are shown to magnitude 6.5.

Uranus and Neptune

Uranus ends its retrograde motion on 30 January (it has been moving westward since September 2024) while in **Aries**. It will have a mag. of 5.7. Uranus moves into **Taurus** in March. It will re-enter retrograde motion on 6 September 2025, moving westward across the sky until 4 February 2026. It will reach opposition on 21 November in Taurus, mag. 5.6.

Neptune moved into **Pisces** in May 2022; it will stay in Pisces until August 2029. It enters retrograde motion on 4 July 2025 at magnitude 7.8. It will reach opposition on 23 September (mag. 7.7). It reverts to direct motion on 10 December and will continue moving eastwards until 7 July 2026.

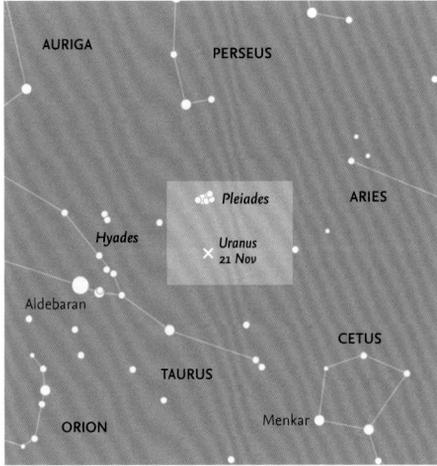

Uranus is in Taurus at the time of its opposition and not far from the Pleiades, on 21 November. The boxed area is shown in more detail to the right.

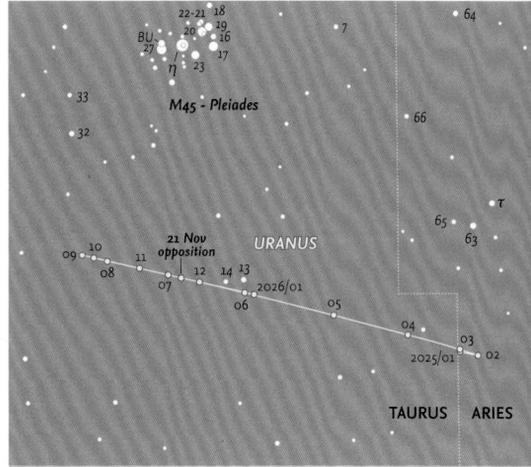

The path of Uranus in 2025. Uranus comes to opposition on 21 November. All stars brighter than magnitude 7.5 are shown.

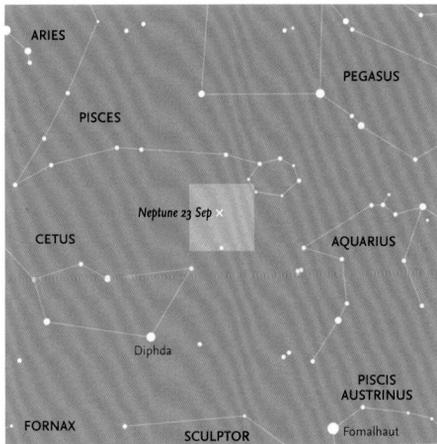

In 2025, Neptune is to be found in the southern part of Pisces. The planet comes to opposition on 23 September.

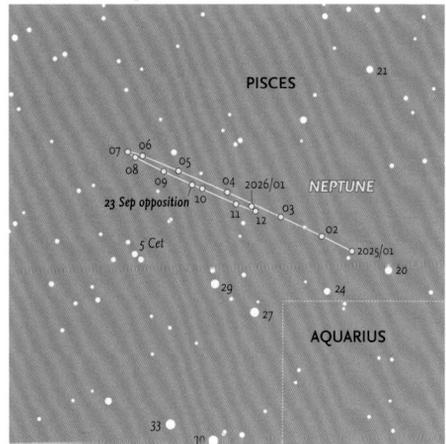

The path of Neptune in 2025. It is in the constellation of Pisces for the whole year. All stars down to magnitude 8.5 are shown.

Minor Planets in 2025

Several minor planets rise above magnitude 9.0 in 2025, and four come to opposition at, or above, mag. 9.0. They are closest to Earth at this point and reach their highest point in the sky around midnight – this is the best time to see them. On 2 May the asteroid (4) *Vesta* will lie in *Libra*, reaching a peak magnitude of 5.6 at opposition. On 11 August (89) *Julia* will reach magnitude 8.5 in *Aquarius* and (6) *Hebe* will reach opposition later in the month on 26 August, visible at magnitude 7.6.

On 2 October the dwarf planet (1) *Ceres* will rise in magnitude to 7.6, at a distance of 1.97 AU (Astronomical Units, equivalent to the average distance from the Earth to the Sun), though its visibility will be hindered by a waxing gibbous Moon. *Ceres* is the only dwarf planet that lies within the orbit of Neptune and it completes its orbit in 4.6 years. The Earth could accommodate 2,500 of *Ceres*.

The three small maps at the top of the next page show the areas covered by the larger maps in a lighter blue. A white cross marks the position of the minor planet at the day of its opposition.

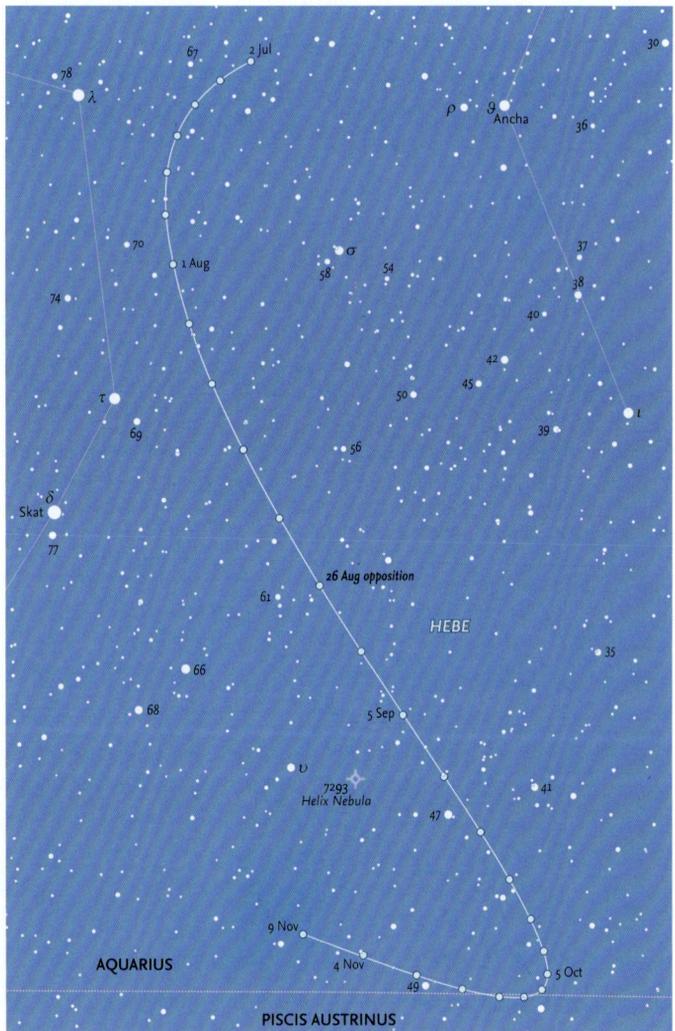

The path of the minor planet (6) *Hebe* around its opposition on 26 August (mag. 7.6). Background stars are shown down to magnitude 9.5.

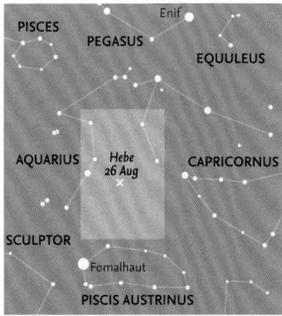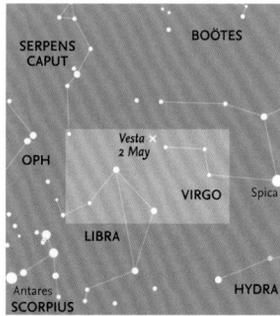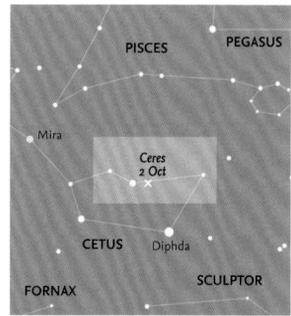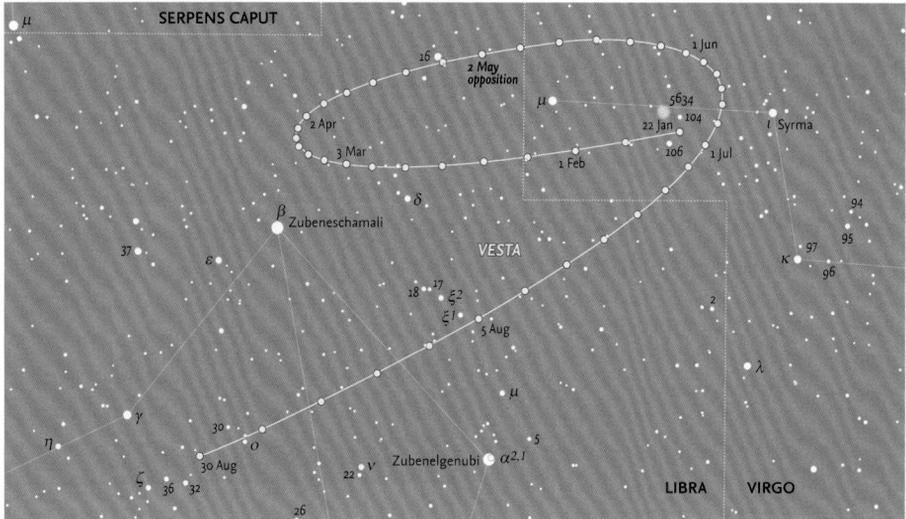

The path of the minor planet (4) Vesta around its opposition on 2 May (mag. 5.6). Background stars are shown down to magnitude 8.5.

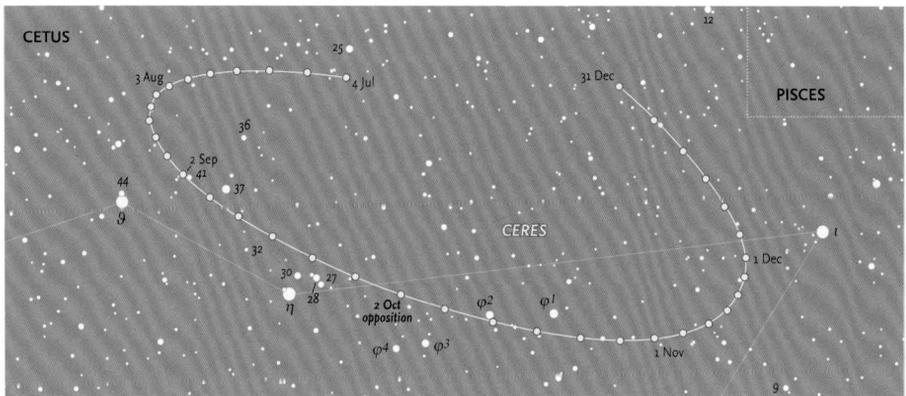

The path of the dwarf planet (1) Ceres around its opposition on 2 October (mag. 7.6). Background stars are shown down to magnitude 9.5.

Comets in 2025

Although comets may occasionally become very striking objects in the sky, as was the case with Comet C/2020 F3 NEOWISE in 2020, their occurrence and particularly the existence or length of any tail and their overall magnitude are notoriously difficult to predict. Naturally, it is only possible to predict the return of periodic comets (whose names have the prefix 'P'). Many comets appear unexpectedly (these have names with the prefix 'C'). Bright, readily visible comets such as C/1995 Y1 Hyakutake, C/1995 O1 Hale-Bopp, C/2006 P1 McNaught or C/2020 F3 NEOWISE are rare. Most periodic comets are faint and only a very small number ever become bright enough to be easily visible with the naked eye or with binoculars.

Comet 24P/Schaumasse will be visible after midnight in December 2025, moving through the constellations of Leo, Coma Berenices and then passing into Virgo in early January 2026. It will make its closest approach on 4 January 2026, passing within a distance equivalent to 60% of the Earth-Sun distance. It will brighten towards the end of the year, reaching a magnitude of between 8 and 9.

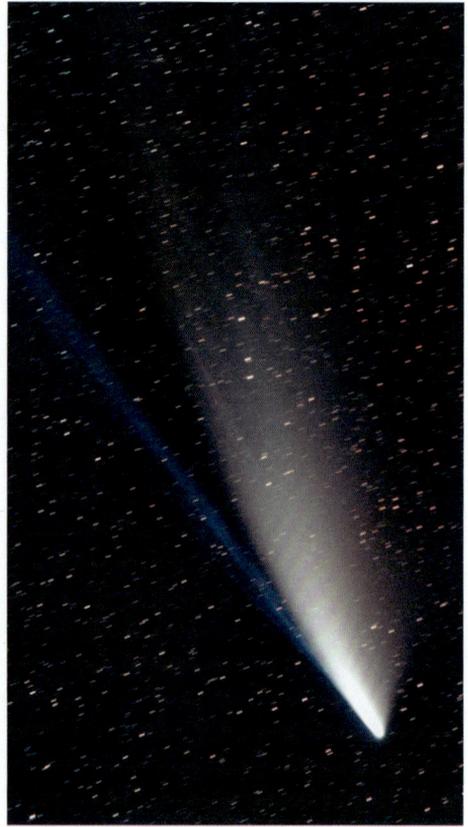

The Comet C/2020 F3 NEOWISE photographed by Nick James on 17 July 2020, showing the light-coloured dust tail, together with the blue ion tail.

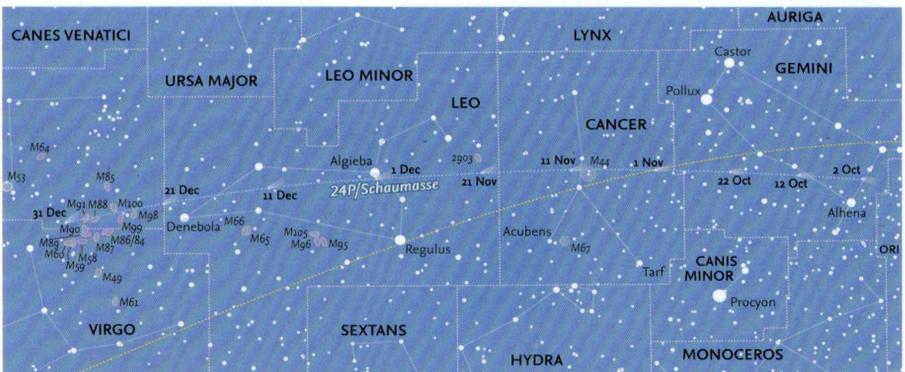

The path of Comet 24P/Schaumasse from 2 October to 31 December 2025. It rises above magnitude 9.0 in December. Background stars are shown down to magnitude 6.0.

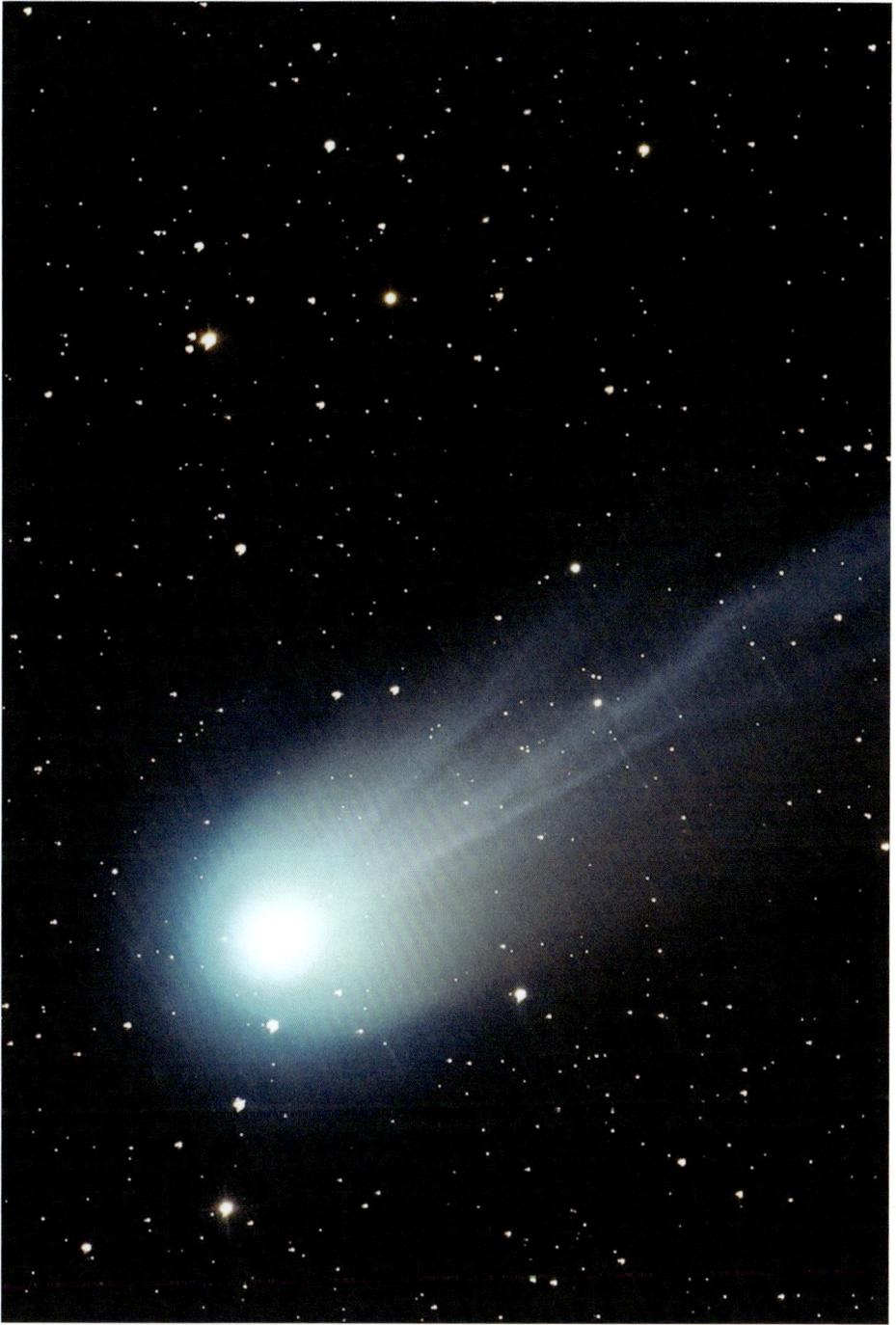

Comet 12P/Pons-Brooks, showing the coma (halo) of gas surrounding the nucleus and a tail.

Introduction to the Month-by-Month Guide

The monthly charts

The pages devoted to each month contain a pair of charts showing the appearance of the night sky, looking north and looking south. The charts (as with all the charts in this book) are drawn for the latitude of 50°N , so observers farther north will see slightly more of the sky on the northern horizon, and slightly less on the southern. These areas are, of course, those most likely to be affected by poor observing conditions caused by haze, mist or smoke. In addition, stars close to the horizon are always dimmed by atmospheric absorption, so sometimes the faintest stars marked on the charts may not be visible.

The three times shown for each chart require a little explanation. The charts are drawn to show the appearance at 23:00 GMT for the 1st of each month. The same appearance will apply an hour earlier (22:00 GMT) on the 15th, and yet another hour earlier (21:00 GMT) at the end of the month (shown as the 1st of the following month). GMT is identical to the Universal Time (UT) used by astronomers around the world. In Europe, Summer Time is introduced in March, so the March charts apply to 23:00 GMT on 1 March, 22:00 GMT on 15 March, but 22:00 BST (British Summer Time) on 1 April. The change back from Summer Time (in Europe) occurs in October, so the charts for that month apply to 00:00 BST for 1 October, 23:00 BST for 15 October and 21:00 GMT for 1 November.

The charts may be used for earlier or later times during the night. To observe two hours earlier, use the charts for the preceding month; for two hours later, the charts for the next month.

Meteors

Details of specific meteor showers are given in the months when they come to maximum, regardless of whether they begin or end in other months. Note that not all the respective radiants are marked on the charts for that

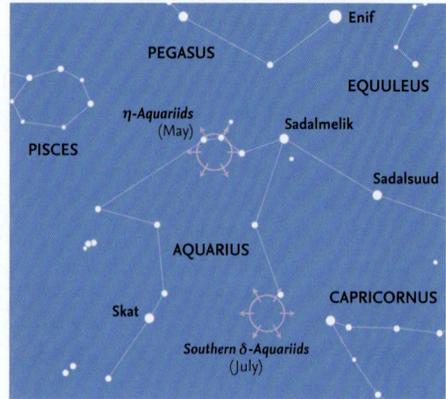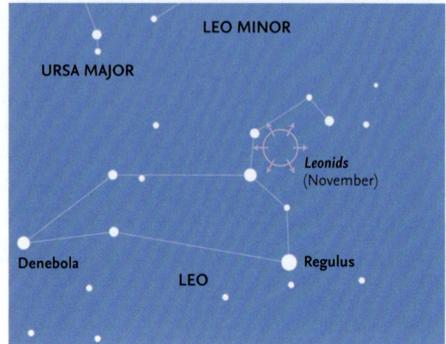

particular month, because the radiants may be below the horizon, or lie in constellations that are not readily visible during the month of maximum. For this reason, special charts for the Eta (η) and Delta (δ) Aquariids (May and July, respectively) and the Leonids (November) are given here. As explained earlier, however, meteors from such showers may still be seen, because the most effective region for seeing meteors is some $40\text{--}45^{\circ}$ from the radiant, and that area of sky may well be above the horizon. A table of the best meteor showers visible during the year is also given here. The rates given are based on the properties of the meteor streams, and are those that an experienced observer might see under ideal conditions. Generally, the observed rates will be far lower.

Shower	Dates of activity 2025	Date of maximum 2025	Possible hourly rate
Quadrantids	26 December to 12 January	4 January	120
April Lyrids	16 April to 25 April	22 April	18
η -Aquariids	19 April to 28 May	5 May	40
α -Capricornids	3 July to 15 August	30 July	5
Southern δ -Aquariids	12 July to 23 August	30 July	25
Perseids	17 July to 24 August	12 August	150
α -Aurigids	28 August to 5 September	31 August	6
Southern Taurids	10 September to 20 November	10 October	5
Orionids	2 October to 7 November	22 October	15
Draconids	6 October to 10 October	8 October	var.
Northern Taurids	20 October to 10 December	12 November	5
Leonids	6 November to 30 November	17 November	15
Geminids	4 December to 20 December	14 December	120
Ursids	17 December to 26 December	22 December	10

Meteors that are brighter than magnitude -4 (approximately the maximum magnitude reached by Venus) are known as **fireballs** or **bolides**. Examples are shown on pages 32, 35 and 77. Fireballs sometimes cause sonic booms that may be heard some time after the meteor is seen.

The photographs

As an aid to identification – especially as some people find it difficult to relate charts to the actual stars they see in the sky – one or more photographs of constellations visible in certain specific months are included. It should be noted, however, that because of the limitations of the photographic and printing processes, and the differences between the sensitivity of different individuals to faint starlight (especially in their ability to detect different colours), and the degree to which they have become adapted to the dark, the apparent brightness of stars in the photographs will not necessarily precisely match that seen by any one observer.

The Moon calendar

The Moon calendar is largely self-explanatory. It shows the phase of the Moon for every day of the month, with the exact times (in Universal Time) of New Moon, First Quarter, Full Moon and Last Quarter. Because the times are calculated from the Moon's actual orbital parameters, some of the times shown

will, naturally, fall during daylight, but any difference is too small to affect the appearance of the Moon on that date. Also shown is the **age** of the Moon (the day in the **lunation**), beginning at New Moon, which may be used to determine the best time for observation of specific lunar features.

The Moon

The section on the Moon includes details of any lunar or solar eclipses that may occur during the month (visible from anywhere on Earth). Similar information is given about any important occultations. Mainly, however, this section summarizes when the Moon passes close to planets or the five prominent stars close to the ecliptic. The dates when the Moon is closest to the Earth (at **perigee**) and farthest from it (at **apogee**) are shown in the monthly calendars, and only mentioned here when they are particularly significant, such as the nearest and farthest points during the year.

The planets and minor planets

Brief details are given of the location, movement and brightness of the planets from Mercury to Saturn throughout the month. None of the planets can, of course, be seen when they are close to the Sun, so such periods are generally noted. All of the planets may sometimes lie on the opposite side of the Sun to the Earth (at superior conjunction), but

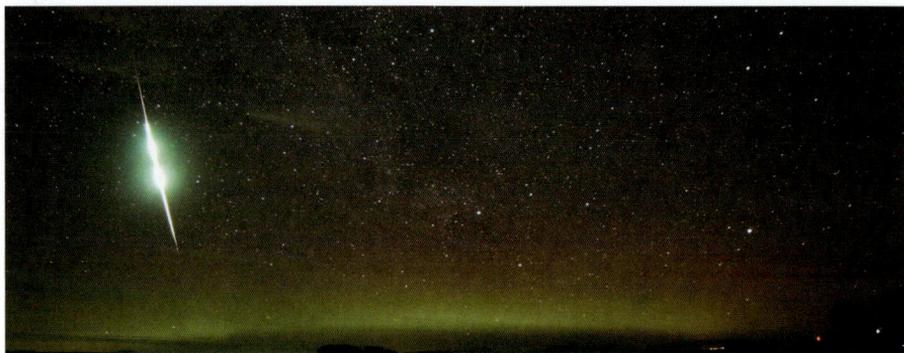

A fireball (with flares approximately as bright as the Full Moon), photographed against a weak auroral display from Tarbat Ness by Denis Buczynski in Scotland on 22 January 2017.

in the case of the inferior planets, Mercury and Venus, they may also pass between the Earth and the Sun (at inferior conjunction) and are invisible for a period of time, the length of which varies from conjunction to conjunction. Those two planets are normally easiest to see around either eastern or western elongation, in the evening or morning sky, respectively. Not every elongation is favourable, so although every elongation is listed, only those where observing conditions are favourable are shown in the individual diagrams of events.

The dates at which the superior planets reverse their motion (from direct motion to **retrograde**, and retrograde to direct) and of opposition (when a planet generally reaches its maximum brightness) are given. Some planets, especially distant Saturn, may spend most or all of the year in a single constellation. Jupiter and Saturn are normally easiest to see around opposition, which occurs every year. Mars, by contrast, moves relatively rapidly against the background stars and in some years never comes to opposition.

Uranus is normally magnitude 5.7–5.9, and thus at the limit of naked-eye visibility under exceptionally dark skies, but bright enough to be readily visible in binoculars. Because its orbital period is so long (over 84 years), Uranus moves only slowly along the ecliptic, and often remains within a single constellation for a whole year. The chart on page 25 shows its position during 2025.

Similar considerations apply to Neptune, although it is always fainter (generally magnitude 7.8–8.0), it is still visible in most binoculars. It takes about 164.8 years to complete one orbit of the Sun. As with Uranus, it frequently spends a complete year in one constellation. Its chart is also on page 25.

In any year, few minor planets ever become bright enough to be detectable in binoculars. Just one, (4) Vesta, on rare occasions brightens sufficiently for it to be visible to the naked eye. Our limit for visibility is magnitude 9.0 and details and charts are given for those objects that exceed that magnitude during the year, normally around opposition. To assist in recognition of a planet or minor planet as it moves against the background stars, the latter are shown to a fainter magnitude than the object at opposition. Minor-planet charts for 2025 are on pages 26 and 27.

The ecliptic charts

Although the ecliptic charts are primarily designed to show the positions and motions of the major planets, they also show the motion of the Sun during the month. The light-tinted area shows the area of the sky that is invisible during daylight, but the darker area gives an indication of which constellations are likely to be visible at some time of the night. The closer a planet is to the border between dark and light, the more difficult it will be to see in the twilight.

The monthly calendar

For each month, a calendar shows details of significant events, including when planets are close to one another in the sky, close to the Moon, or close to any one of five bright stars that are spaced along the ecliptic. The times shown are given in Universal Time (UT), always used by astronomers throughout the year, and which is identical to Greenwich Mean Time (GMT). So during the summer months, they do not show Summer Time, which will always be one hour later than the time shown.

The diagrams of interesting events

Each month, a number of diagrams show the appearance of the sky when certain events take place. However, the exact positions of celestial objects and their separations greatly depend on the observer's position on Earth. When the Moon is one of the objects involved, because it is relatively close to Earth, there may be very significant changes from one location to another. Close approaches between planets or between a planet and a star are less affected by changes of location, which may thus be ignored.

The diagrams showing the appearance of the sky are drawn for the latitude of London, so will be approximately correct for most of Britain and Europe. However, for an observer farther north (say, in Edinburgh), a planet or star listed as being north of the Moon will appear even farther north, whereas one south of the Moon will appear closer to it – or may even be hidden (occulted) by it. For an observer farther south than London, there will be corresponding changes in the opposite direction: for a star or planet south of the Moon, the separation will increase, and for one north of the Moon, the separation will decrease. This is particularly important when

occultations occur, which may be visible from one location, but not another. There is one occultation of Saturn and one of Venus in 2025. Both are visible from London, however the occultation of Venus will happen during the day. Ideally, details should be calculated for each individual observer, but this is obviously impractical. In fact, positions and separations are actually calculated for a theoretical observer located at the centre of the Earth.

The details given regarding the positions of the various bodies should be used as a guide to their location. A similar situation arises with the times that are shown. These are calculated according to certain technical criteria, which need not concern us here. However, they do not necessarily indicate the exact time when two bodies are closest together. Similarly, dates and times are given, even if they fall in daylight, when the objects are likely to be completely invisible. However, such times do give an indication that the objects concerned will be in the same general area of the sky during both the preceding and the following nights.

Data used in this Guide

The data given in this Guide, such as timings and distances between objects, have been computed with a program developed by the US Naval Observatory in Washington DC (MICA, the Multiyear Interactive Computer Almanac). Additional data was provided by the following sources: the Astronomical Applications Department of the US Naval Observatory; the Sky Events Calendar by Fred Espenak and Sumit Dutta (NASA's GSFC); the NASA Jet Propulsion Laboratory (JPL) Horizons System; the International Astronomical Union's (IAU) Minor Planet Center.

Key to the symbols used on the monthly star maps.

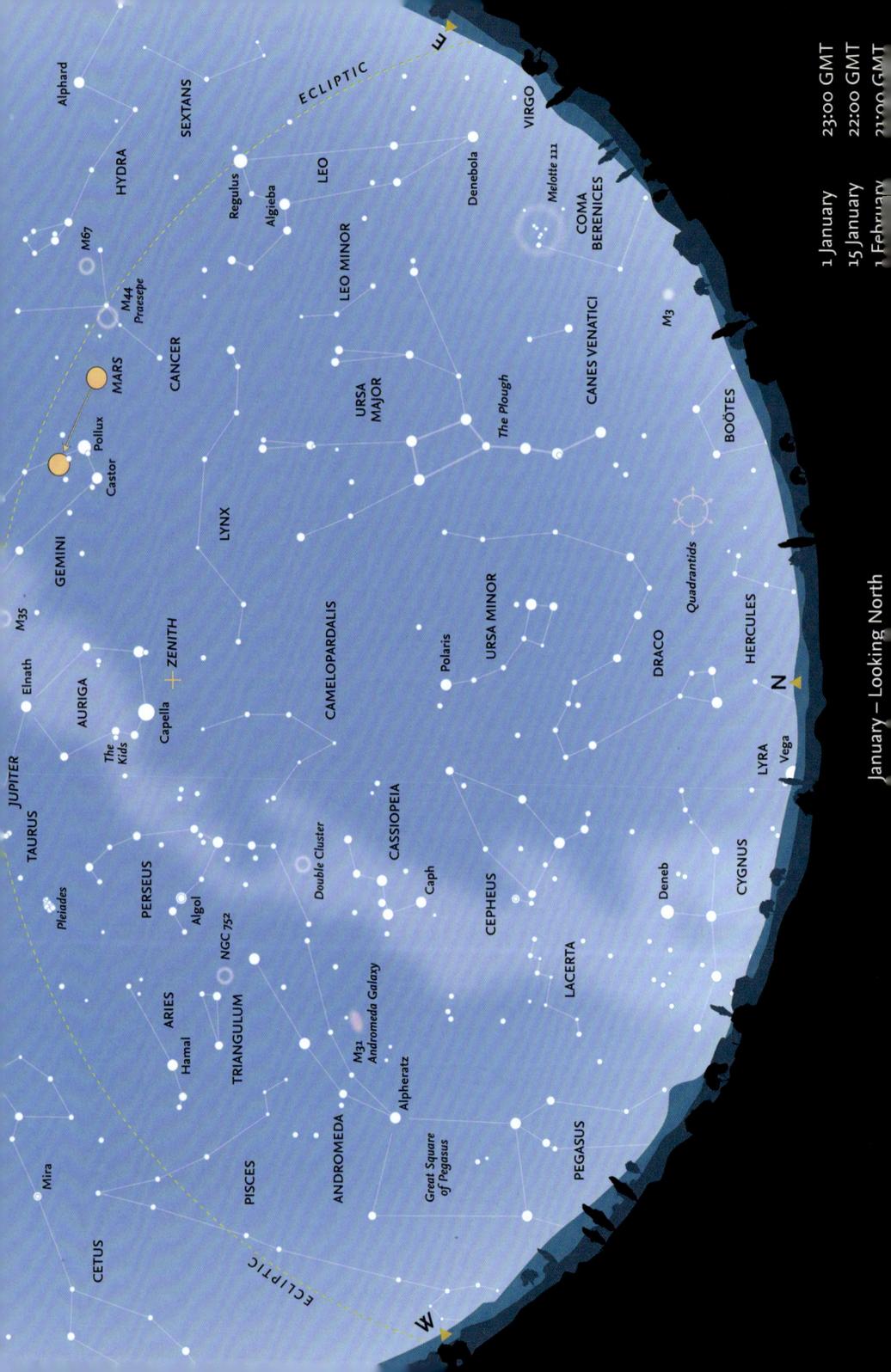

1 January
15 January
1 February

23:00 GMT
22:00 GMT
21:00 GMT

January – Looking North

Alphard
HYDRA
SEXTANS
LEO
Denebola
Meloite 111
COMA BERENICES
VIRGO
Leo Minor
Ursa Major
The Plough
CANCER
MARS
Castor
Pollux
GEMINI
LYNX
CAMELOPARDALIS
URSA MINOR
Polaris
URSA MAJOR
The Plough
CANCER VENATICI
M3
BOÖTES
Auriga
Elnath
M35
The Kids
Capella
ZENITH
CASSIOPEIA
Polaris
URSA MINOR
DRACO
HERCULES
BOÖTES
AURIGA
PERSEUS
Pleiades
Algol
NGC 752
Double Cluster
CASSIOPEIA
Ceph
CEPHEUS
Deneb
CYGNUS
LYRA
Vega
N
Mira
CETUS
PISCES
ANDROMEDA
Great Square of Pegasus
Alpheratz
M31 Andromeda Galaxy
LACERTA
PEGASUS
ECLIPTIC
W

January – Looking North

Most of the important circumpolar constellations are easy to see in the northern sky at this time of year. *Ursa Major* stands more-or-less vertically above the horizon in the northeast, with the zodiacal constellation of *Leo* rising in the east. To the north, the stars of *Ursa Minor* lie below *Polaris* (the Pole Star). The head of *Draco* is low on the northern horizon, but may be difficult to see unless observing conditions are good. Both *Cepheus* and *Cassiopeia* are readily visible in the northwest, and even the faint constellation of *Camelopardalis* is high enough in the sky for it to be easily visible.

Near the zenith is the constellation of *Auriga* (the Charioteer), with brilliant *Capella* (α Aurigae), directly overhead. Slightly to the west of Capella lies a small triangle of fainter stars, known as 'the Kids' (Ancient mythological representations of Auriga show him carrying two young goats.) Together with the northernmost bright star in *Taurus*, *Elnath* (β Tauri), the body of Auriga forms a large pentagon on the sky, with the Kids lying on the western side. Farther down towards the west are the constellations of *Perseus* and *Andromeda*, and the Great Square of Pegasus is approaching the horizon.

Meteors

The *Quarantid* meteor shower actually begins in late December (on 26 December 2024) and continues until 12 January. It is one of the strongest and most consistent meteor showers. It comes to maximum on the night of 4 January, when the Moon is a waxing crescent, so moonlight will cause some interference. However, the meteors are bright, bluish- or yellowish-white and may reach a maximum rate of 110 per hour. The parent object is minor planet 2003 EH₁.

The shower is named after the former constellation *Quadrans Muralis* (the Mural Quadrant), an early form of astronomical

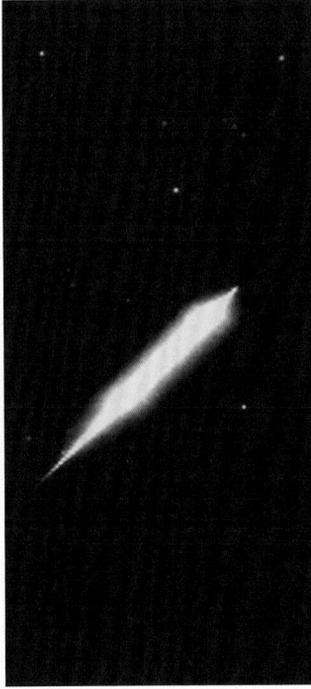

A late *Quarantid* fireball, photographed from Portmahomack, Ross-shire, Scotland on 15 January 2018 at 23:44 UT.

Ursa Major and its bright asterism, the *Plough*, the key constellation to navigating the northern sky.

instrument. The *Quadrantid* radiant, marked on the chart, is now within the northernmost part of *Boötes*, roughly halfway between θ Boötis and τ Herculis.

January – Looking South

The southern sky is dominated by **Orion**, prominent during the winter months, visible at some time during the night. It is highly distinctive, with a line of three stars that form Orion's Belt. To most observers, the bright star **Betelgeuse** (α Orionis), shows a reddish tinge, in contrast to the brilliant bluish-white **Rigel** (β Orionis). The three stars of the belt lie directly south of the celestial equator. A vertical line of three stars forms the 'sword' that hangs south of the 'belt'. With good viewing, the central 'star' appears as a hazy spot, even to the naked eye, and is actually the **Orion Nebula**. Binoculars reveal the four stars of the Trapezium, which illuminate the nebula.

The Belt points up to the northwest towards **Taurus** (the Bull) and orange-tinted **Aldebaran** (α Tauri). Close to Aldebaran, there is a conspicuous 'V' of stars, called the **Hyades** cluster. (Despite appearances, Aldebaran is not part of the cluster.) Farther along, the same line from Orion passes below a bright cluster of stars, the **Pleiades**, or Seven Sisters. Even the smallest pair of binoculars reveals this as a beautiful group of bluish-white stars. The two most conspicuous of the other stars in Taurus lie directly above Orion, and form an elongated triangle with Aldebaran. The northernmost, **Elnath** (β Tauri), was once considered to be part of the constellation of **Auriga**.

The constellation of Orion dominates the sky during this period of the year, and is a useful starting point for recognizing other constellations in the southern sky. Here, orange Betelgeuse, blue-white Rigel and the pinkish Orion Nebula are prominent. Orion can be found in the southern part of the sky (see page 36).

The Moon's phases for January 2025

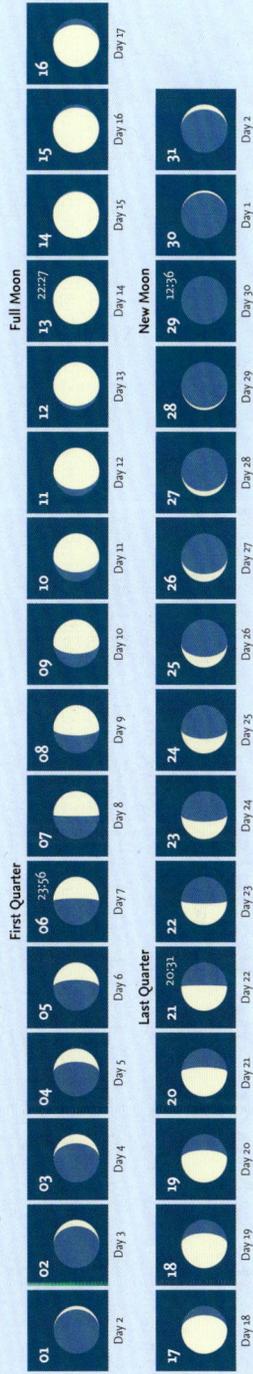

January – Moon and Planets

The Moon

On 3 January, a few days before First Quarter, the Moon will be only 1.4° from **Venus**, visible in the early evening. Venus will be mag. -4.4. A day later the Moon will occult **Saturn**, visible from Europe, Africa and western Russia. From London the occultation will start at 17:21 GMT, and Saturn will reappear at 18:32. On 6 January the Moon will be at First Quarter, setting around midnight. On 10 January the waxing gibbous Moon will pass within 5.4° N of **Jupiter** (mag. -2.7), visible all night until just after 04:00 GMT. On 13 January the Full Moon will be 2.1° S of **Pollux**. One day later, **Mars** and the Moon will be together in the morning sky, less than half a degree apart, with Mars at mag. -1.4. Two days later the Moon will be 2.2° N of **Regulus**. The Moon will be a tenth of a degree from **Spica** on 21 January, and on the dawn of the

24th it will appear only 0.3° S of **Antares**. On 29 January the Moon passes between the Sun and the Earth, visible as a New Moon. As the month ends, the Moon will appear as a waxing crescent, setting shortly after the Sun.

The planets

Venus comes to greatest eastern elongation on 10 January (47.2° E), when it will be visible at mag. -4.4. **Mars** will reach perigee on 12 January, passing within a distance of 0.64 AU of the Earth. The best time to observe Mars will be close to midnight on 16 January when it reaches opposition. **Jupiter** will lie in **Taurus**, on 31 January it will be 5.2° N of **Aldebaran**. On 20 January **Saturn** and **Venus** will be 2.2° apart, with Venus the brighter of the two at mag. -4.5. Saturn will be in **Aquarius** and visible until just after 20:00 GMT. On 30 January **Uranus** ends its westward retrograde motion while in **Aries**. **Neptune** will lie in **Pisces**, setting earlier in the evening towards the end of the month.

The path of the Sun and the planets along the ecliptic in January.

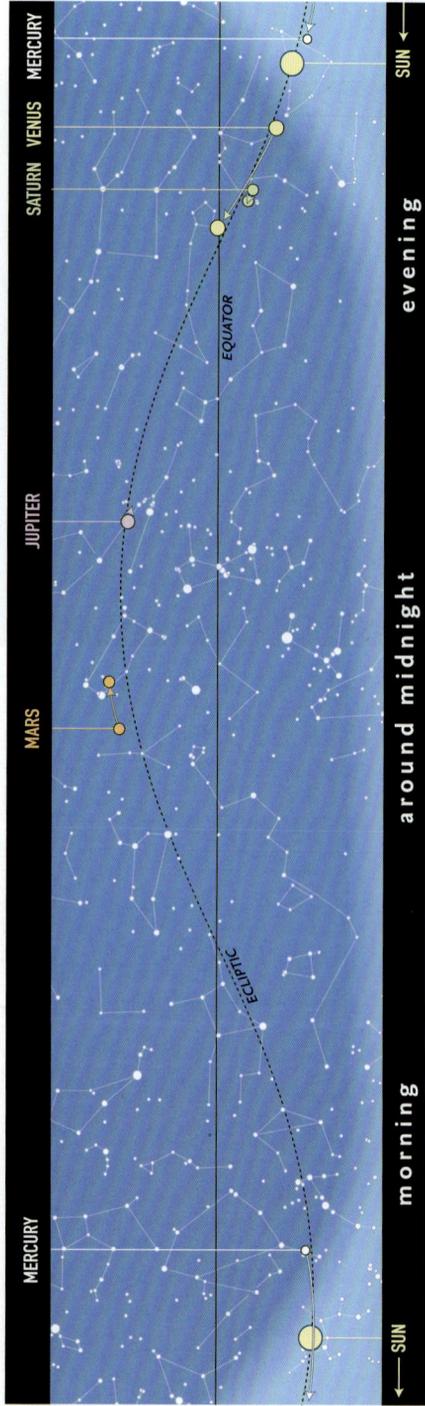

Calendar for January

- 03 15:24 Venus (mag. -4.4) 1.4°N of Moon
- 04 14:00 Earth at perihelion: 0.98333 AU
- 04 17:18 Saturn (mag. 1.1) 0.7°S of Moon.
An occultation will be visible from the UK.
- 06 23:56 FIRST QUARTER MOON
- 07 23:34 Moon at perigee: 370,173 km
- 10 01:01 Pleiades 0.3°S of Moon
- 10 04:00 Venus at greatest elongation: 47.2°E
- 10 23:13 Jupiter (mag. -2.7) 5.5°S of Moon
- 13 21:45 Pollux 2.2°N of Moon
- 13 22:27 FULL MOON
- 14 03:42 Mars (mag. -1.4) 0.2°S of Moon
- 16 01:00 Mars at opposition (mag. -1.4)
- 16 14:57 Regulus 2.2°S of Moon
- 18 16:00 Venus (mag. -4.6) 2.2°N of Saturn (mag. 1.1)
- 19 14:00 Mercury at aphelion
- 21 03:53 Spica 0.1°N of Moon
- 21 04:55 Moon at apogee: 404,299 km
- 21 20:31 LAST QUARTER MOON
- 23 17:07 Mars (mag. -1.3) 2.3°S of Pollux
- 24 23:34 Antares 0.3°N of Moon
- 25 17:36 NEW MOON

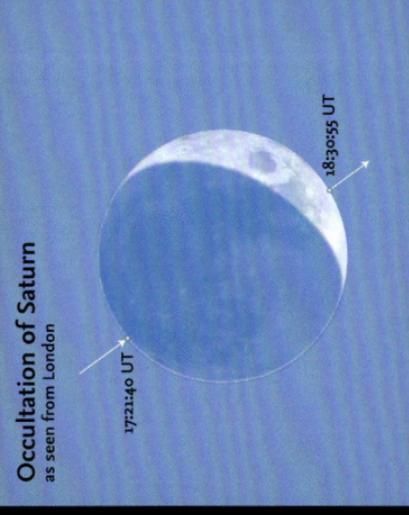

4 January • The lunar occultation of Saturn, as seen from London. They will be 28° above the horizon in the south-southwest. Zenith is vertically upwards.

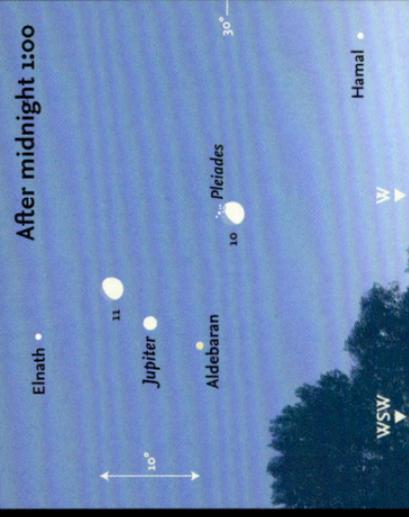

10–11 January • On 10 January, the Moon passes just south of the Pleiades. One day later it is close to Jupiter (mag. -2.7) and Aldebaran.

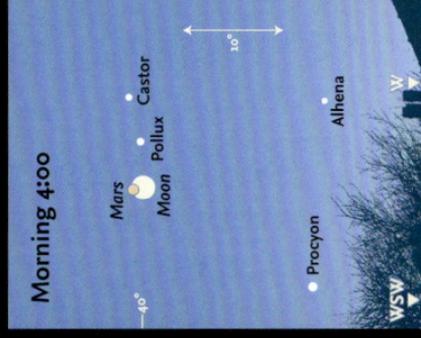

Morning 4:00

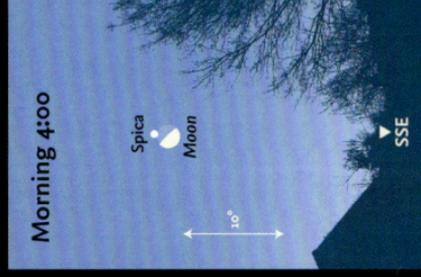

Morning 4:00

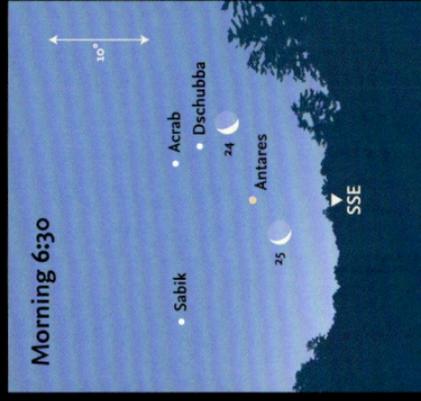

Morning 6:30

14 January • The Moon is close to Mars (mag. -1.4) and lines up with the Twin Stars, Castor and Pollux.

21 January • The Last Quarter Moon beside Spica in the south-southeast.

24–25 January • On 24 January, the Moon lines up with Acrab (β Sco) and Dschubba (δ Sco). One day later it is south of Antares.

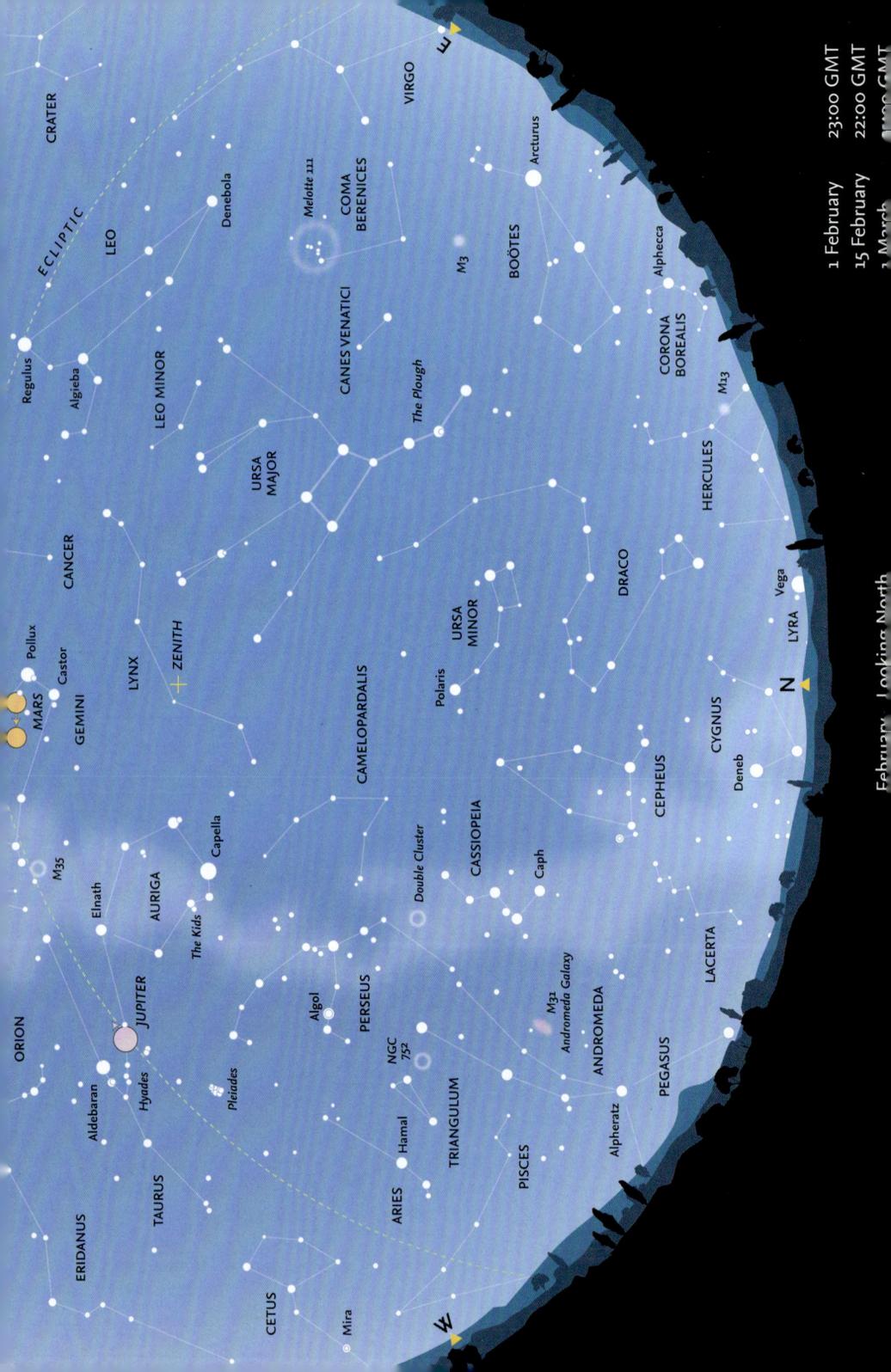

CRATER
LEO
CANCER
LYNX
GEMINI
AURIGA
ORION
ERIDANUS
TAURUS
CETUS
MIRA
URSA MAJOR
URSA MINOR
BOÖTES
VIRGO
M3
ARCTURUS
CORONA BOREALIS
HERCULES
DRACO
LYRA
VEGA
M13
CAMELOPARDALIS
CASSIOPEIA
CEPHEUS
CYGNUS
DENEBO
LACERTA
PEGASUS
ALPHERTZ
TRIANGULUM
PISCIS
ANDROMEDA
M31
ANDROMEDA GALAXY
PERSEUS
ALGOL
NGC 752
HAMAL
ARIES
TAURUS
HYADES
ALDEBARAN
ORION
M35
ELNATH
AURIGA
THE KIDS
CAPPELLA
AURIGA
DOUBLE CLUSTER
CASSIOPEIA
CAPH
CEPHEUS
DENEBO
LYRA
VEGA
M13
HERCULES
CORONA BOREALIS
ALPHECCA
BOÖTES
ARCTURUS
VIRGO
M3
URSA MINOR
POLARIS
CAMELOPARDALIS
URSA MAJOR
THE PLOUGH
CANNES VENATICI
COMA BERENICES
MELLOTTE 111
DENEBO
LEO
ALGIEBA
REGULUS
ECLIPTIC
ZENITH
N
MARS
MARS
CASTOR
POLIUX

1 February 23:00 GMT
15 February 22:00 GMT
1 March 21:00 GMT

February Looking North

February – Looking North

The months of January and February are probably the best time for seeing the section of the Milky Way that runs in the northern and western sky from **Cygnus**, low on the northern horizon, through **Cassiopeia**, **Perseus** and **Auriga** and then down through **Gemini** and **Monoceros** (see chart on page 42). Although not as readily visible as the denser star clouds of the summer Milky Way, on a clear night so many stars may be seen that even a distinctive constellation such as Cassiopeia is not immediately obvious.

The head of **Draco** is now higher in the sky and easier to recognize. **Deneb** (α Cygni), the brightest star in **Cygnus**, may just be visible, almost due north at midnight. **Vega** (α Lyrae) in **Lyra** is so low that it is difficult to see, but may become visible later in the night. The constellation of **Boötes** – sometimes described as shaped like a kite, an ice-cream cone, or the letter ‘P’ – with orange-tinted **Arcturus** (α Boötis), is beginning to clear the eastern horizon. Arcturus, at magnitude -0.05, is the brightest star in the northern hemisphere of the sky. The inconspicuous constellation of **Coma Berenices** is now well above the horizon in the east. The concentration of faint stars at the northwestern corner somewhat resembles a tiny, detached portion of the Milky Way. This is Melotte 111, an open star cluster (which is sometimes called the Coma Cluster, but must not be confused with the important Coma Cluster of galaxies, Abell 1656, mentioned on page 55).

On the other side of the sky, in the northwest, most of the constellation of **Andromeda** is still easily seen, although **Alpheratz** (α Andromedae), the star that forms the northeastern corner of the Great Square of Pegasus – even though it is actually part of Andromeda – is approaching the horizon and becoming more difficult to detect. High overhead, at the zenith, try to make out the very faint constellation of

Lynx. It was introduced in 1687 by the famous astronomer Johannes Hevelius to fill the largely blank area between **Auriga**, **Gemini** and **Ursa Major**, and is reputed to be so named because one needed the eyes of a lynx to detect it.

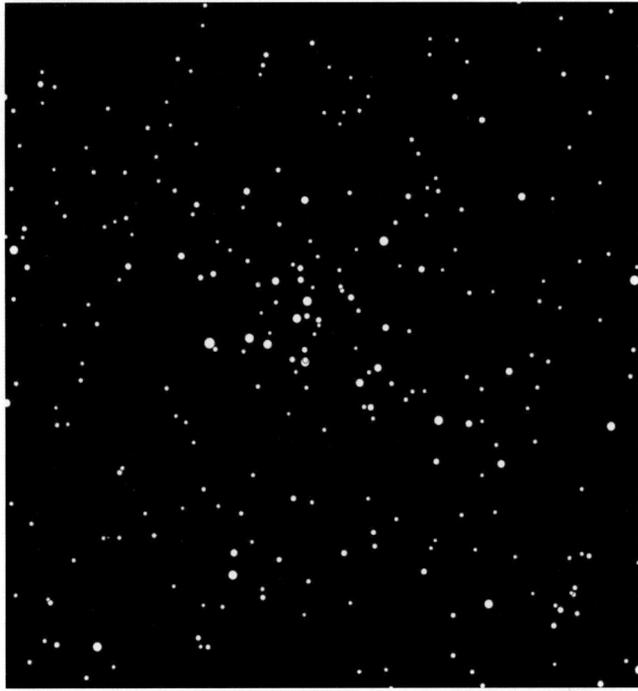

A very large, and frequently ignored, open star cluster, Melotte 111, also known as the Coma Cluster, is readily visible in the eastern sky during February.

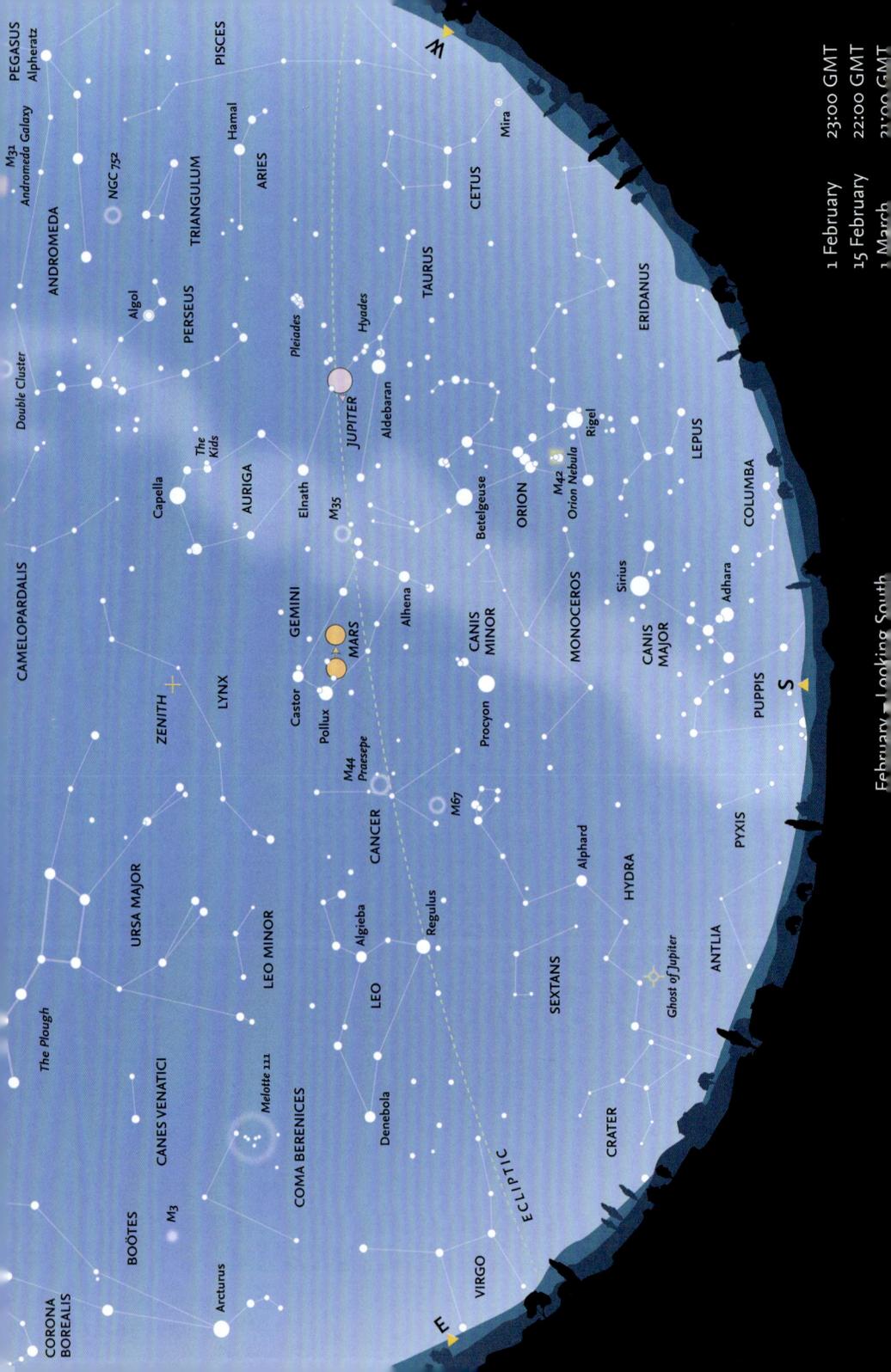

PEGASUS
Alpheratz

M31
Andromeda Galaxy

ANDROMEDA

Double Cluster

CAMELOPARDALIS

ZENITH

LYNX

URSA MAJOR

BOÖTES

CORONA BOREALIS

PISCES

ANDROMEDA

PERSEUS

AURIGA

GEMINI

LYNX

URSA MAJOR

CANES VENATICI

BOÖTES

CORONA BOREALIS

NGC 752

ANDROMEDA

PERSEUS

AURIGA

GEMINI

LYNX

URSA MAJOR

CANES VENATICI

BOÖTES

CORONA BOREALIS

Hamal

ANDROMEDA

PERSEUS

AURIGA

GEMINI

LYNX

URSA MAJOR

CANES VENATICI

BOÖTES

CORONA BOREALIS

ARIES

ANDROMEDA

PERSEUS

AURIGA

GEMINI

LYNX

URSA MAJOR

CANES VENATICI

BOÖTES

CORONA BOREALIS

Pleiades

ANDROMEDA

PERSEUS

AURIGA

GEMINI

LYNX

URSA MAJOR

CANES VENATICI

BOÖTES

CORONA BOREALIS

Hyades

ANDROMEDA

PERSEUS

AURIGA

GEMINI

LYNX

URSA MAJOR

CANES VENATICI

BOÖTES

CORONA BOREALIS

Aldebaran

ANDROMEDA

PERSEUS

AURIGA

GEMINI

LYNX

URSA MAJOR

CANES VENATICI

BOÖTES

CORONA BOREALIS

JUPITER

ANDROMEDA

PERSEUS

AURIGA

GEMINI

LYNX

URSA MAJOR

CANES VENATICI

BOÖTES

CORONA BOREALIS

M35

ANDROMEDA

PERSEUS

AURIGA

GEMINI

LYNX

URSA MAJOR

CANES VENATICI

BOÖTES

CORONA BOREALIS

Aldebaran

ANDROMEDA

PERSEUS

AURIGA

GEMINI

LYNX

URSA MAJOR

CANES VENATICI

BOÖTES

CORONA BOREALIS

Mars

ANDROMEDA

PERSEUS

AURIGA

GEMINI

LYNX

URSA MAJOR

CANES VENATICI

BOÖTES

CORONA BOREALIS

Alhena

ANDROMEDA

PERSEUS

AURIGA

GEMINI

LYNX

URSA MAJOR

CANES VENATICI

BOÖTES

CORONA BOREALIS

Procyon

ANDROMEDA

PERSEUS

AURIGA

GEMINI

LYNX

URSA MAJOR

CANES VENATICI

BOÖTES

CORONA BOREALIS

Betelgeuse

ANDROMEDA

PERSEUS

AURIGA

GEMINI

LYNX

URSA MAJOR

CANES VENATICI

BOÖTES

CORONA BOREALIS

Orion Nebula

ANDROMEDA

PERSEUS

AURIGA

GEMINI

LYNX

URSA MAJOR

CANES VENATICI

BOÖTES

CORONA BOREALIS

Rigel

ANDROMEDA

PERSEUS

AURIGA

GEMINI

LYNX

URSA MAJOR

CANES VENATICI

BOÖTES

CORONA BOREALIS

Sirius

ANDROMEDA

PERSEUS

AURIGA

GEMINI

LYNX

URSA MAJOR

CANES VENATICI

BOÖTES

CORONA BOREALIS

Adhara

ANDROMEDA

PERSEUS

AURIGA

GEMINI

LYNX

URSA MAJOR

CANES VENATICI

BOÖTES

CORONA BOREALIS

ERIDANUS

ANDROMEDA

PERSEUS

AURIGA

GEMINI

LYNX

URSA MAJOR

CANES VENATICI

BOÖTES

CORONA BOREALIS

LEPUS

ANDROMEDA

PERSEUS

AURIGA

GEMINI

LYNX

URSA MAJOR

CANES VENATICI

BOÖTES

CORONA BOREALIS

COLUMBA

ANDROMEDA

PERSEUS

AURIGA

GEMINI

LYNX

URSA MAJOR

CANES VENATICI

BOÖTES

CORONA BOREALIS

PUPPIS

ANDROMEDA

PERSEUS

AURIGA

GEMINI

LYNX

URSA MAJOR

CANES VENATICI

BOÖTES

CORONA BOREALIS

ANTLIA

ANDROMEDA

PERSEUS

AURIGA

GEMINI

LYNX

URSA MAJOR

CANES VENATICI

BOÖTES

CORONA BOREALIS

HYDRA

ANDROMEDA

PERSEUS

AURIGA

GEMINI

LYNX

URSA MAJOR

CANES VENATICI

BOÖTES

CORONA BOREALIS

CRATER

ANDROMEDA

PERSEUS

AURIGA

GEMINI

LYNX

URSA MAJOR

CANES VENATICI

BOÖTES

CORONA BOREALIS

SEXTANS

ANDROMEDA

PERSEUS

AURIGA

GEMINI

LYNX

URSA MAJOR

CANES VENATICI

BOÖTES

CORONA BOREALIS

ALPHA

ANDROMEDA

PERSEUS

AURIGA

GEMINI

LYNX

URSA MAJOR

CANES VENATICI

BOÖTES

CORONA BOREALIS

WEST

ANDROMEDA

PERSEUS

AURIGA

GEMINI

LYNX

URSA MAJOR

CANES VENATICI

BOÖTES

CORONA BOREALIS

EAST

ANDROMEDA

PERSEUS

AURIGA

GEMINI

LYNX

URSA MAJOR

CANES VENATICI

BOÖTES

CORONA BOREALIS

SOUTH

February – Looking South

Apart from **Orion**, the most prominent constellation visible this month is **Gemini**, with its two lines of stars running southwest towards Orion. Many people have difficulty in remembering which is which of the two stars **Castor** and **Pollux**. **Castor** (α Geminorum), the fainter star (mag. 1.9), is closer to the North Celestial Pole. **Pollux** (β Geminorum) is the brighter of the two (mag. 1.2), but is farther away from the Pole. **Pollux** is one of the first-magnitude stars that may be occulted by the Moon. **Castor** is remarkable because it is actually a multiple system, consisting of no fewer than six individual stars.

Orion's Belt points down to the southeast towards **Sirius**, the brightest star in the sky (at mag. -1.4) in the constellation of **Canis Major**, the whole of which is now clear of the southern horizon. Forming an equilateral triangle with **Betelgeuse** in Orion and **Sirius** in **Canis Major** is **Procyon**, the brightest star in the small constellation of **Canis Minor**. Between **Canis Major** and **Canis Minor** is the faint constellation of **Monoceros**, which actually straddles the Milky Way. Although faint, there are many clusters in this area. Directly east of **Procyon** is the highly distinctive asterism of six stars that form the

The constellation of **Gemini**. The two brightest stars, visible near the left-hand top corner of the photograph, are **Castor** (top) and **Pollux**.

'head' of **Hydra**, the largest of all 88 constellations, and which trails such a long way across the sky that it is only around midnight in mid-March that the whole constellation becomes visible.

The Moon's phases for February 2025

First Quarter

Last Quarter

Full Moon

New Moon

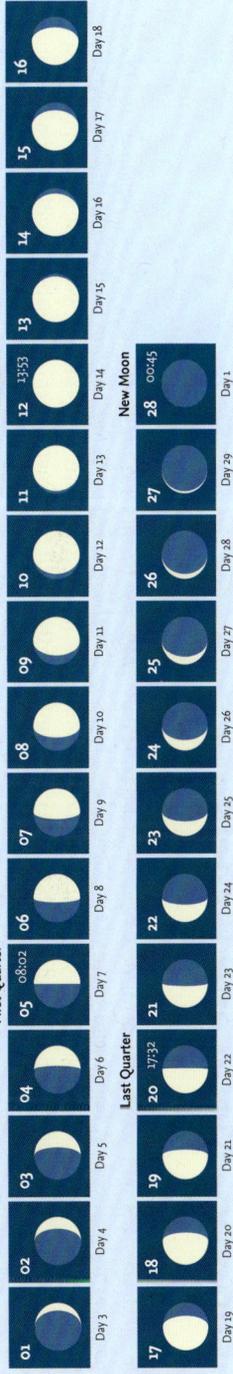

February – Moon and Planets

The Moon

On 1 February the thin waxing crescent Moon will be 1° from **Saturn** (mag. 1.0) and just over 2° from **Venus** (mag. -4.6), visible until 3 hours after sunset. First Quarter Moon will be on 5 February and two days later it will be seen 5.5° N of **Jupiter** (mag. -2.5) until a few hours after midnight. On the 9th the Moon will occult **Mars**, an event that will be visible from the northwest of Great Britain, Russia, China and eastern Canada. From London they will be less than a degree apart. The following day the Moon will be 2.1° S of **Pollux** and two days later the Full Moon will appear 2.2° N of **Regulus**. On 17 February it will be **Spica's** turn, less than half a degree from the waning gibbous Moon. The Last Quarter Moon is on 20 February and the following day the waning crescent Moon will be half a degree from orange-red **Antares**. The month ends with a New Moon on the 28th.

The path of the Sun and the planets along the ecliptic in February.

The planets

Mercury (mag. -1.0 to -1.6) moves from **Aquarius** to **Pisces** on 26 February, setting before the Sun until 9 February, after which it will set progressively later than the Sun. **Venus** will reach its highest point in the sky on 7 February, reaching greatest brightness on 16 February at mag. -4.2 and setting several hours after the Sun. **Mars** will be visible with its orange hue all night, shining brighter at the beginning of the month (mag. -1.1 to -0.3). On 4 February **Jupiter** (mag. -2.5) will reach the end of its retrograde motion (in **Taurus**), ending its westward movement through the constellations and returning to its usual eastward motion. **Saturn** (mag. 1.1) in **Aquarius** will be low in the western sky shortly after sunset. **Uranus** (mag. 5.7 to 5.8) will be high in **Aries** a few hours before midnight. Neptune (mag. 7.8) is in **Pisces**.

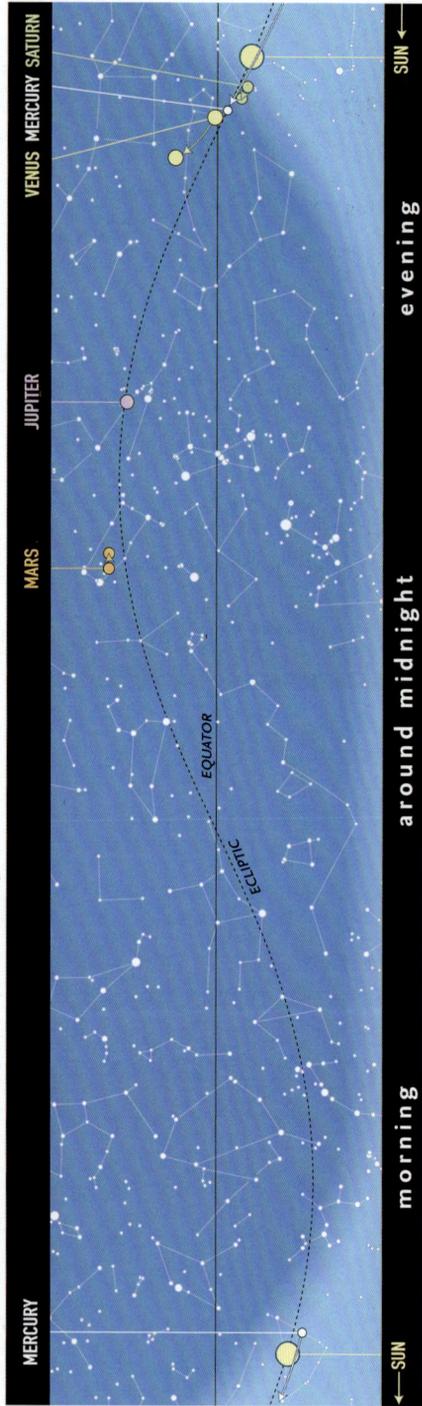

Calendar for February

- 01 04:26 Saturn (mag. 1.0) 1.0°S of Moon
- 01 20:27 Venus (mag. -4.5) 2.3°N of Moon
- 02 02:43 Moon at perigee: 367,457 km
- 05 08:02 FIRST QUARTER MOON
- 06 06:43 Pleiades 0.5°S of Moon
- 07 03:35 Jupiter (mag. -2.5) 5.5°S of Moon
- 09 19:36 Mars (mag. -0.9) 0.8°S of Moon
- 10 05:15 Pollux 2.2°N of Moon
- 12 13:53 FULL MOON
- 12 23:21 Regulus 2.3°S of Moon
- 17 12:01 Spica 0.3°N of Moon
- 18 01:11 Moon at apogee: 404,882 km
- 19 18:00 Venus at perihelion
- 20 17:32 LAST QUARTER MOON
- 21 08:21 Antares 0.4°N of Moon
- 28 09:45 NEW MOON

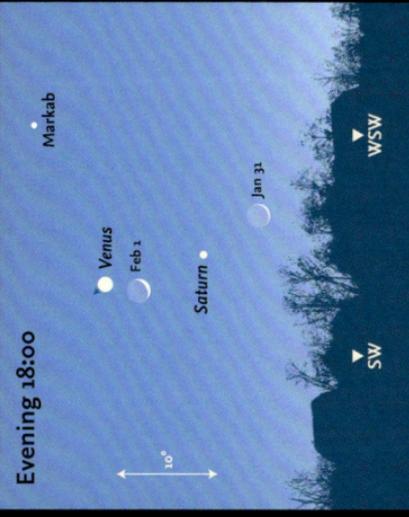

31 January – 1 February • The crescent Moon passes Saturn (mag. 1.0) and the much brighter Venus (mag. -4.6). Markab (α Peg) is higher in the west-southwest.

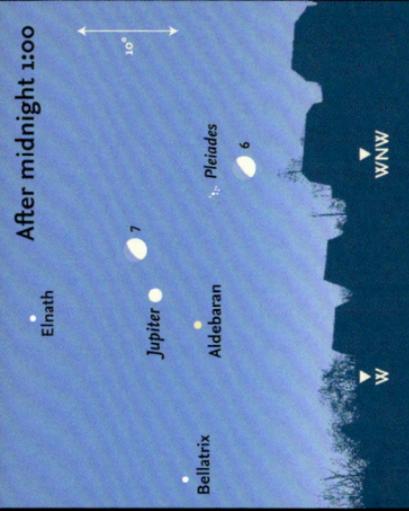

6–7 February • After midnight, the Moon is in the west-northwestern sky, in the company of the Pleiades, Aldebaran and Jupiter (mag. -2.5).

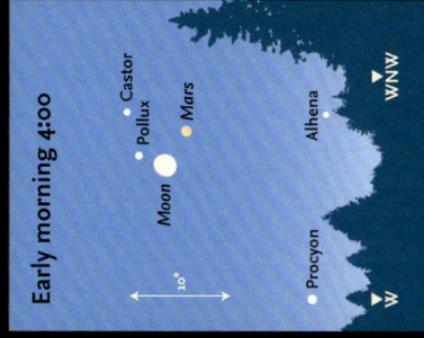

10 February • The bright waxing gibbous Moon with Mars (mag. -0.8), Castor and Pollux.

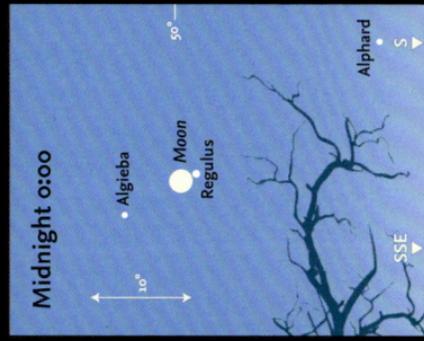

13 February • High in the south-southeast, the Moon lines up with Regulus and Algieba (γ Leo).

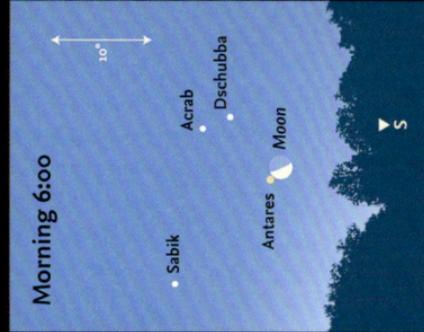

21 February • The Moon is in the constellation of Scorpius, close to the red star Antares in the south.

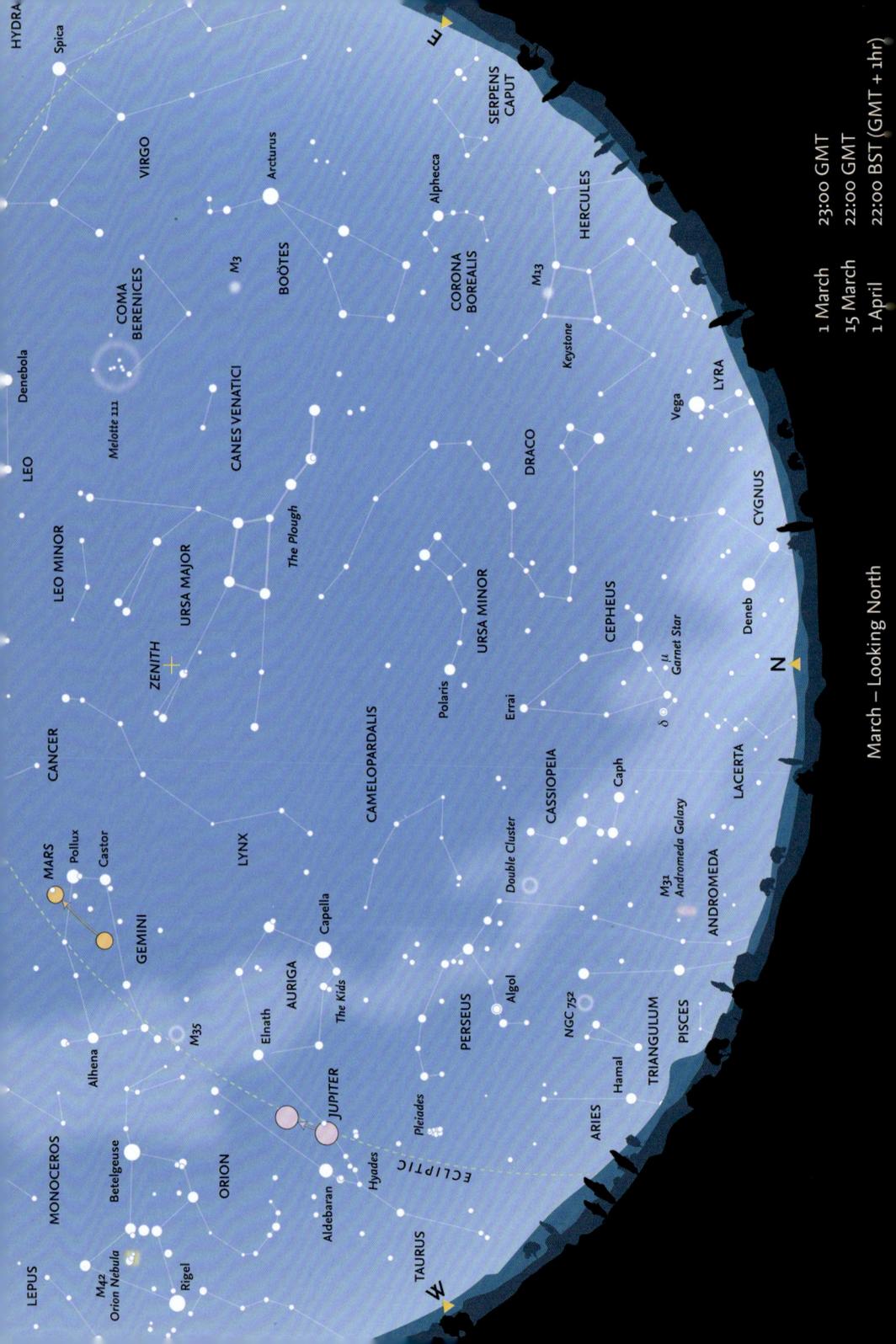

1 March 23:00 GMT
 15 March 22:00 GMT
 1 April 22:00 BST (GMT + 1hr)

March – Looking North

N

TAURUS

ECLIPTIC

Hyades

Pleiades

Aldebaran

JUPITER

The Kids

Capella

AURIGA

Elnath

LYNX

CAMELOPARDALIS

Polaris

URSA MINOR

Errai

DRACO

Keystone

M13

Alphecca

HAIR

March – Looking North

The Sun crosses the celestial equator on 20 March, at the vernal equinox, when day and night are of almost equal length, and the northern season of spring is considered to begin. (The hours of daylight and darkness change most rapidly around the equinoxes in March and September.) It is also in March that British Summer Time (BST) begins (on Saturday–Sunday 29–30 March) so the charts show the appearance at 11 p.m. for 1 March and 10 p.m. (BST) for 1 April. (In the rest of Europe, Daylight Saving Time is introduced on the same date.)

Early in the month, the constellation of **Cepheus** lies almost due north, with the distinctive 'W' of **Cassiopeia** to its west. Cepheus lies across the border of the Milky Way and is often described as like the gable-end of a house or a church tower and steeple. Despite the large number of stars revealed at the base of the constellation by binoculars, one star stands out because of its deep red colour. This is **μ Cephei**, also known as the Garnet Star. It is a truly gigantic star, a red supergiant, and one of the largest stars known. It is about 1,400 times the diameter of the Sun, and if placed in the Solar System would extend beyond the orbit of Jupiter. (Betelgeuse, in Orion, is also a red supergiant, but it is 'only' about 500 times the diameter of the Sun.)

Another famous and very important star in Cepheus is **δ Cephei**, which is the prototype for the class of variable stars known as Cepheids. These giant stars show a regular variation in their luminosity, and there is a direct relationship between the period of the changes in magnitude and the stars' actual luminosity. From a knowledge of the period of any Cepheid, its actual luminosity – known as its absolute magnitude – may be derived. A comparison of its apparent magnitude on the sky and its absolute magnitude enables the star's exact distance to be determined. Once the distances to the first Cepheid variables had been established, examples in more distant galaxies provided information about the scale

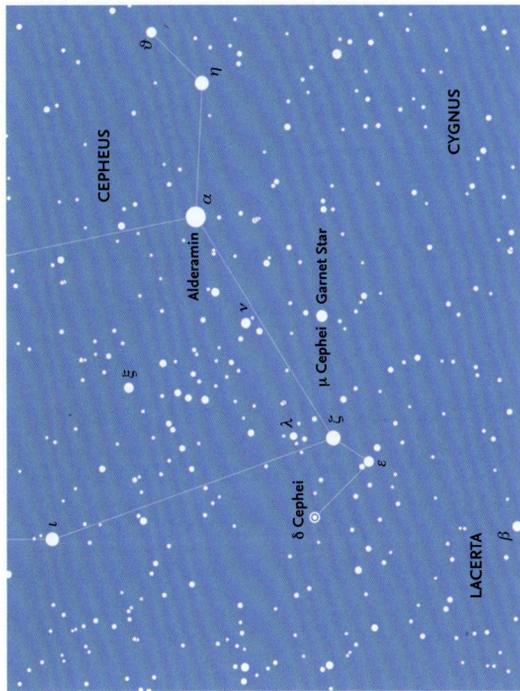

A finder chart for δ Cephei and μ Cephei (the Garnet Star). All stars brighter than magnitude 7.5 are shown. A photograph of the area is on page 49.

of the universe. Cepheid variables are the first major 'rung' in the cosmic distance ladder. Both important stars are shown on the accompanying chart and in the photograph on page 49.

Below Cepheus to the east (to the right), it may be possible to catch a glimpse of **Deneb** (α Cygni), just above the horizon. Slightly farther round towards the northeast, **Vega** (α Lyrae) is marginally higher in the sky. From southern Britain, Deneb is just far enough north to be circumpolar (although difficult to see in January and February because it is so low on the northern horizon). Vega, by contrast, farther south, is completely hidden during the depths of winter.

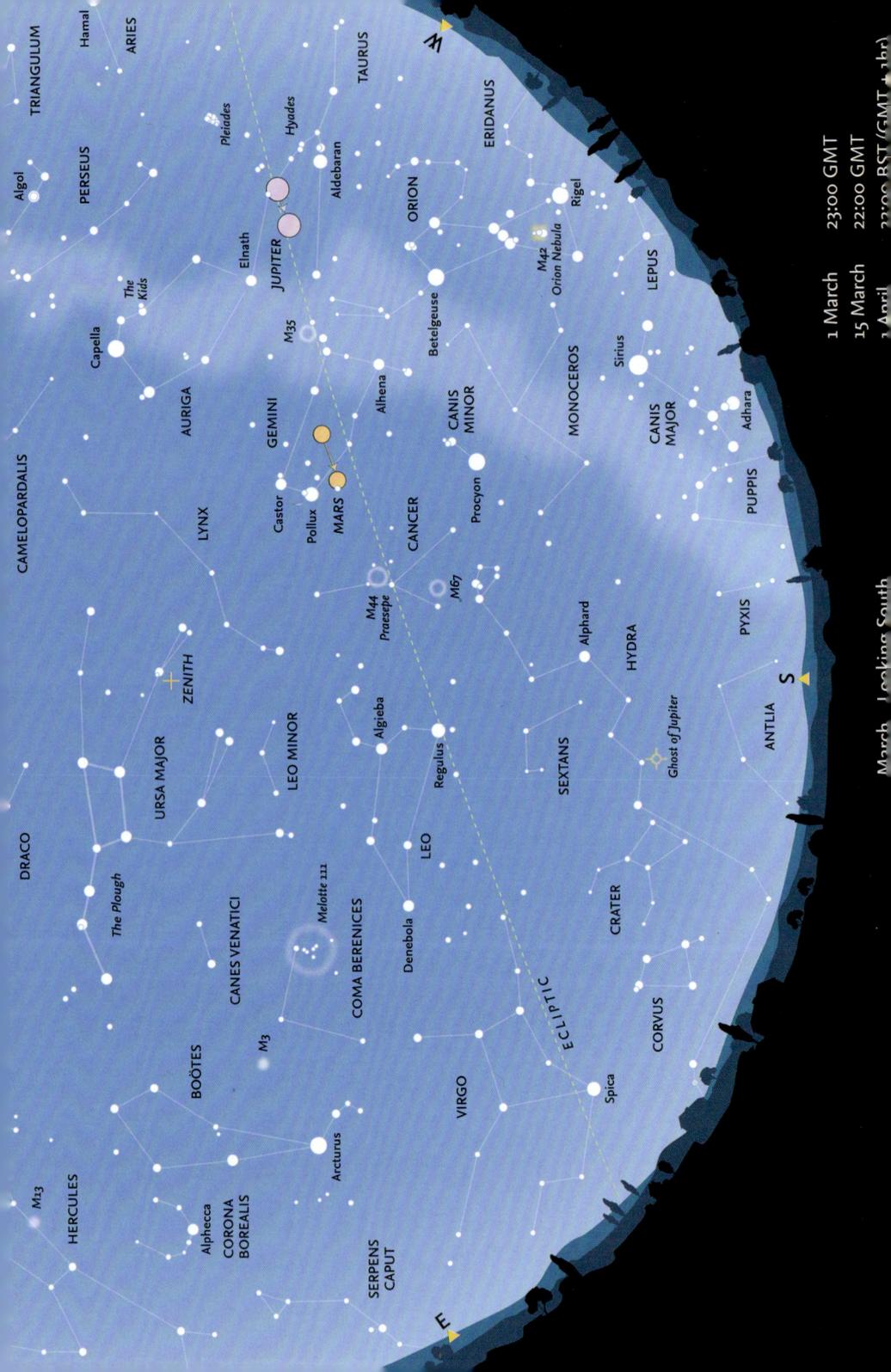

1 March 23:00 GMT
 15 March 22:00 GMT
 1 April 22:00 BST (GMT +1hr)

March Looking South

March – Looking South

Due south at 22:00 at the beginning of the month, lying between the constellations of **Gemini** in the west and **Leo** in the east, and fairly high in the sky above the head of **Hydra**, is the faint and rather undistinguished zodiacal constellation of **Cancer**. Rather like the triskelion, the symbol for the Isle of Man, it has three ‘legs’ radiating from the centre, where there is an open cluster, M44 or **Praesepe** (‘the Manger’ but also known as ‘the Beehive’). On a clear night this cluster, known since antiquity, is just a hazy spot to the naked eye, but appears in binoculars as a group of dozens of individual stars.

Also prominent in March is the constellation of Leo, with the ‘backward question mark’ (or ‘Sickle’) of bright stars forming the head of the mythological lion. **Regulus** (α Leonis) – the ‘dot’ of the ‘question mark’ or the handle of the sickle and the brightest star in Leo – lies very close to the ecliptic and is one of the few first-magnitude stars that may be occulted by the Moon. However, there are no occultations of Regulus in 2025, nor of any of the other four bright stars near the ecliptic.

The constellation of Cepheus, with the ‘W’ of Cassiopeia on the left. The locations of both δ and μ Cephei are shown on the chart on page 47.

The Moon’s phases for March 2025

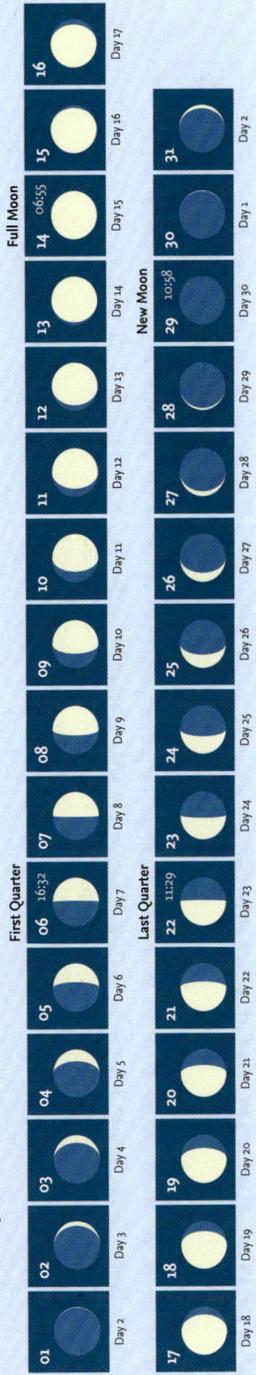

March – Moon and Planets

The Moon

On 1 March the thin waxing crescent Moon will appear just over 6° from **Venus** (mag. -4.6) in the early evening sky. On 6 March the First Quarter Moon will pass 5.6°N of **Jupiter** (mag. -2.3). On 9 March the waxing gibbous Moon will be visible less than 2° from **Mars** (mag. -0.1) and 2.0°S of **Pollux**. Three days later the bright waxing gibbous Moon will be 2.2°N of **Regulus**. A total lunar eclipse on 14 March will be visible from some western parts of Europe, the Americas, northeastern Russia and Africa – a partial eclipse will be visible from London before the Moon drops below the horizon. On 16 March the Moon and **Spica** will be less than half a degree apart. On 20 March the waning Moon is only 0.5°S of **Antares**, visible at dawn. Last Quarter Moon is on

22 March. The Moon and **Saturn** (mag. 1.1) will be less than 2° apart on 28 March, setting with the Sun. New Moon occurs on 29 March.

The Planets

Mercury will reach its highest point in the sky on 8 March (mag. -0.4). One day later **Venus** (mag. -4.4) will pass 6.3°N of Mercury (mag. -0.2), visible at dusk. **Mars** (mag. -0.2 to 0.4) is still easily visible throughout the first half of the night. **Jupiter** (mag. -2.3 to -2.1) is also best seen before midnight, placed in **Taurus**. **Saturn** (mag. 1.1 to 1.2), lying in **Aquarius**, sets with the Sun. Uranus (mag. 5.8) lies in **Aries** and is above the horizon a few hours before midnight. **Neptune** (mag. 7.8) is in **Pisces**.

The path of the Sun and the planets along the ecliptic in March.

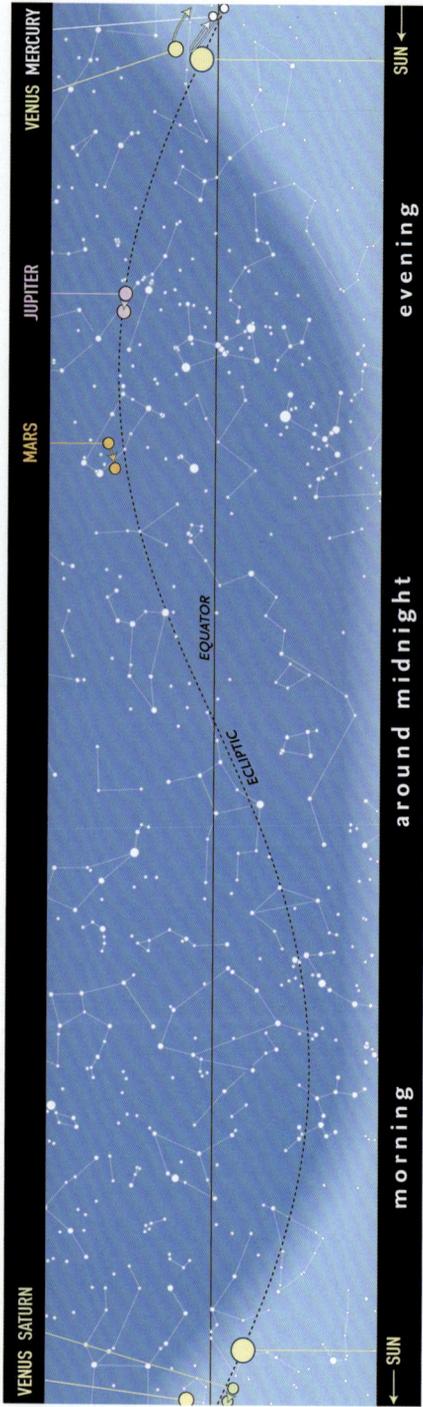

Calendar for March

01	04:03	Mercury (mag. -0.1) 0.4°N of Moon
01	21:18	Moon at perigee: 361,967 km
04	14:00	Mercury at perihelion
05	12:32	Pleiades 0.6°S of Moon
06	11:31	Jupiter (mag. -2.3) 5.5°S of Moon
06	16:32	FIRST QUARTER MOON
08	06:00	Mercury at greatest elong.: 18.2°E
09	00:37	Mars (mag. -0.1) 1.7°S of Moon
09	11:05	Pollux 2.1°N of Moon
12	06:57	Regulus 2.4°S of Moon
14	06:55	FULL MOON
14	06:53	Total lunar eclipse; mag. 1.178
16	19:16	Spica 0.3°N of Moon
17	16:37	Moon at apogee: 405,754 km
20	09:02	Vernal Equinox
20	15:58	Antares 0.5°N of Moon
22	11:29	LAST QUARTER MOON
29	10:47	Partial solar eclipse; mag. 0.938
29	10:58	NEW MOON
29	19:29	Mars (mag. 0.4) ±9°S of Pollux
30	05:26	Moon at perigee: 358,127 km

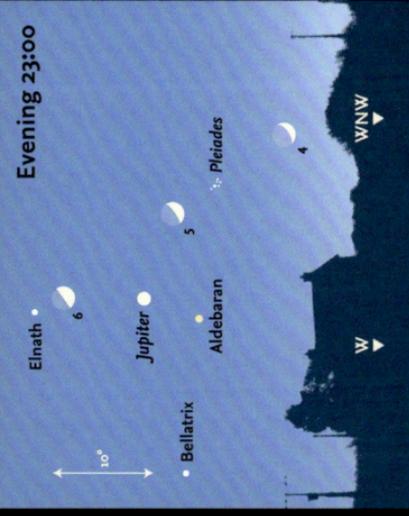

4-6 March • Late in the evening the Moon passes the Pleiades, Aldebaran, Jupiter (dimmer at mag. -2.3) and approaches Elnath (β Tau) in the west.

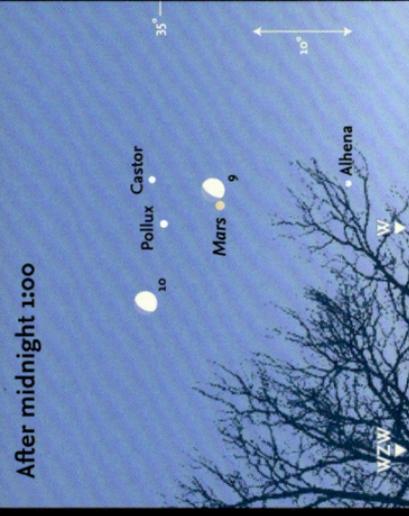

9-10 March • High in the west, the waxing gibbous Moon can be found in the constellation of Gemini. It moves along Mars (mag. -0.1), Castor and Pollux.

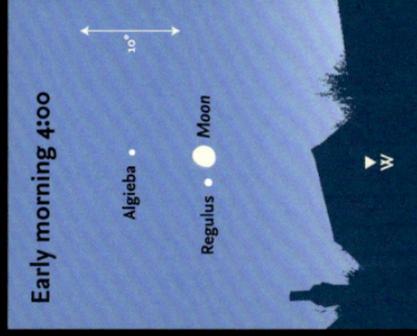

12 March • In the early morning the Moon, together with Regulus and Algiba, is due west.

15-16 March • The waning gibbous Moon passes Spica close to the southeastern horizon.

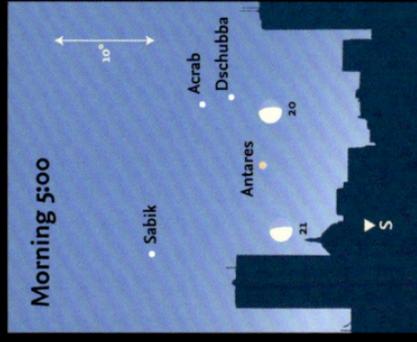

20-21 March • The Moon passes below Antares, Acrab, Dschubba and Sabik (η Oph) are nearby.

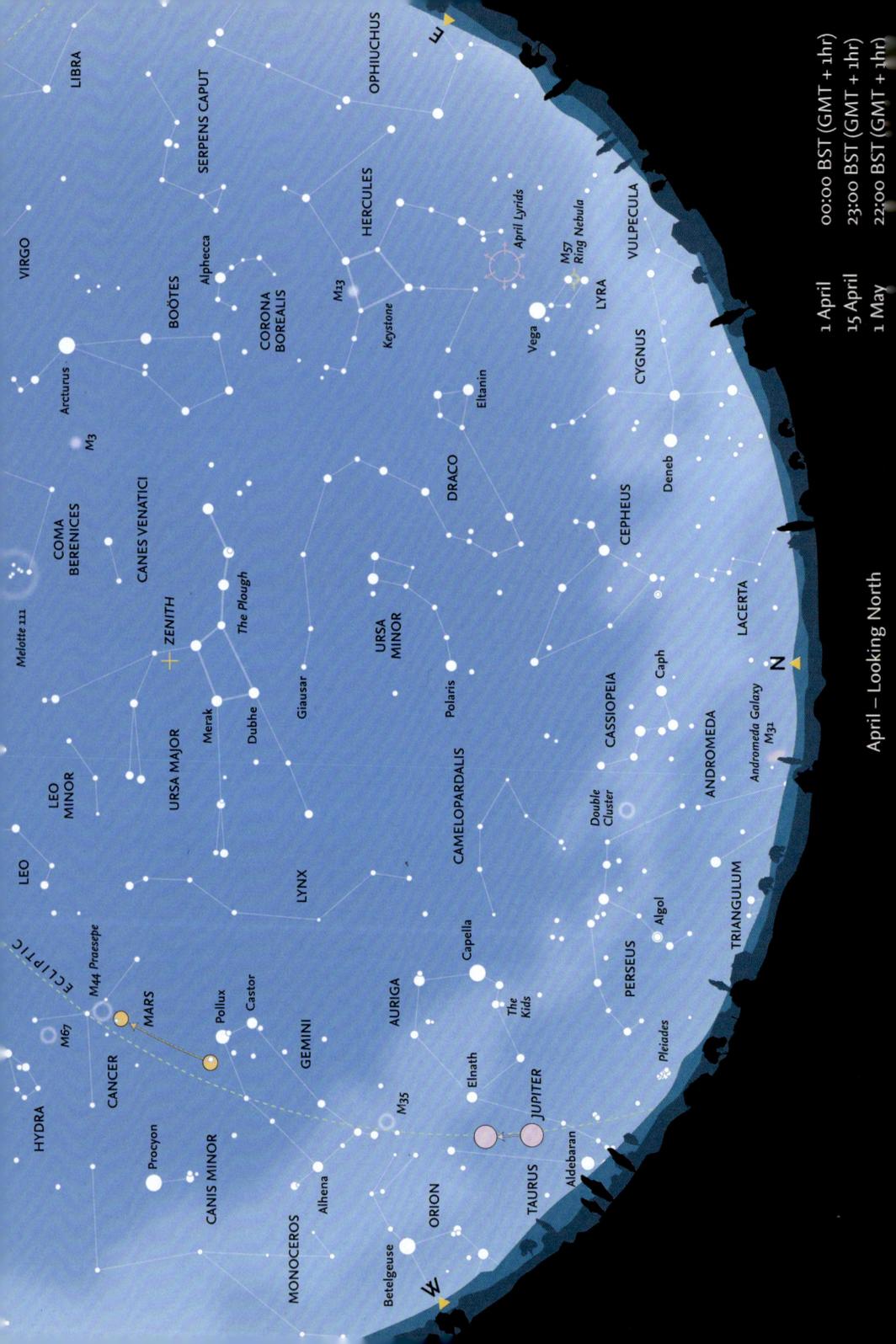

00:00 BST (GMT + 1hr)
 23:00 BST (GMT + 1hr)
 22:00 BST (GMT + 1hr)

1 April
 15 April
 1 May

April – Looking North

April – Looking North

Cygnus and the brighter regions of the Milky Way are now becoming visible, running more-or-less parallel with the horizon in the early part of the night. Rising in the northeast is the small constellation of **Lyra** and the distinctive 'keystone' of **Hercules** above it. This asterism is very useful for locating the bright globular cluster M13 (see map on page 59), which lies on one side of the quadrilateral. The winding constellation of **Draco** weaves its way from the four stars that mark its 'head', on the border with Hercules, to end at **Giasar** (λ Draconis) between **Polaris** (α Ursae Minoris) and the 'Pointers', **Dubhe** and **Merak** (α and β Ursae Majoris, respectively). **Ursa Major** is 'upside down' high overhead, near the zenith. The constellation of **Gemini** stands almost vertically in the west. **Auriga** is still clearly seen in the northwest, but, by the end of the month, the southern portion of **Perseus** is starting to dip below the northern horizon. The very faint constellation of **Camelopardalis** lies in the northwest between Polaris and the constellations of Auriga and Perseus.

Meteors

There is one moderate meteor shower this month, the **Lyrids** (often known as the **April Lyrids**). This year the shower begins on 16 April and peaks on 22 April, a day or so after Last Quarter Moon – the Moon will be below the horizon until 03:00 GMT, ensuring a dark sky. There is another stronger shower, the **η -Aquariids**, that begins on 19 April and peaks on 5 May.

The constellation of Hercules (centre), with Lyra (bottom left) and Corona Borealis (top right).

April – Looking South

Leo is the most prominent constellation in the southern sky in April and vaguely looks like the creature after which it is named. **Gemini**, with **Castor** and **Pollux** remains clearly visible in the west, and **Cancer** lies between the two constellations. To the east of Leo, the whole of **Virgo**, with **Spica** (α Virginis), its brightest star, is well clear of the horizon. Below Leo and Virgo, the complete length of **Hydra** is visible, running beneath both constellations, with **Alphard** (α Hydrae) halfway between **Regulus** and the southwestern horizon. Farther east, the two small constellations of **Crater** and the rather brighter **Corvus** lie between Hydra and Virgo.

Boötes and **Arcturus** are prominent in the eastern sky, together with the circlet of **Corona Borealis**, framed by Boötes and the neighbouring constellation of **Hercules**. Between Leo and Boötes lies the constellation of **Coma Berenices**, notable for being the location of the open cluster **Melotte 111** (see page 41) and the **Coma Cluster** of galaxies (Abell 1656). There are about 1,000 galaxies in this cluster, which is located near the North Galactic Pole, where we are looking out of the plane of the Galaxy and are thus able to see deep into space. Only about ten of the brightest galaxies in the Coma Cluster are visible with the largest amateur telescopes.

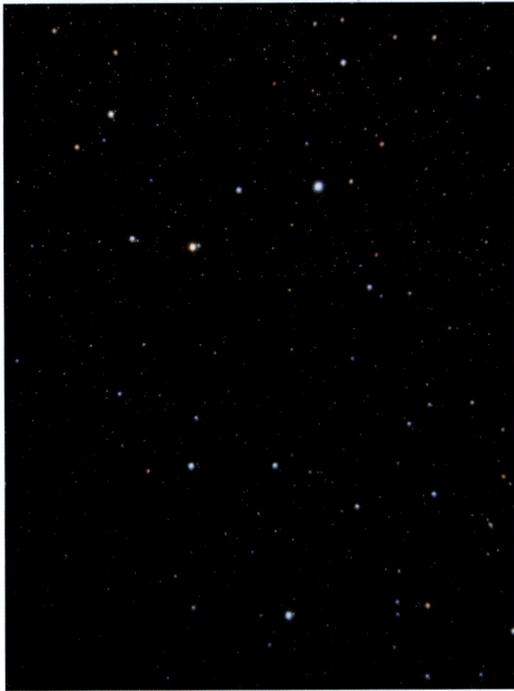

The distinctive constellation of Leo, with **Regulus** and the 'Sickle' on the west. **Algieba** (γ Leonis), north of **Regulus**, appears double, but is a multiple system of four stars.

The Moon's phases for April 2025

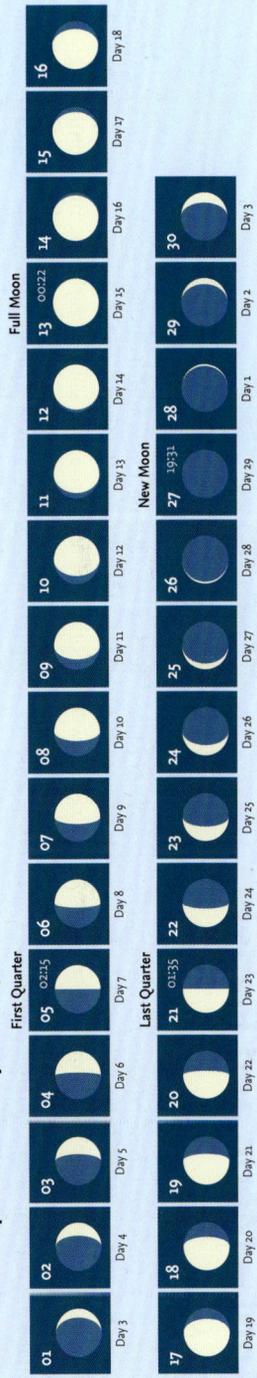

April – Moon and Planets

The Moon

On 3 April the waxing crescent Moon will be visible 5.5°N of **Jupiter** (mag. -2.1). On 5 April the First Quarter Moon will pass 2.2°N of **Mars** (mag. 0.5) and 2.0°S of **Pollux**. Three days later the bright waxing gibbous Moon will lie 2.0°N of **Regulus**. The Full Moon on 13 April will be visible less than half a degree from **Spica**. On 16 April the Moon and **Antares** are 0.4° apart. Last Quarter occurs on 21 April. On 25 April the waning crescent Moon passes 2.4°S of **Venus** (mag. -4.5) and 2.3°N of **Saturn** (mag. 1.0), all are visible very low in the sky just before sunrise. A day later the faint Moon will lie 4.4°N of **Mercury** (mag. 0.2). The following day it is a New Moon. On 30 April the thin crescent Moon will appear 5.4°N of **Jupiter** (mag. -2.0) in the early evening sky.

The planets

On 11 April **Mercury** reaches its highest point in the sky, at mag. 0.3 during the daytime. On 21 April it will have greatest western elongation. On 24 April **Venus** will reach greatest brightness (mag. -4.5), visible shortly before sunrise – it will rise earlier as the month progresses. **Mars** (mag. 0.4 to 0.9) is high in the sky several hours before midnight. **Jupiter** (mag. -2.1 to -2.0) in **Taurus** is also visible in the early evening. **Saturn** (mag. 1.2) will be close to **Venus** and **Neptune** on 28 April, they will all pass within 4° of each other in **Pisces** before sunset. **Uranus** (mag. 5.8) is in **Taurus** and **Neptune** (mag. 7.8) is in **Pisces**.

The path of the Sun and the planets along the ecliptic in April.

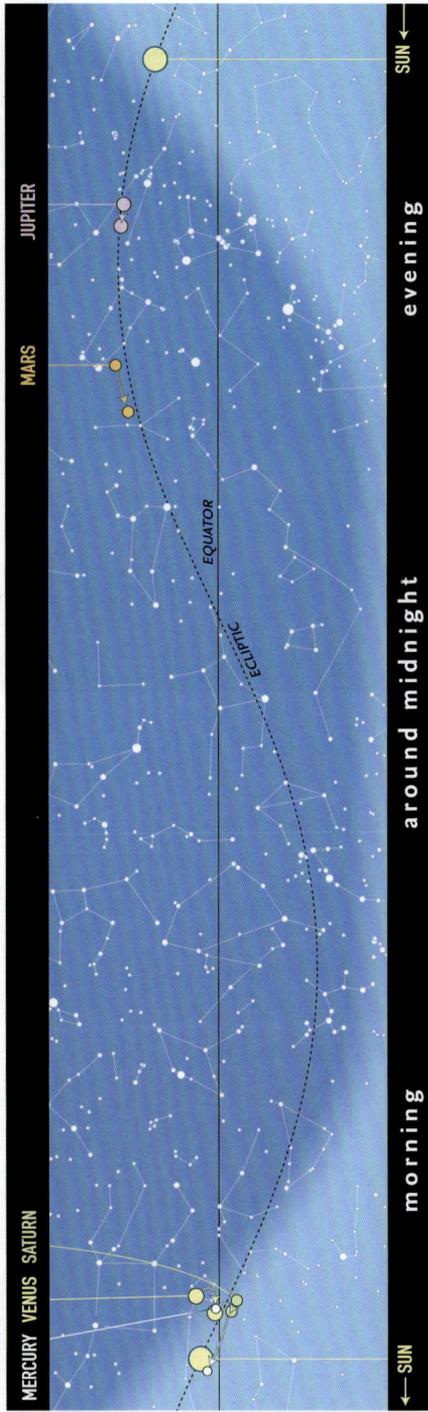

Calendar for April

01	20:28	Pleiades 0.6°S of Moon
03	00:23	Jupiter (mag. -2.1) 5.5°S of Moon
05	02:15	FIRST QUARTER MOON
05	16:46	Pollux 2.0°N of Moon
05	19:04	Mars (mag. 0.5) 2.0°S of Moon
08	11:51	Regulus 2.0°S of Moon
10	12:00	Mercury (mag. 1.0) 2.1°N of Saturn
13	00:22	FULL MOON
13	01:39	Spica 0.3°N of Moon
13	22:48	Moon at apogee: 406,295 km
16	22:00	Mars at aphelion: 1.66606 AU
16	22:19	Antares 0.4°N of Moon
21	01:35	LAST QUARTER MOON
21	19:00	Mercury at greatest elong.: 27.4°W
25	01:21	Venus (mag. -4.5) 2.4°N of Moon
25	04:15	Saturn (mag. 1.0) 2.3°S of Moon
26	01:05	Mercury (mag. 0.2) 4.4°S of Moon
27	16:15	Moon at perigee: 357,119 km
27	19:31	NEW MOON
28	19:00	Venus (mag. -4.8) 3.7°N of Saturn (mag. 1.2)
29	06:35	Pleiades 0.5°S of Moon
30	17:33	Jupiter (mag. -2.0) 5.4°S of Moon

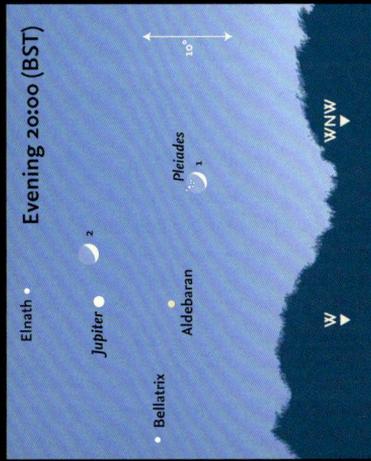

1-2 April • The waxing crescent Moon passes the Pleiades, Aldebaran and Jupiter, almost due west. Bellatrix (γ Ori) is farther southwest.

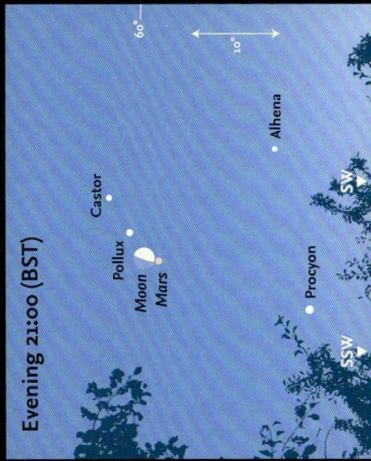

5 April • High in the south-southwest, the Moon is close to Mars (mag. 0.5) and lines up with Castor and Pollux. Procyon is about 20° closer to the horizon.

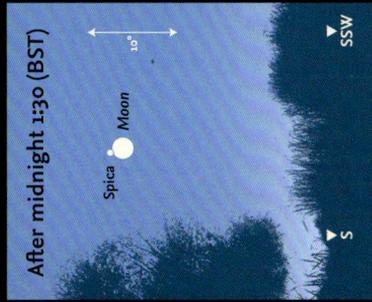

13 April • In the southern sky, the Full Moon is close to Spica.

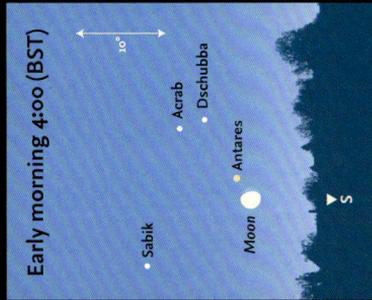

17 April • The waning gibbous Moon is due south, in the constellation of Scorpius and close to Antares.

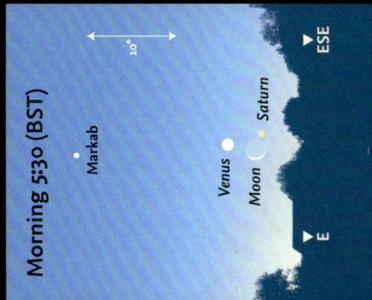

25 April • Shortly before sunrise the Moon, Venus (mag. -4.8) and Saturn (mag. 1.2) are close to the horizon.

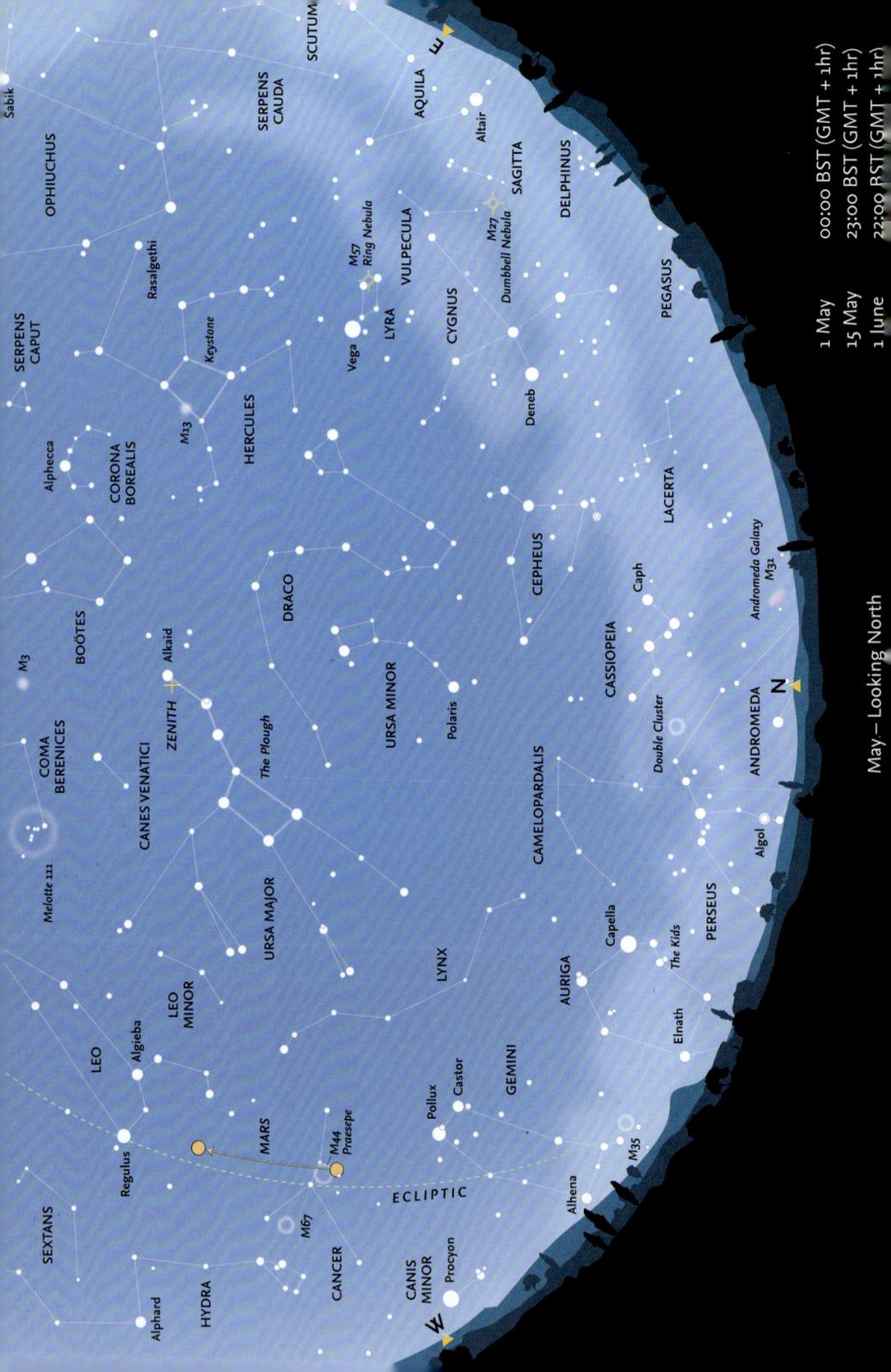

00:00 BST (GMT + 1hr)
 1 May
 23:00 BST (GMT + 1hr)
 15 May
 22:00 BST (GMT + 1hr)
 1 June

May – Looking North

00:00 BST (GMT + 1hr)
 1 May
 23:00 BST (GMT + 1hr)
 15 May
 22:00 BST (GMT + 1hr)
 1 June

May – Looking North

May – Looking North

Cassiopeia is now low over the northern horizon and, to its west, the southern portions of both *Perseus* and *Auriga* are becoming difficult to observe, although the *Double Cluster*, between *Perseus* and *Cassiopeia* is still clearly visible. The *Andromeda Galaxy* is now too low to be readily visible. The constellations of *Lyra*, *Cepheus*, *Ursa Minor* and the whole of *Draco* are well placed in the sky. *Gemini*, with *Castor* and *Pollux*, is sinking towards the western horizon. *Capella* (α Aurigae) and the stars in asterism 'the Kids' are still clear of the horizon.

In the east, two of the stars of the 'Summer Triangle', *Vega* (α Lyrae) and *Deneb* (α Cygni), are clearly visible, and the third star, *Altair* in *Aquila*, is beginning to climb above the horizon. The whole of *Cygnus* is now visible. The sprawling constellation of *Hercules* is high in the east and the brightest globular cluster in the northern hemisphere, M13, is visible to the naked eye on the western side of the asterism known as the *Keystone*.

Three faint constellations may be identified before the lighter nights of summer make them difficult objects. Below *Cepheus*, in the northeastern sky is the zig-zag constellation of *Lacerta*, while to the west, above *Perseus* and *Auriga* is *Camelopardalis* and, farther west, the line of faint stars forming *Lynx*.

Later in the night (and in the month) the westernmost stars of *Pegasus* begin to come into view, while the stars of *Andromeda* are skimming the northeastern horizon and the *Andromeda Galaxy* may become visible. High overhead, *Alkaid* (η Ursa Majoris), the last star in the 'tail' of the Great Bear, is close to the zenith, while the main body of the constellation has swung round into the western sky.

Meteors

The η -*Aquariids* are one of the two meteor showers associated with Comet 1P/Halley (the other being the Orionids, in October). The η -*Aquariids* are not particularly favourably placed for observers in the

northern hemisphere, because the radiant is near the celestial equator, near the 'Water Jar' in *Aquarius*, well below the horizon until late in the night (around dawn). However, meteors may still be seen in the eastern sky even when the radiant is below the horizon. There is a radiant map for the η -*Aquariids* on page 30.

Their maximum in 2025, on 5 May, occurs one day after First Quarter. The Moon will be setting in the west towards midnight, bringing more favourable conditions for viewing in the east. Maximum hourly rate is about 40 per hour and a large proportion (about 25 per cent) of the meteors leave persistent trains which can last for several seconds to minutes.

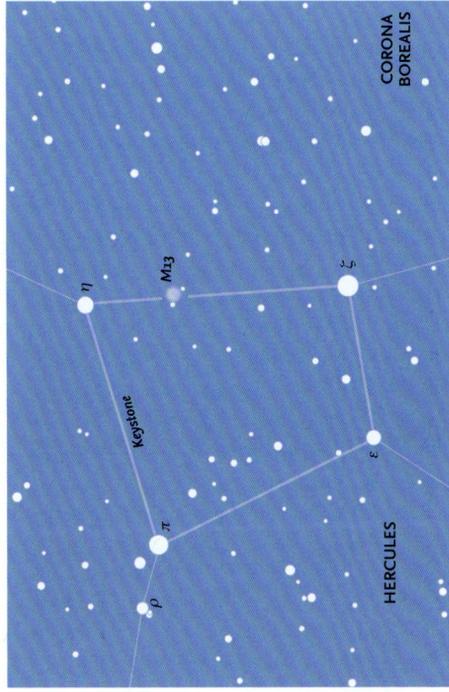

A finder chart for M13, the finest globular cluster in the northern sky. All stars down to magnitude 7.5 are shown.

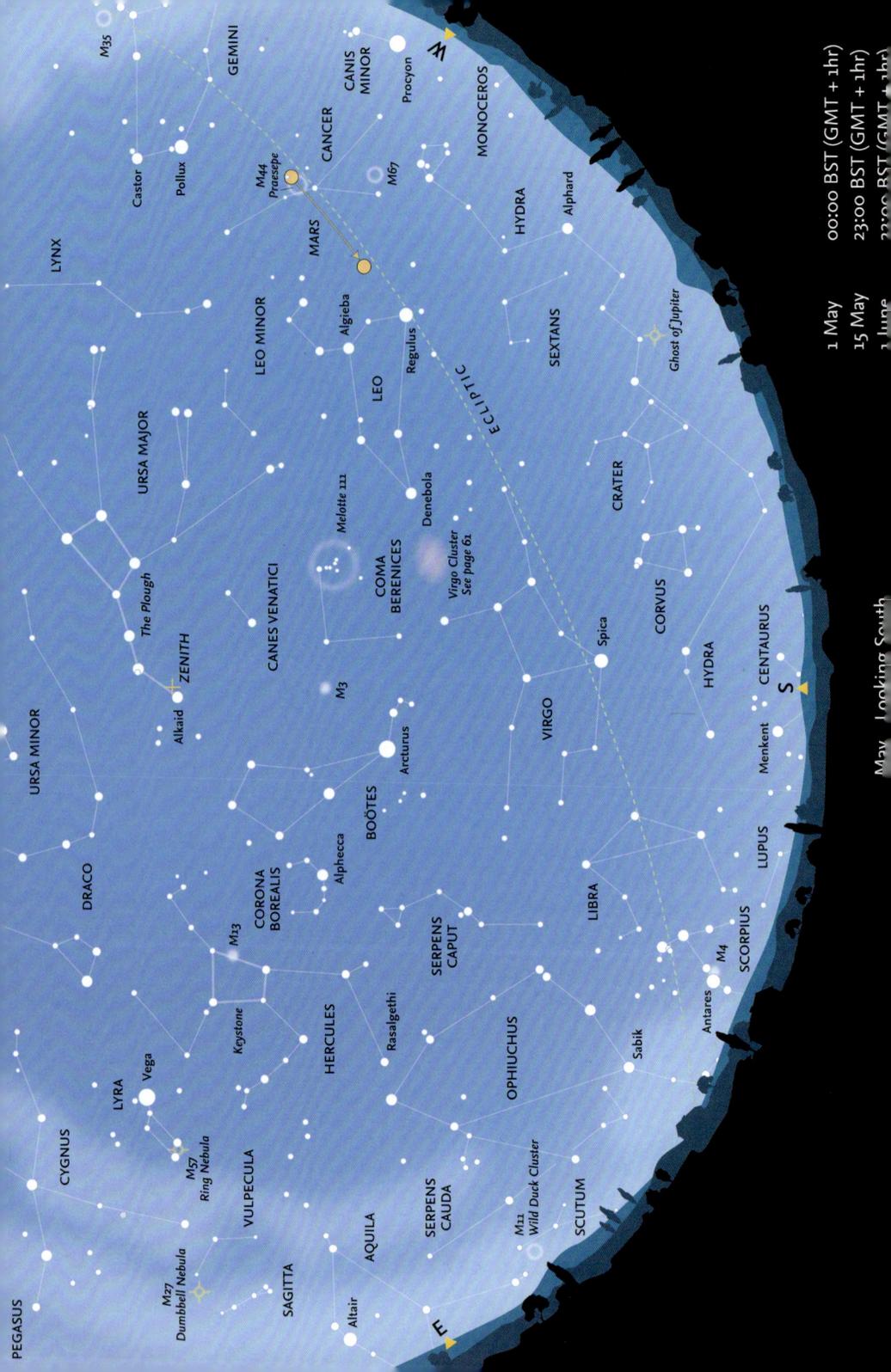

1 May 00:00 BST (GMT + 1hr)
15 May 23:00 BST (GMT + 1hr)
1 June 23:00 BST (GMT + 1hr)

May Looking South

May – Looking South

Early in the night, the constellation of **Virgo**, with **Spica** (α Virginis), lies due south, with **Leo** and both **Regulus** and **Denebola** (α and β Leonis, respectively) to its west still well clear of the horizon. Later in the night, the rather faint zodiacal constellation of **Libra** becomes visible and, to its east, the ruddy star **Antares** (α Scorpii) begins to climb up over the horizon.

Virgo contains the nearest large cluster of galaxies, which is the centre of the Local Supercluster, of which the Milky Way galaxy forms part. The Virgo Cluster contains some 2,000 galaxies, the brightest of which are visible in amateur telescopes.

Arcturus in **Boötes** is high in the south, with the distinctive circlet of **Corona Borealis** clearly visible to its east. The brightest star (α Coronae Borealis) is known as **Alphacca**. The large constellation of **Ophiuchus** (which actually crosses the ecliptic and is thus the ‘thirteenth’ zodiacal constellation) is climbing into the eastern sky. Before the constellation boundaries were formally adopted by the International Astronomical Union in 1930, the southern region of Ophiuchus was regarded as

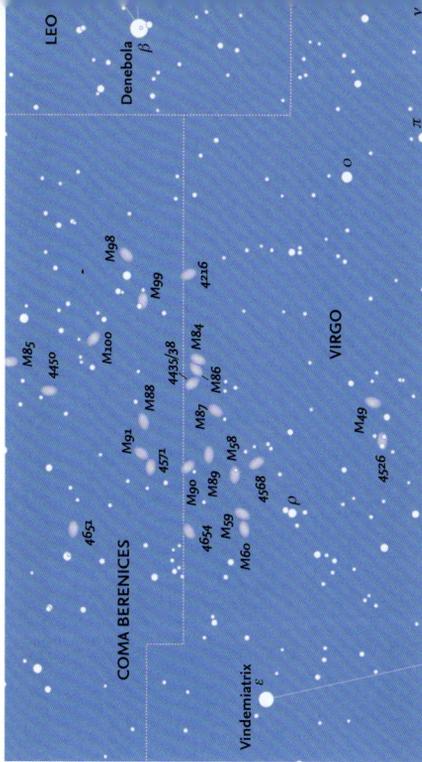

A finder chart for some of the brightest galaxies in the Virgo Cluster (see page 60). All stars brighter than magnitude 8.5 are shown.

forming part of the constellation of **Scorpius**, which had been part of the zodiac since antiquity.

The Moon's phases for May 2025

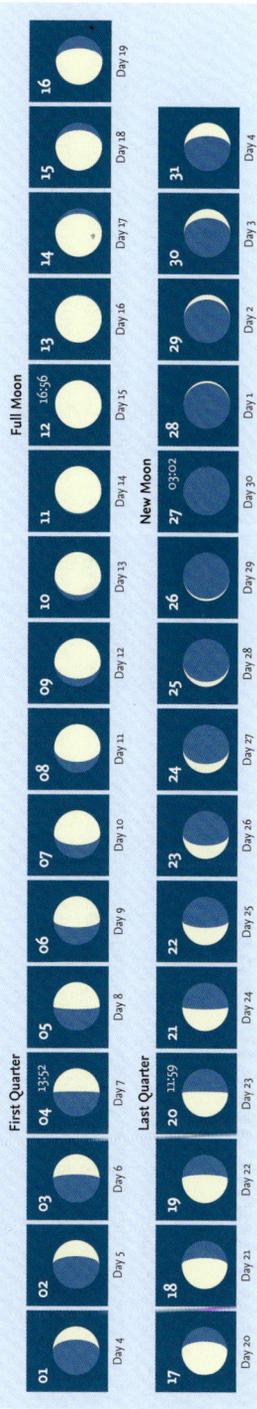

May – Moon and Planets

The Moon

On 3 May the Moon will be 2.1° S of **Pollux** around midnight, and the following night the Moon and **Mars** (mag. 1.0) will be 2.1° apart. On 5 May the Moon and **Regulus** are 2.0° apart. On 10 May **Spica** is 0.4° N of the waxing gibbous Moon. The Full Moon is on 12 May. On 14 May the Moon will be 0.3° S of **Antares**. The Last Quarter Moon is on 20 May. On 22 May the waning crescent Moon will be almost 3° N of **Saturn** (mag. 0.9) during the daytime. On 24 May the Moon and **Venus** (mag. -4.4) will be 4° apart. The New Moon will be visible on 27 May. On 30 May the thin crescent Moon will lie 2.3° from **Pollux**.

The planets

On 2 May minor planet (4) **Vesta** will be at opposition in **Libra**, reaching its highest point at midnight. **Mercury** (mag. 0.1 to -2.3) climbs above the horizon shortly before sunrise. **Venus** is also visible at dawn, on 31 May it will reach greatest western elongation at mag. -4.4. **Mars** (mag. 0.9 to 1.2) continues to move eastward. **Jupiter** (mag. -2.0 to -1.9) in **Taurus** sets earlier in the evening as the month progresses. **Saturn** (mag. 1.2 to 1.1) in **Pisces** is above the horizon at dawn. **Uranus** (mag. 5.8) follows in close proximity to the Sun in the sky. **Neptune** (mag. 7.8) is in **Pisces**.

The path of the Sun and the planets along the ecliptic in May.

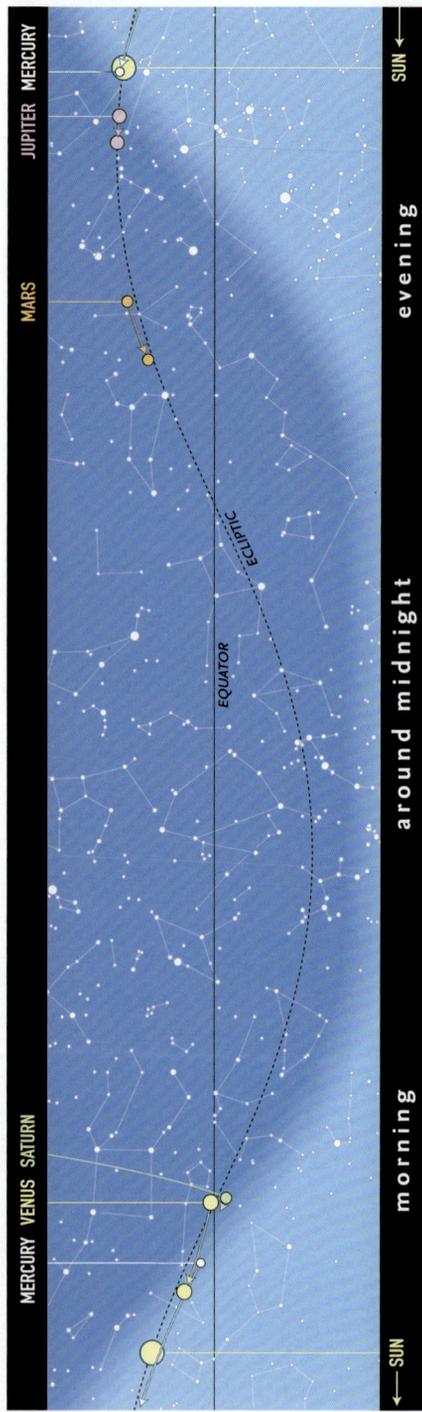

Calendar for May

- 02 06:28 Minor planet (4) Vesta at opposition (mag. 5.7)
- 03 00:02 Pollux 2.2°N of Moon
- 03 23:12 Mars (mag. 1.0); 2.1°S of Moon
- 04 13:52 FIRST QUARTER MOON
- 05 η-Aquariid Meteor Shower maximum
- 05 17:58 Regulus 2.2°S of Moon
- 10 07:43 Spica 0.4°N of Moon
- 11 00:49 Moon at apogee: 406,245 km
- 12 16:56 FULL MOON
- 14 04:10 Antares 0.3°N of Moon
- 20 11:59 LAST QUARTER MOON
- 22 17:51 Saturn (mag. 0.9) 2.8°S of Moon
- 23 23:52 Venus (mag. -4.4) 4.0°S of Moon
- 26 01:37 Moon at perigee: 359,023 km
- 27 03:02 NEW MOON
- 28 13:12 Jupiter (mag. -1.9) 5.2°S of Moon
- 30 09:13 Pollux 2.4°N of Moon
- 31 12:00 Mercury at perihelion

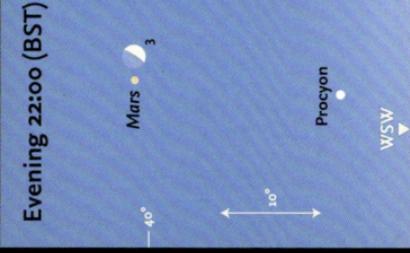

2-3 May • High in the western sky, the Moon passes Castor and Pollux. On 3 May, it is close to Mars (mag. 0.9). Procyon (α CMI), Alhena (γ Gem) and Elhath (β Tau) are all closer to the horizon.

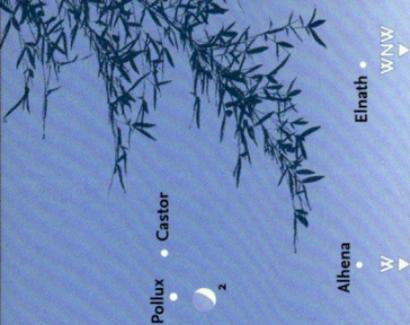

10 May • In the early morning the Moon and Spica are in the west-southwest, less than 10° above the horizon.

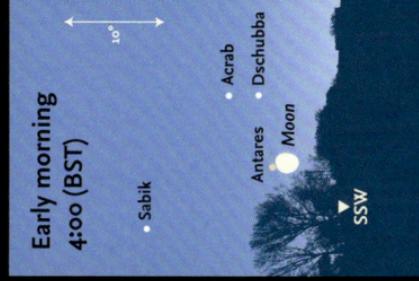

14 May • The Moon is in the constellation of Scorpius and close to the red star Antares

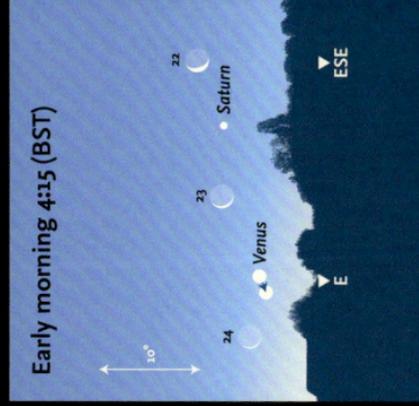

22-24 May • Shortly before sunrise (at 4:58) the crescent Moon passes Saturn (mag. 1.1) and brilliant Venus (mag. -4.4)

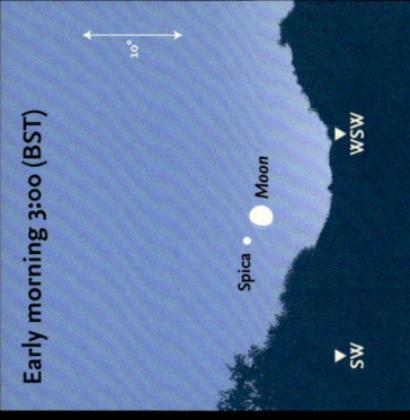

29 May • The Moon forms a nice isosceles triangle with Castor and Pollux

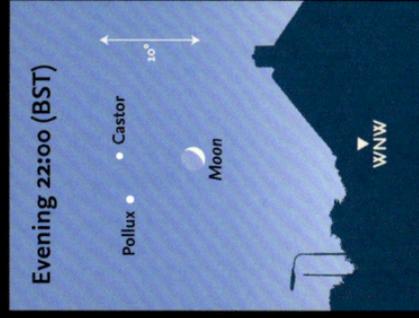

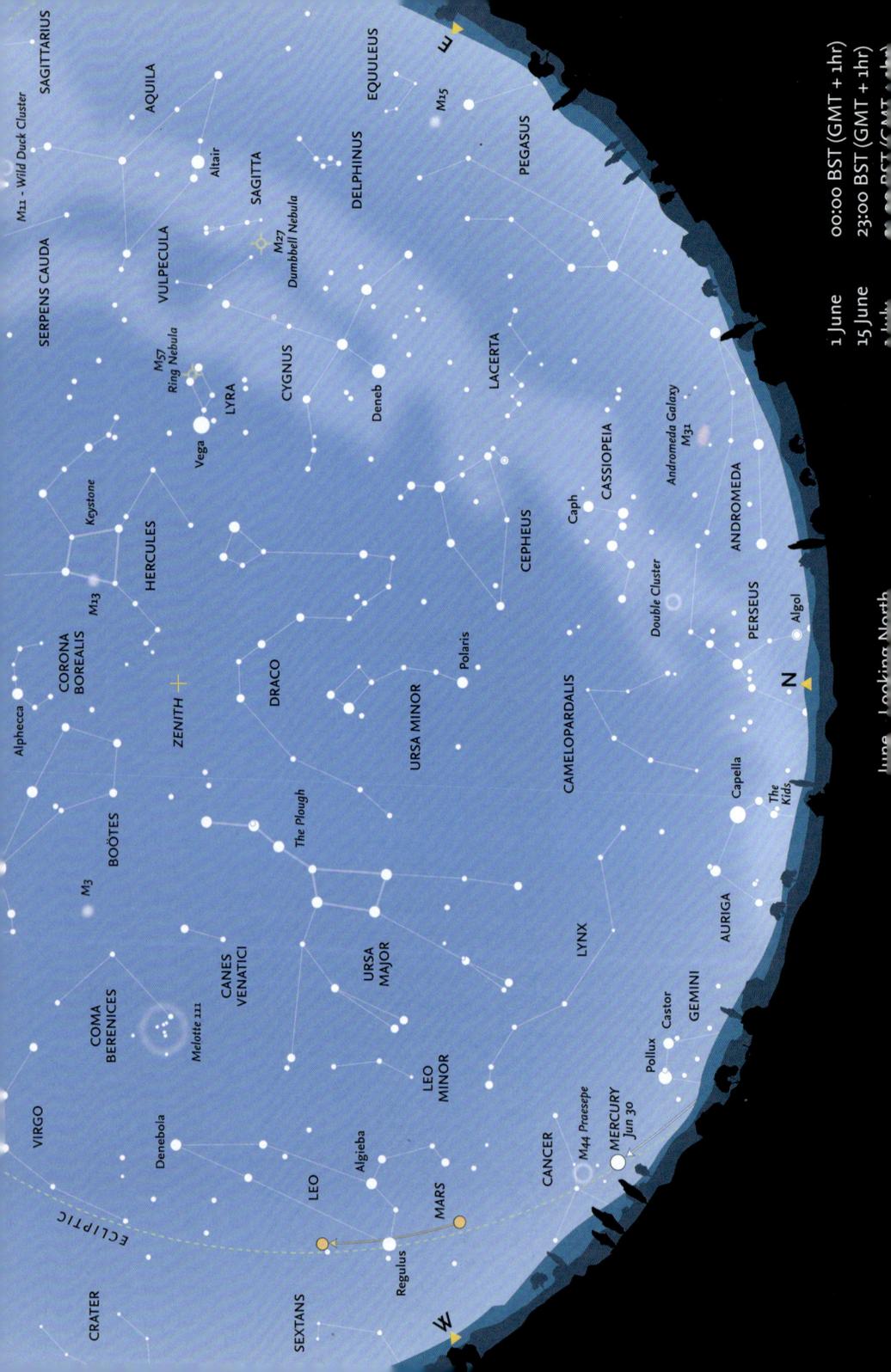

00:00 BST (GMT + 1hr)
 23:00 BST (GMT + 1hr)

1 June
 15 June

June Looking North

June – Looking North

Around summer solstice (21 June) even in southern England and Ireland a form of twilight persists throughout the night. Farther north, in Scotland, the sky remains so light that most of the fainter stars and constellations are invisible. There, even brighter stars such as the seven stars making up the well-known asterism known as the **Plough** in **Ursa Major** may be difficult to detect except around local midnight, 00:00 UT (01:00 BST).

But there is one compensation during these light nights: even southern observers may be lucky enough to witness a display of

noctilucent clouds (NLC). These are highly distinctive clouds shining with an electric-blue tint, observed in the sky in the direction of the North Pole. They are the highest clouds in the atmosphere, occurring at altitudes of 80–85 km, far above all other clouds. They are only visible during summer nights, for about a month or six weeks on either side of the solstice, when observers are in darkness, but the clouds themselves remain illuminated by sunlight, reaching them from the Sun, itself hidden below the northern horizon.

Noctilucent clouds, photographed by Alan Tough from Nairn in Scotland on 31 May 2020, at 00:28.

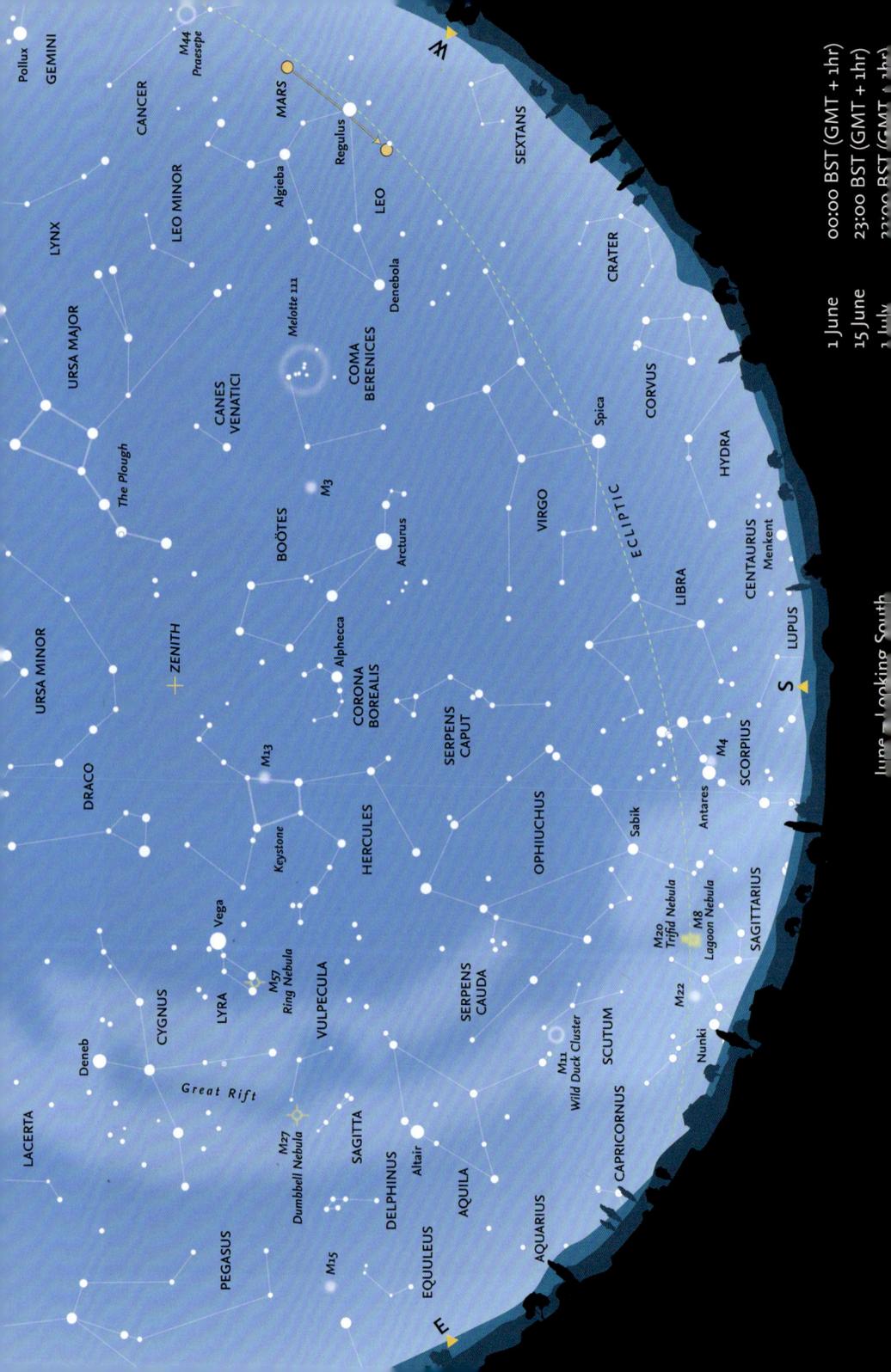

00:00 BST (GMT + 1hr)
 23:00 BST (GMT + 1hr)
 22:00 BST (GMT + 1hr)

1 June
 15 June
 1 July

June Looking South

EL

S

ZENITH

The Plough

ECLIPTIC

Wild Duck Cluster

Great Rift

Dumbbell Nebula

M20
 Trifid Nebula

M8
 Lagoon Nebula

Keystone

Vega

M13

Alphecca

M3

Melotte 111

COMA
 BERENICES

Denebola

Regulus

MARS

M44
 Praesepe

Pollux

GEMINI

CANCER

LEO MINOR

LYNX

URSA MAJOR

URSA MINOR

DRACO

LACERTA

CYGNUS

M57
 Ring Nebula

LYRA

M57
 Ring Nebula

VULPECULA

PEGASUS

SAGITTA

M27
 Dumbbell Nebula

M15

DELPHINIUS

Altair

EQUULEUS

AQUILA

AQUARIUS

CAPRICORNUS

SCUTUM

OPHIUCHUS

HERCULES

CORONA
 BOREALIS

BOOTES

URSA MAJOR

URSA MINOR

LYNX

CANCER

LEO

LEO MINOR

GEMINI

POLLUX

MARS

REGULUS

COMA
 BERENICES

DENEBOBA

ARCTURUS

SERPENS
 CAPUT

OPHIUCHUS

SERPENS
 CAUDA

AQUILA

EQUULEUS

MARS

REGULUS

COMA
 BERENICES

DENEBOBA

ARCTURUS

SERPENS
 CAPUT

OPHIUCHUS

SERPENS
 CAUDA

AQUILA

EQUULEUS

MARS

REGULUS

COMA
 BERENICES

DENEBOBA

ARCTURUS

SERPENS
 CAPUT

OPHIUCHUS

SERPENS
 CAUDA

AQUILA

EQUULEUS

MARS

REGULUS

COMA
 BERENICES

DENEBOBA

ARCTURUS

SERPENS
 CAPUT

OPHIUCHUS

SERPENS
 CAUDA

AQUILA

EQUULEUS

MARS

REGULUS

COMA
 BERENICES

DENEBOBA

ARCTURUS

SERPENS
 CAPUT

OPHIUCHUS

SERPENS
 CAUDA

AQUILA

EQUULEUS

MARS

REGULUS

COMA
 BERENICES

DENEBOBA

ARCTURUS

SERPENS
 CAPUT

OPHIUCHUS

SERPENS
 CAUDA

AQUILA

EQUULEUS

MARS

REGULUS

COMA
 BERENICES

DENEBOBA

ARCTURUS

SERPENS
 CAPUT

OPHIUCHUS

SERPENS
 CAUDA

AQUILA

EQUULEUS

MARS

REGULUS

COMA
 BERENICES

DENEBOBA

ARCTURUS

SERPENS
 CAPUT

OPHIUCHUS

SERPENS
 CAUDA

AQUILA

EQUULEUS

MARS

REGULUS

COMA
 BERENICES

DENEBOBA

ARCTURUS

SERPENS
 CAPUT

OPHIUCHUS

SERPENS
 CAUDA

AQUILA

EQUULEUS

MARS

REGULUS

COMA
 BERENICES

DENEBOBA

ARCTURUS

SERPENS
 CAPUT

OPHIUCHUS

SERPENS
 CAUDA

AQUILA

EQUULEUS

MARS

REGULUS

COMA
 BERENICES

DENEBOBA

ARCTURUS

SERPENS
 CAPUT

OPHIUCHUS

SERPENS
 CAUDA

AQUILA

EQUULEUS

MARS

REGULUS

COMA
 BERENICES

DENEBOBA

ARCTURUS

SERPENS
 CAPUT

OPHIUCHUS

SERPENS
 CAUDA

AQUILA

EQUULEUS

MARS

REGULUS

COMA
 BERENICES

DENEBOBA

ARCTURUS

SERPENS
 CAPUT

OPHIUCHUS

SERPENS
 CAUDA

AQUILA

EQUULEUS

MARS

REGULUS

COMA
 BERENICES

DENEBOBA

ARCTURUS

SERPENS
 CAPUT

OPHIUCHUS

SERPENS
 CAUDA

AQUILA

EQUULEUS

MARS

REGULUS

COMA
 BERENICES

DENEBOBA

ARCTURUS

SERPENS
 CAPUT

OPHIUCHUS

SERPENS
 CAUDA

AQUILA

EQUULEUS

MARS

REGULUS

COMA
 BERENICES

DENEBOBA

ARCTURUS

SERPENS
 CAPUT

OPHIUCHUS

SERPENS
 CAUDA

AQUILA

EQUULEUS

MARS

REGULUS

COMA
 BERENICES

DENEBOBA

ARCTURUS

SERPENS
 CAPUT

OPHIUCHUS

SERPENS
 CAUDA

AQUILA

EQUULEUS

MARS

REGULUS

COMA
 BERENICES

DENEBOBA

ARCTURUS

SERPENS
 CAPUT

OPHIUCHUS

SERPENS
 CAUDA

AQUILA

EQUULEUS

MARS

REGULUS

COMA
 BERENICES

DENEBOBA

ARCTURUS

SERPENS
 CAPUT

OPHIUCHUS

SERPENS
 CAUDA

AQUILA

EQUULEUS

MARS

REGULUS

COMA
 BERENICES

DENEBOBA

ARCTURUS

SERPENS
 CAPUT

OPHIUCHUS

SERPENS
 CAUDA

AQUILA

EQUULEUS

MARS

REGULUS

COMA
 BERENICES

DENEBOBA

ARCTURUS

SERPENS
 CAPUT

OPHIUCHUS

SERPENS
 CAUDA

AQUILA

EQUULEUS

MARS

REGULUS

COMA
 BERENICES

DENEBOBA

ARCTURUS

SERPENS
 CAPUT

OPHIUCHUS

SERPENS
 CAUDA

AQUILA

EQUULEUS

MARS

REGULUS

COMA
 BERENICES

DENEBOBA

ARCTURUS

SERPENS
 CAPUT

OPHIUCHUS

SERPENS
 CAUDA

AQUILA

EQUULEUS

MARS

REGULUS</

June – Looking South

Although the persistent twilight makes observing even the southern sky difficult, the rather undistinguished constellation of **Libra** lies almost due south. The red super-giant star **Antares** – the name means the ‘rival of Mars’ – in **Scorpius** is visible slightly to the east of the meridian, but the ‘tail’ or ‘sting’ remains below the horizon. Higher in the sky is the large constellation of **Ophiuchus** (the ‘Serpent Bearer’), lying between the two halves of the constellation of **Serpens**: **Serpens Caput** (‘Head of the Serpent’) to the west and **Serpens Cauda** (‘Tail of the Serpent’) to the east. (Serpens is the only constellation to be divided into two distinct parts.) The ecliptic runs across Ophiuchus, and the Sun actually spends far more time in the constellation than it does in the ‘classical’ zodiacal constellation of Scorpius, a small area of which lies between Libra and Ophiuchus.

Higher in the southern sky, the three constellations of **Boötes**, **Corona Borealis** and **Hercules** are now better placed for observation than at any other time of the year. This is an ideal time to observe the fine globular cluster of M13 in Hercules (see finder chart on page 59).

The constellations of Boötes and Corona Borealis are high in the sky in June. Arcturus has an orange tint and is the brightest star (mag. -0.05) in the northern celestial hemisphere.

The Moon's phases for June 2025

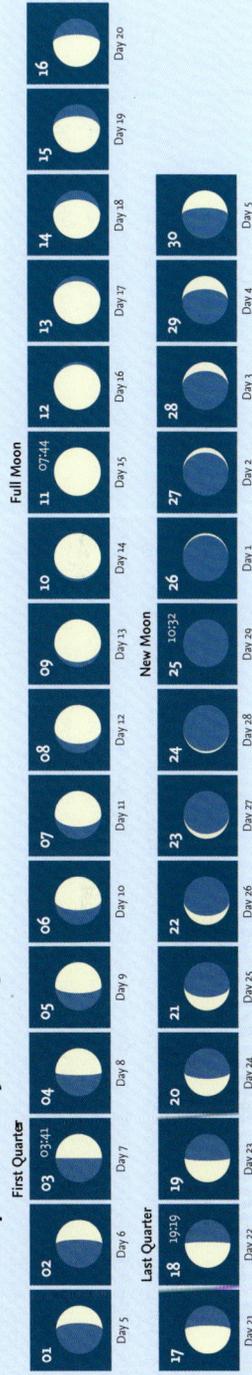

June – Moon and Planets

The Moon

On 1 June, the waxing crescent Moon will be 1.4° N of **Mars** (mag. 1.2). The following day the Moon will be less than 2° from **Regulus**. On 3 June the Moon is First Quarter. Three days later the waxing gibbous Moon is 0.5° S of **Spica**. On 10 June the Moon passes 0.3° S of **Antares**, a day later it is a Full Moon. On 18 June the Moon is at Last Quarter. On 19 June the waning Moon, **Saturn** (mag. 1.0) and **Neptune** (mag. 7.8) are all within $3-4^{\circ}$ of each other, above the horizon in the dawn sky. On 25 June there will be a New Moon. On 27 June the thin crescent Moon will pass less than 3° N of **Mercury** (mag. 0.1), visible shortly after sunset. Two days later the Moon and **Regulus** are 1.5° apart. Shortly after midnight on 30 June the Moon and **Mars** (mag. 1.4) will be 0.2° apart.

The planets

Mercury (mag. -2 to 0.3) sets with the Sun in the early part of the month, increasing its separation towards the end of the month as it approaches eastern elongation. **Venus** (mag. -4.4 to -4.2) climbs above the eastern horizon in **Aries** before sunrise. **Mars** (mag. 1.2 to 1.4) in **Leo** is visible in the evening sky, setting earlier towards the end of the month. **Jupiter** (mag. -1.9) moves from **Taurus** to **Gemini** on 12 June and sets shortly after the Sun. **Saturn** (mag. 1.0) and **Neptune** (mag. 7.8) will pass within a degree of each other on 29 June in **Pisces**. **Uranus** (mag. 5.8) is in **Taurus** in the dawn sky.

The path of the Sun and the planets along the ecliptic in June.

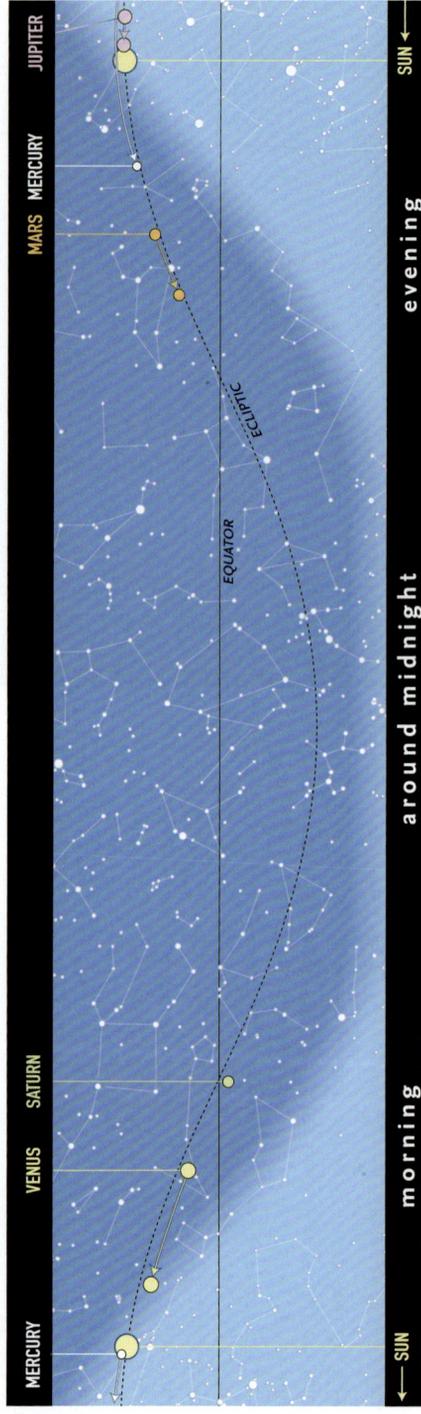

Calendar for June

- 01 02:00 Venus at greatest elong.: 45.9°W
- 01 09:49 Mars (mag. 1.2) 1.4°S of Moon
- 02 01:50 Regulus 1.8°S of Moon
- 03 03:41 FIRST QUARTER MOON
- 06 14:15 Spica 0.5°N of Moon
- 07 10:42 Moon at apogee: 405,553 km
- 10 10:25 Antares 0.3°N 0.7°Moon
- 11 07:44 FULL MOON
- 12 03:00 Venus at aphelion
- 17 02:05 Mars (mag. 1.4) 0.7°N of Regulus
- 18 19:19 LAST QUARTER MOON
- 19 03:47 Saturn (mag. 1.0) 3.4°S of Moon
- 21 02:42 Summer Solstice
- 21 19:51 Mercury (mag. -0.2) 4.8°S of Pollux
- 23 02:59 Pleiades 0.6°S of Moon
- 23 04:43 Moon at perigee: 363,178 km
- 25 09:19 Jupiter (mag. -1.9) 5.1°S of Moon
- 25 10:32 NEW MOON
- 26 19:14 Pollux 2.5°N of Moon
- 27 06:02 Mercury (mag. 0.1) 2.9°S of Moon
- 29 10:26 Regulus 1.5°S of Moon
- 30 01:05 Mars (mag. 1.4) 0.2°S of Moon

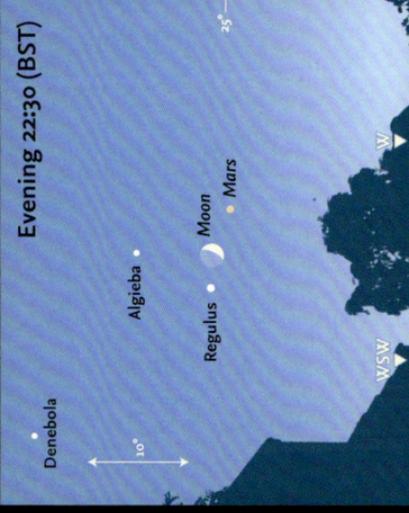

1 June • The Moon is in the constellation of Leo, and in the company of Mars (mag 1.2) and Regulus. Algieba (γ Leo) is about 8° above the Moon.

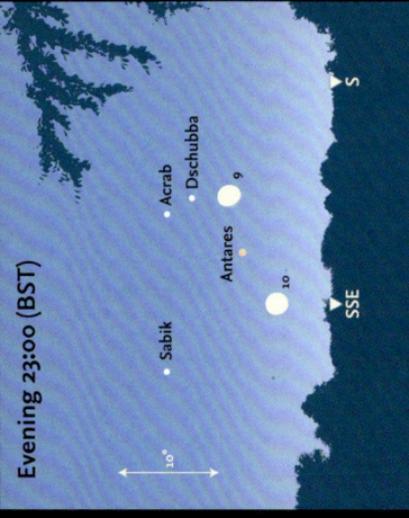

9–10 June • The Moon passes through the constellation of Scorpius, with the red star Antares. The name means ‘rival of Mars’, because of its colour.

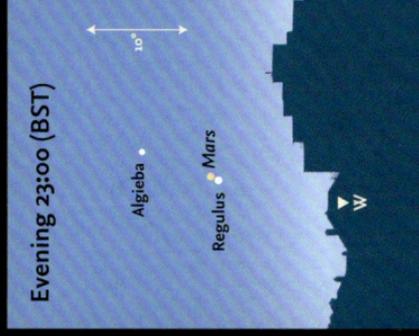

16 June • Mars is very close to Regulus in the western sky and almost equally as bright.

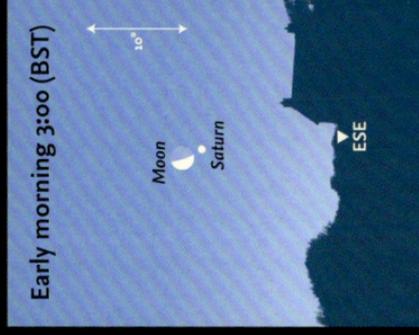

19 June • The Moon with Saturn (mag. 1.0) in the east-southeastern sky.

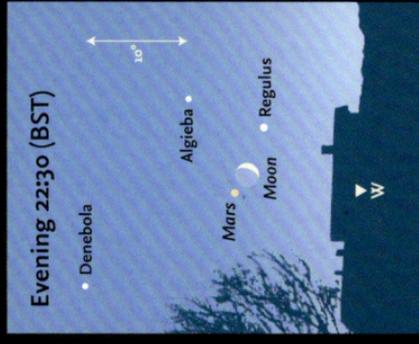

29 June • The waxing crescent Moon is in the company of Mars, Regulus and the slightly fainter Algieba.

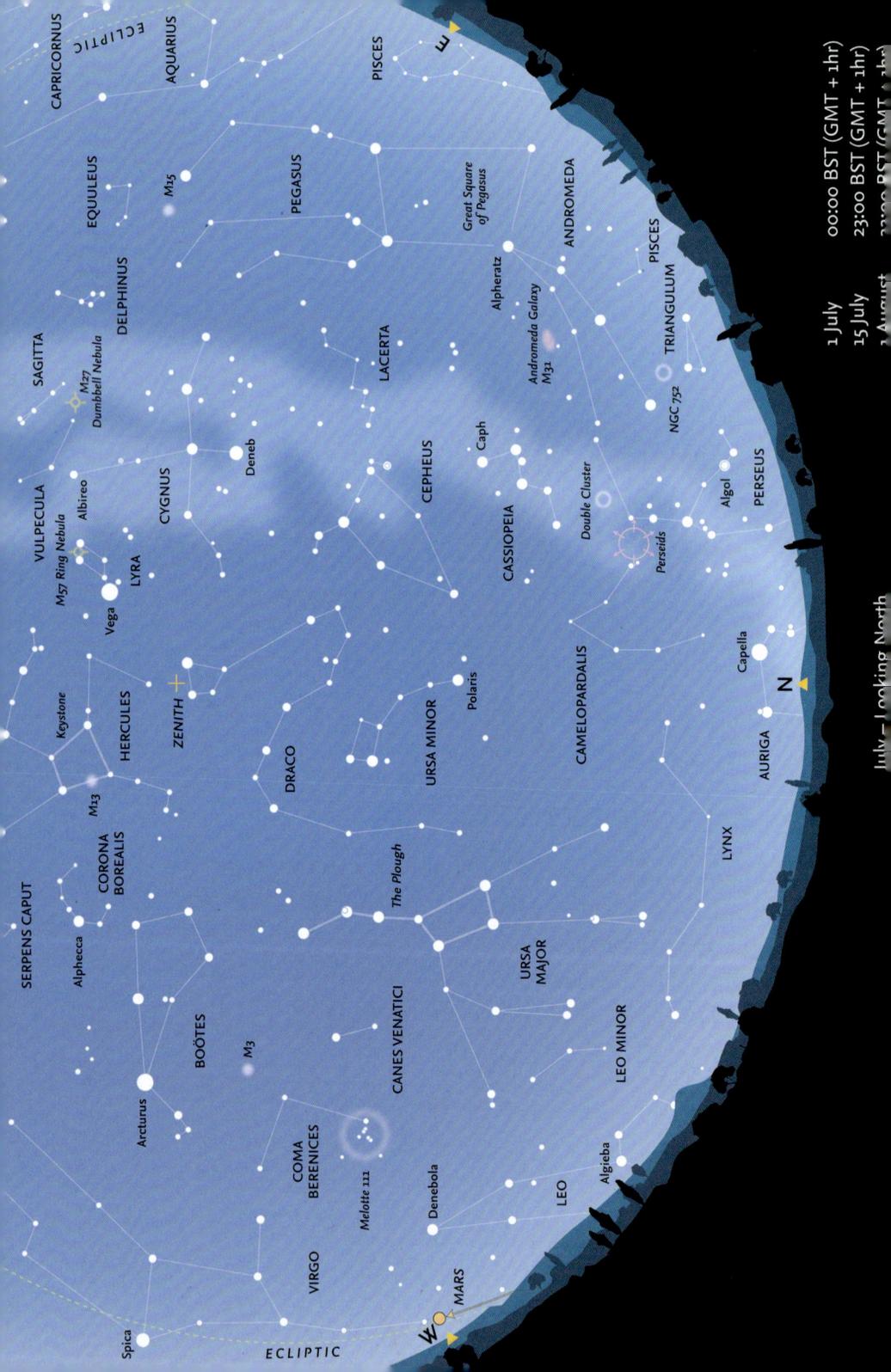

CAPRICORNUS
 AQUARIUS
 EQUULEUS
 DELPHINUS
 SAGITTA
 M37
 Dumbbell Nebula
 VULPECULA
 M57
 Ring Nebula
 ALBIREO
 LYRA
 CYGNUS
 Deneb
 PEGASUS
 LACERTA
 URSA MINOR
 POLARIS
 URSA MAJOR
 THE PLOUGH
 CANES VENATICI
 SERPENS CAPUT
 CORONA BOREALIS
 HERCULES
 M13
 KEYSTONE
 DRACO
 URSA MINOR
 POLARIS
 URSA MAJOR
 THE PLOUGH
 CANES VENATICI
 BOÖTES
 M3
 COMA BERENICES
 MELIATHE 111
 VIRGO
 Denebola
 LEO
 ALGIEBA
 LEO MINOR
 LYNX
 AURIGA
 CAPPELLA
 CAMELOPARDALIS
 DOUBLE CLUSTER
 PERSEUS
 ALGOL
 PERSEUS
 CASSIOPEIA
 CAPH
 ANDROMEDA
 GREAT SQUARE OF PEGASUS
 ANDROMEDA GALAXY
 M31
 TRIANGULUM
 NGC 752
 PISCES
 PISCES
 ECLIPTIC
 ECLIPTIC
 N
 MARS
 W

09:00 BST (GMT + 1hr)
 23:00 BST (GMT + 1hr)
 1 July
 15 July
 31 August

July - Looking North

July – Looking North

As in June, light nights and the chance of observing noctilucent clouds persist throughout July, but later in the month (and particularly after midnight) some of the major constellations begin to be more easily seen. **Capella**, the brightest star in **Auriga** (most of which is too low to be visible), is skimming the northern horizon. **Cassiopeia** is clearly visible in the northeast and **Perseus**, to its south, is beginning to climb clear of the horizon. The band of the Milky Way, from Perseus through Cassiopeia towards **Cygnus**, stretches up into the northeastern sky. If the sky is dark and clear, you may be able to make out the small, faint constellation of **Lacerta**, lying across the Milky Way between Cassiopeia and **Cygnus**. In the east, the stars of **Pegasus** are now well clear of the horizon, with the main line of stars forming **Andromeda** roughly parallel to the horizon in the northeast. **Alpheratz** (α Andromedae) is actually the star at the northeastern corner of the **Great Square of Pegasus**. **Cepheus** and **Ursa Major** are on opposite sides of **Polaris** and **Ursa Minor**, in the east and west, respectively. The head of **Draco** is very close to the zenith so the whole of this winding constellation is readily seen.

Meteors

July brings increasing meteor activity, mainly because there are several minor radiants active in the constellations of **Capricornus** and **Aquarius**. Because of their location, however, observing conditions are not particularly favourable for northern-hemisphere observers, although the first shower, the α -**Capricornids**, active from 3 July to 15 August (peaking 30 July), does often produce very bright fireballs. The maximum rate, however, is only about 5 per hour. The parent body is Comet 169P/NEAT. The most prominent shower is probably that of the **Southern δ -Aquariids**, which are active from around 12 July to 23 August, with a peak on 30 July, although even then the rate is unlikely to reach 25 meteors per hour. In this case, the parent body

Cygnus, sometimes known as the 'Northern Cross', depicts a swan 'flying' down the Milky Way towards Sagittarius. The brightest star, Deneb (α Cygni), represents the tail. Albireo (β Cygni) marks the position of the head and lies near the bottom of the image.

may be Comet 96P/Machholz. This year, both shower maxima occur when the Moon is six days old so observing conditions are reasonably favourable. A chart showing the **δ -Aquariids** radiant is shown on page 30. The Perseids begin on 17 July and peak on 12 August.

July – Looking South

Although part of the constellation remains hidden, this is perhaps the best time of year to see **Scorpius**, with deep red **Antares** (α Scorpii), glowing just above the southern horizon. At around midnight (UT, 01:00 EST), part of **Sagittarius**, with the distinctive asterism of the ‘Teapot’, and the dense star clouds of the centre of the Milky Way, are just visible in the south. The **Great Rift** – actually dust clouds that hide the more distant stars – runs down the Milky Way from **Cygnus** towards Sagittarius. Towards its northern end is the small constellation of **Sagitta** and the planetary nebula M17 (the Dumbbell Nebula) in the otherwise insignificant constellation of **Vulpecula**. The sprawling constellation of **Ophiuchus** lies close to the meridian for a large part of the month, separating the two halves of the constellation of **Serpens**. In the east, the bright ‘Summer Triangle’, consisting of **Vega** in **Lyra**, **Deneb** in **Cygnus** and **Altair** in **Aquila**, begins to dominate the southern sky, as it will throughout August and into September. The small constellation of **Lyra**, containing Vega and a distinctive quadrilateral of stars to its east and south, lies not far south of the zenith.

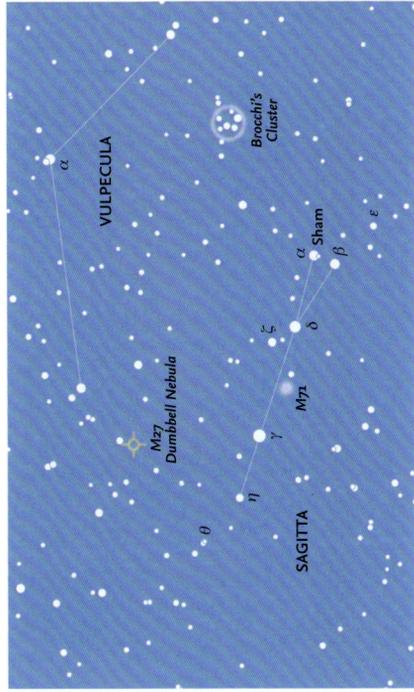

A finder chart for M17, the Dumbbell Nebula, a relatively bright (magnitude 8) planetary nebula – a shell of material ejected in the late stages of a star’s lifetime – in the constellation of Vulpecula. All stars brighter than magnitude 7.5 are shown.

The Moon’s phases for July 2025

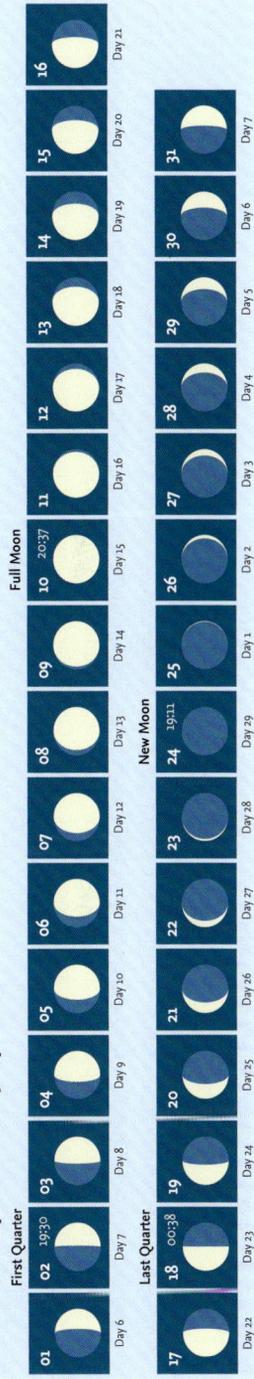

July – Moon and Planets

The Moon

A day after the First Quarter Moon **Spica** is 0.8°N of the Moon. On 7 July the Moon is close to **Antares** at only 0.4° separation. Full Moon is on 10 July. On 16 July the Moon will pass less than 4°N of **Saturn** (mag. 0.9). **Neptune** will also be close by. The Last Quarter Moon is on 18 July. On 23 July the waning Moon will lie within 5° of **Jupiter** (mag. -1.9), visible at dawn. Two days after New Moon on 26 July the crescent Moon will be 1.4°N of **Regulus**. On 28 July the waxing crescent Moon will be just over 1.5° of **Mars** (mag. 1.6). On 31 July **Spica** and the Moon are close together again in the sky, just over a degree apart.

The planets

Mercury will reach greatest western elongation on 4 July, bright at magnitude 0.5 in the early evening sky, dimming to mag. 5.0 in late summer. **Venus** (mag. -4.1 to -4.0) continues to be the morning star placed in **Taurus**, it moves eastwards towards **Orion** at the end of the month. **Mars** is visible in the evening sky in **Leo**, moving into **Virgo** on 28 July. **Jupiter** (mag. -1.9) rises with the Sun in **Gemini**. **Saturn** (mag. 0.9) enters retrograde motion in **Pisces** on 13 July. **Uranus** (mag. 5.8) is in **Taurus**. **Neptune** (mag. 7.8) will enter retrograde motion on 4 July in **Pisces**.

The path of the Sun and the planets along the ecliptic in July.

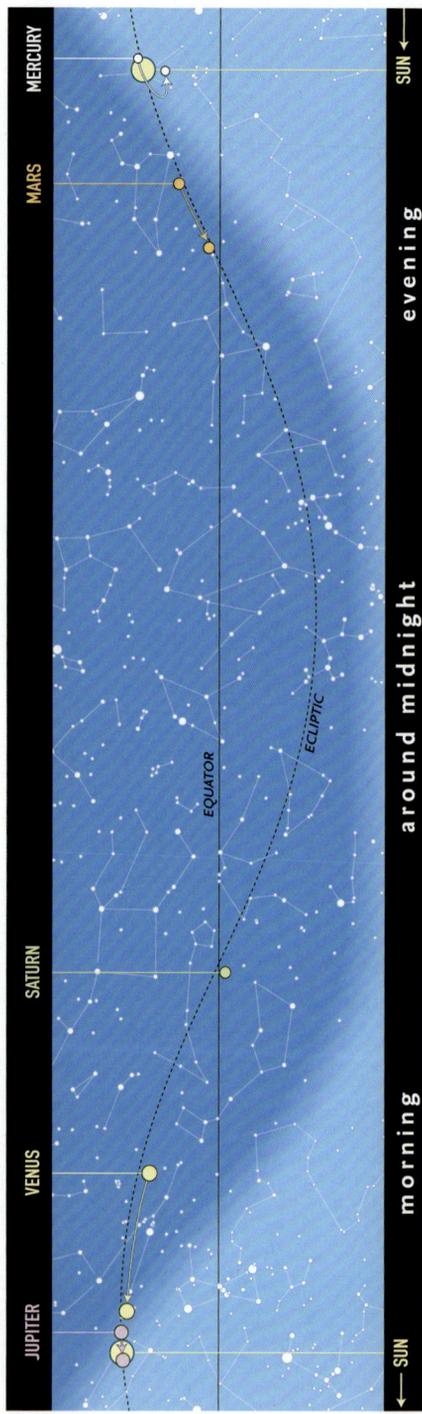

Calendar for July

- 02 19:30 FIRST QUARTER MOON
- 03 21:00 Earth at aphelion: 1.01664 AU
- 03 21:39 Spica 0.8°N of Moon
- 04 04:00 Mercury at greatest elong.: 25.9°E
- 05 02:29 Moon at apogee: 404,627 km
- 07 17:37 Antares 0.4°N of Moon
- 10 20:37 FULL MOON
- 13 08:32 Venus (mag. -4.1) 3.1°N of Aldebaran
- 14 13:00 Mercury at aphelion
- 16 10:19 Saturn (mag. 0.5) 3.8°S of Moon
- 18 00:33 LAST QUARTER MOON
- 20 10:27 Pleiades 0.7°S of Moon
- 20 13:52 Moon at perigee: 368,047 km
- 23 04:20 Jupiter (mag. -1.5) 4.9°S of Moon
- 24 19:11 NEW MOON
- 26 19:44 Regulus 1.4°S of Moon
- 28 19:45 Mars (mag. 1.6) 1.3°N of Moon
- 30 α-Capricornid Meteor Shower maximum
- 30 Southern δ-Aquariid Meteor Shower maximum
- 31 05:45 Spica 1.0°N of Moon

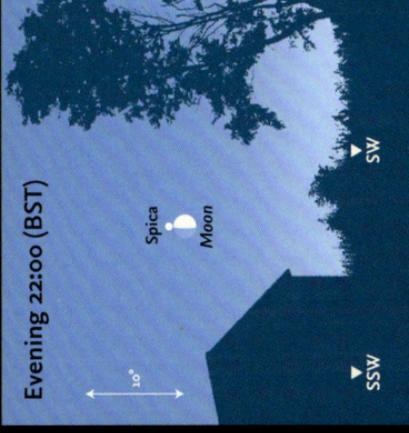

3 July • Spica is less than 1° north of the Moon, low in the southwestern sky.

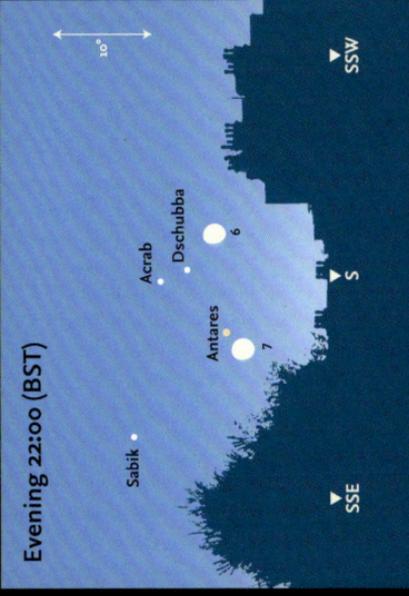

6-7 July • The Moon passes Acrab (β Sco), Dschubba (δ Sco) and Antares. Sabik (η Oph) is also nearby.

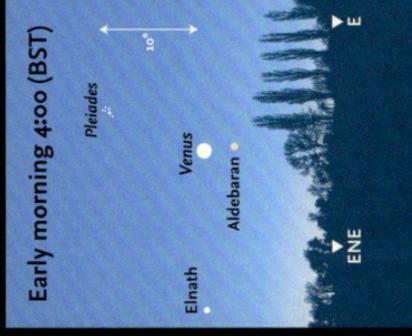

13 July • Just before dawn, Venus (mag. -4.1) is close to Aldebaran, low in the east.

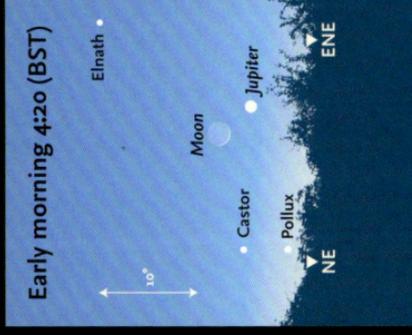

23 July • The thin crescent Moon is close to Jupiter. Castor and Pollux may be too low to be visible.

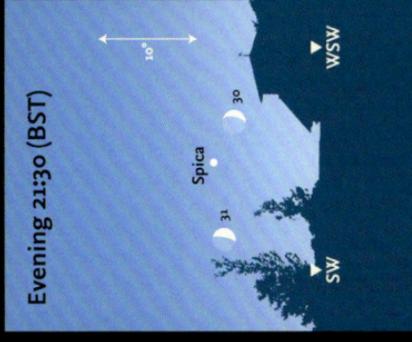

30-31 July • Low in the southwest, the waxing crescent Moon passes Spica

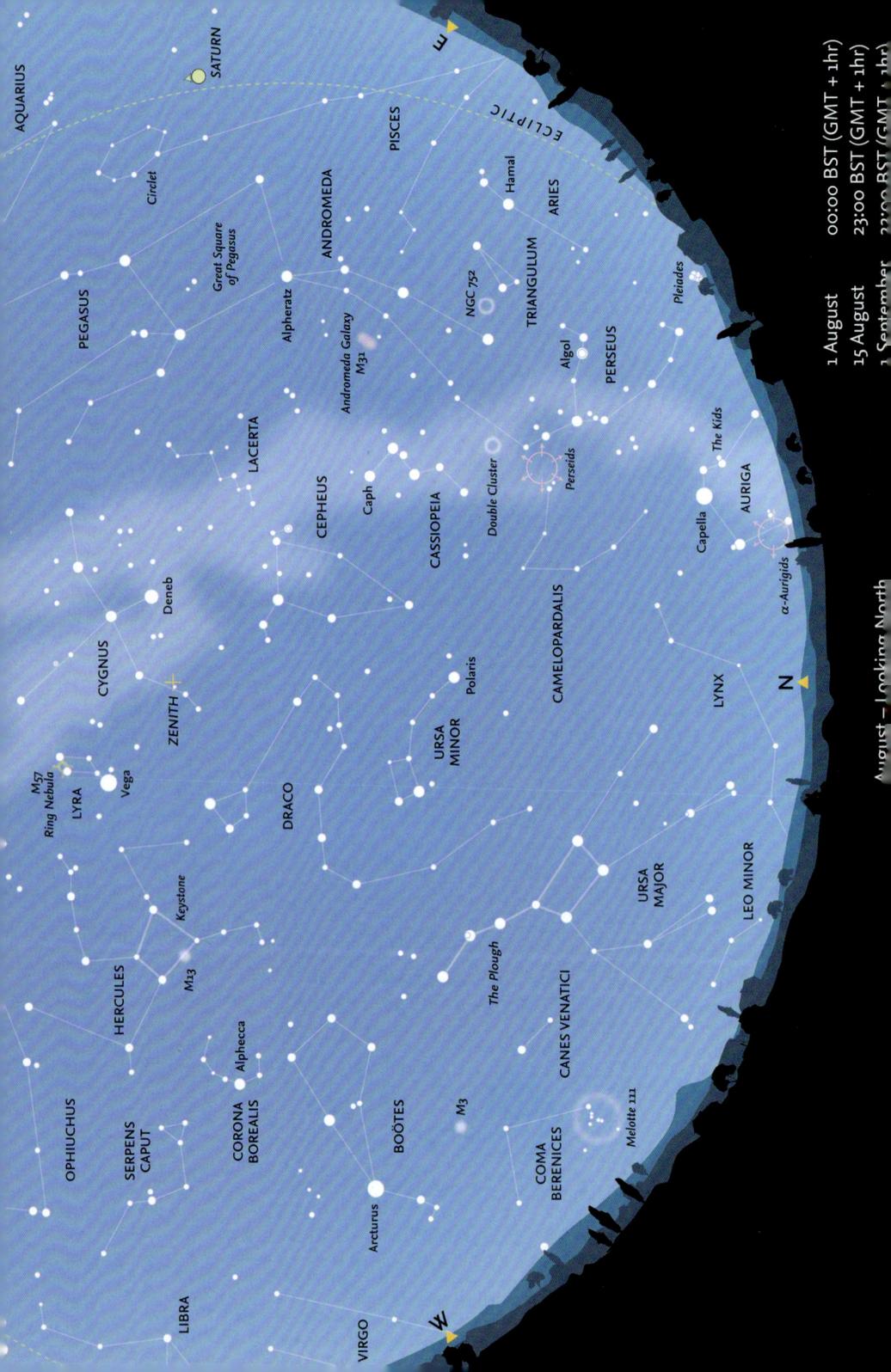

AQUARIUS

SATURN

♃

ECLIPTIC

PEGASUS

Circlet

Great Square of Pegasus

ALPHE RATZ

ANDROMEDA

Andromeda Galaxy M31

PISCES

ARIES

TRIANGULUM

PERSEUS

Pleiades

LACERTA

CEPHEUS

Caph

CASSIOPEIA

Double Cluster

PERSEIDS

The Kids

AURIGA

CYGNUS

Deneb

ZENITH

DRACO

URSA MINOR

Polaris

CAMELOPARDALIS

Capella

α-Aurigids

M57 Ring Nebula

LYRA

Vega

HERCULES

Keystone

M13

DRACO

URSA MINOR

Polaris

CAMELOPARDALIS

Capella

α-Aurigids

OPHIUCHUS

SERPENS CAPUT

CORONA BOREALIS

Alphecca

BOÖTES

Arcturus

M3

THE PLOUGH

CANES VENATICI

Melotte 111

URSA MAJOR

LEO MINOR

LIBRA

VIRGO

♄

N

1 August 00:00 BST (GMT + 1hr)
 15 August 23:00 BST (GMT + 1hr)
 1 September 22:00 BST (GMT + 1hr)

August — Looking North

August – Looking North

Ursa Major is now the 'right way up' in the northwest, although some of the fainter stars in the south of the constellation are difficult to see. Beyond it, *Boötes* stands almost vertically in the west, but pale orange *Arcturus* is sinking towards the horizon. Higher in the sky, both *Corona Borealis* and *Hercules* are clearly visible.

In the northeast, *Capella* is clearly seen, but most of *Auriga* still remains below the horizon. Higher in the sky, *Perseus* is gradually coming into full view and, later in the night and later in the month, the beautiful *Pleiades* cluster rises above the northeastern horizon. Between *Perseus* and *Polaris* lies the faint and unremarkable constellation of *Camelopardalis*.

Higher still, both *Cassiopeia* and *Cepheus* are well placed for observation, despite the fact that *Cassiopeia* is completely immersed in the band of the Milky Way, as is the 'base' of *Cepheus*. *Pegasus* and *Andromeda* are now well above the eastern horizon and, below them, the constellation of *Pisces* is climbing into view. Two of the stars in the 'Summer Triangle', *Deneb* and *Vega*, are close to the zenith high overhead.

Meteors

August is the month when one of the best meteor showers of the year occurs: the *Perseids*. This is a long shower, generally beginning about 17 July and continuing until around 24 August, with a maximum on 12 August, when the rate may reach as high as 100 meteors per hour (and on rare occasions, even higher). In 2025, maximum is three days after Full Moon, so conditions are not favourable, particularly at dawn. The *Perseids* are debris from Comet 109P/Swift-Tuttle (the Great Comet of 1862). *Perseid* meteors are fast and many of the brighter ones leave persistent trains. Some bright fireballs also occur during the shower.

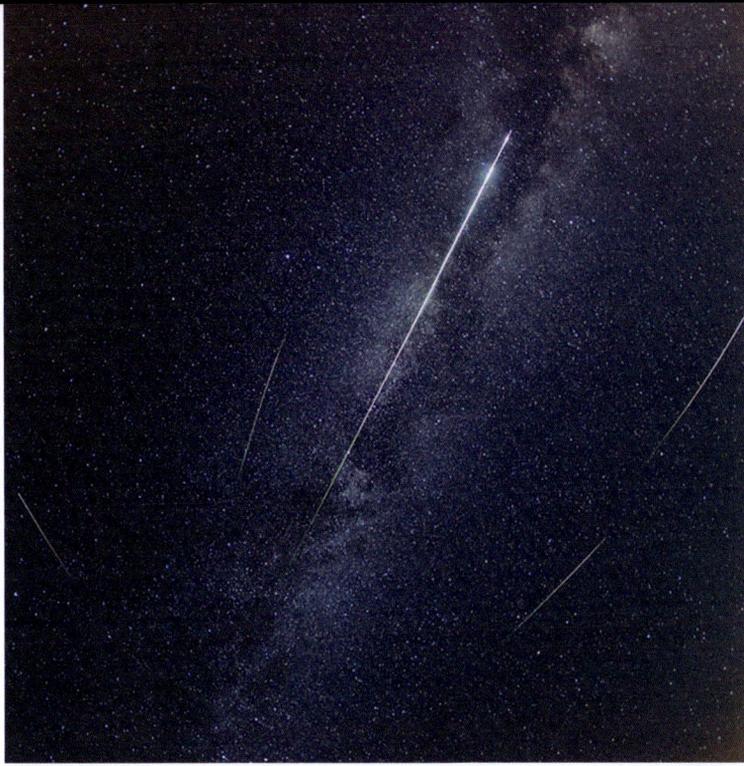

A brilliant *Perseid* fireball, streaking alongside the Great Rift in the Milky Way, photographed in 2012 by Jens Hackmann from near Weikersheim in Germany. Four additional fainter *Perseids* are also visible in the image.

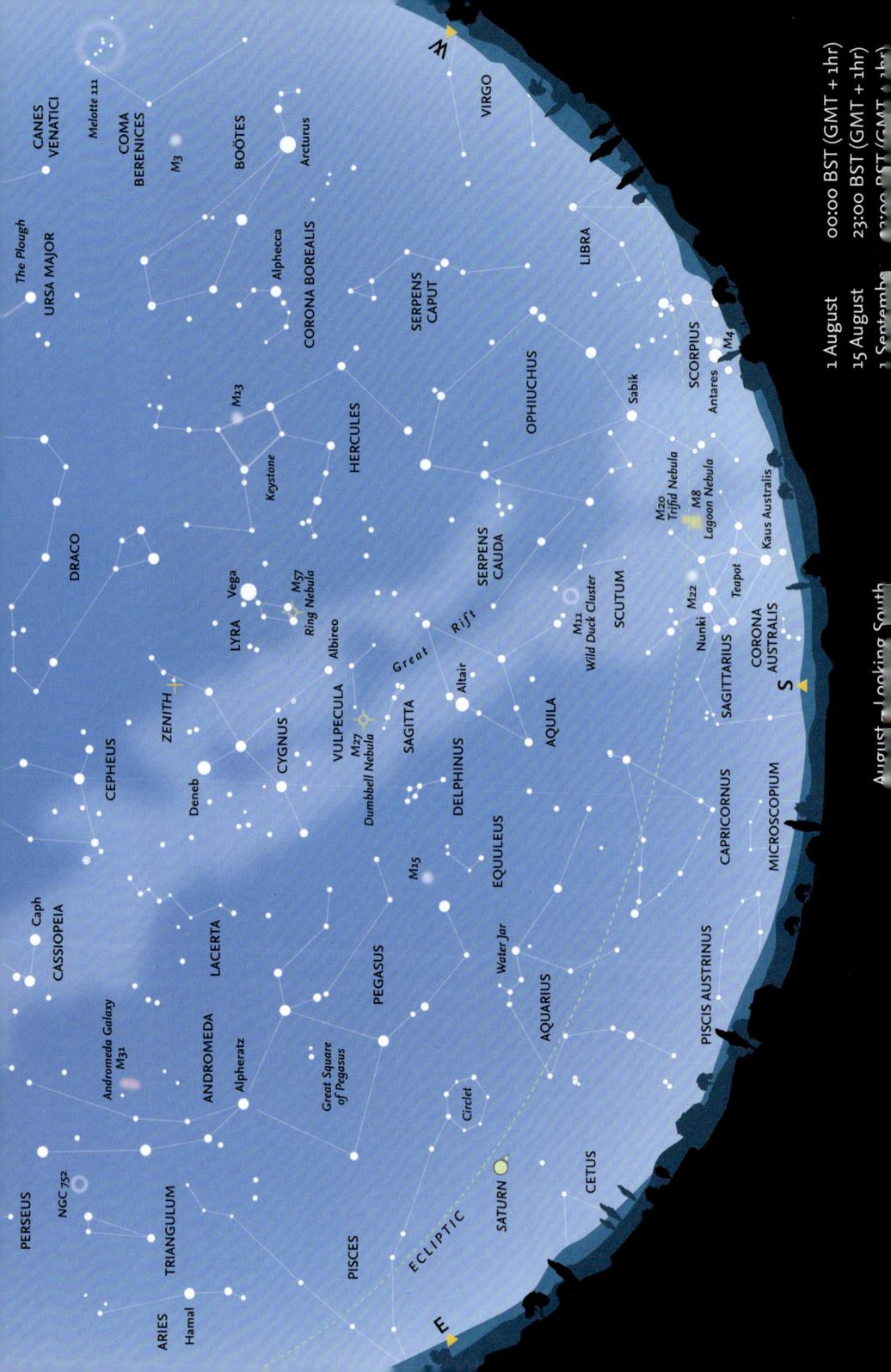

00:00 BST (GMT + 1hr)
23:00 BST (GMT + 1hr)
1 August
15 August
1 September

August - Looking South

The Plough

CANES
VENATICI

Melotte 111

COMA
BERENICES

M3

BOÖTES

Arcturus

Alphecca

CORONA BOREALIS

SERPENS
CAPUT

VIRGO

LIBRA

OPHIUCHUS

SCORPIUS

Antares

M4

M20
Trifid Nebula

M8
Lagoon Nebula

M13

Wild Duck Cluster

M11

Scutum

Sabik

Corona Australis

Kaus Australis

Teapot

Sagittarius

Nunki

M22

Corona Australis

S

Capricornus

Microscopium

Piscis Austrinus

Cetus

Aquarius

Equuleus

Delphinus

Sagitta

Vulpecula

Cygnus

Lyra

Vega

M57
Ring Nebula

Albireo

M27
Dumbbell Nebula

Sagitta

Altair

Great

Rigel

Serpens Cauda

Aquila

Water Jar

Great Square of Pegasus

Pegasus

M15

Delphinus

Equuleus

Aquarius

Cetus

Saturn

Ecliptic

Pisces

Triangulum

Andromeda

Lacerta

Cepheus

Zenith

Deneb

Cygnus

Vulpecula

Sagitta

Delphinus

Equuleus

Aquila

Sagittarius

Capricornus

Microscopium

Piscis Austrinus

Cetus

Aquarius

Equuleus

Delphinus

Sagitta

Vulpecula

Cygnus

Lyra

Vega

M57
Ring Nebula

Albireo

M27
Dumbbell Nebula

Sagitta

Altair

Great

Rigel

Serpens Cauda

Aquila

Water Jar

Great Square of Pegasus

Pegasus

M15

Delphinus

Equuleus

Aquarius

Cetus

Saturn

Ecliptic

Pisces

Triangulum

Andromeda

Lacerta

Cepheus

Zenith

Deneb

Cygnus

Vulpecula

Sagitta

Delphinus

Equuleus

Aquila

Sagittarius

Capricornus

Microscopium

Piscis Austrinus

Cetus

Aquarius

Equuleus

Delphinus

Sagitta

Vulpecula

Cygnus

Lyra

Vega

M57
Ring Nebula

Albireo

M27
Dumbbell Nebula

Sagitta

Altair

Great

Rigel

Serpens Cauda

Aquila

Water Jar

Great Square of Pegasus

Pegasus

M15

Delphinus

Equuleus

Aquarius

Cetus

Saturn

Ecliptic

Pisces

Triangulum

Andromeda

Lacerta

Cepheus

Zenith

Deneb

Cygnus

Vulpecula

Sagitta

Delphinus

Equuleus

Aquila

Sagittarius

Capricornus

Microscopium

Piscis Austrinus

Cetus

Aquarius

Equuleus

Delphinus

Sagitta

Vulpecula

Cygnus

Lyra

Vega

M57
Ring Nebula

Albireo

M27
Dumbbell Nebula

Sagitta

Altair

Great

Rigel

Serpens Cauda

Aquila

Water Jar

Great Square of Pegasus

Pegasus

M15

Delphinus

Equuleus

Aquarius

Cetus

Saturn

Ecliptic

Pisces

Triangulum

Andromeda

Lacerta

Cepheus

Zenith

Deneb

Cygnus

Vulpecula

Sagitta

Delphinus

Equuleus

Aquila

Sagittarius

Capricornus

Microscopium

Piscis Austrinus

Cetus

Aquarius

Equuleus

Delphinus

Sagitta

Vulpecula

Cygnus

Lyra

Vega

M57
Ring Nebula

Albireo

M27
Dumbbell Nebula

Sagitta

Altair

Great

Rigel

Serpens Cauda

Aquila

Water Jar

Great Square of Pegasus

Pegasus

M15

Delphinus

Equuleus

Aquarius

Cetus

Saturn

Ecliptic

Pisces

Triangulum

Andromeda

Lacerta

Cepheus

Zenith

Deneb

Cygnus

Vulpecula

Sagitta

Delphinus

Equuleus

Aquila

Sagittarius

Capricornus

Microscopium

Piscis Austrinus

Cetus

Aquarius

Equuleus

Delphinus

Sagitta

Vulpecula

Cygnus

Lyra

Vega

M57
Ring Nebula

Albireo

M27
Dumbbell Nebula

Sagitta

Altair

Great

Rigel

Serpens Cauda

Aquila

Water Jar

Great Square of Pegasus

Pegasus

M15

Delphinus

Equuleus

Aquarius

Cetus

Saturn

Ecliptic

Pisces

Triangulum

Andromeda

Lacerta

Cepheus

Zenith

Deneb

Cygnus

Vulpecula

Sagitta

Delphinus

Equuleus

Aquila

Sagittarius

Capricornus

Microscopium

Piscis Austrinus

Cetus

Aquarius

Equuleus

Delphinus

Sagitta

Vulpecula

Cygnus

Lyra

Vega

M57
Ring Nebula

Albireo

M27
Dumbbell Nebula

Sagitta

Altair

Great

Rigel

Serpens Cauda

Aquila

Water Jar

Great Square of Pegasus

Pegasus

M15

Del

August – Looking South

The whole of the summer Milky Way stretches across the sky in the south, from **Cygnus**, high in the sky near the zenith, past **Aquila**, with bright **Altair** (α Aquilae), to part of the constellation of **Sagittarius** close to the horizon, where the pattern of stars known as the “Teapot” is visible. This area contains many nebulae and both open and globular clusters. Between **Albireo** (β Cygni) and Altair lie the two small constellations of **Vulpecula** and **Sagitta**, with the latter easier to distinguish (because of its shape) from the clouds of the Milky Way. Between Sagitta and **Pegasus** to the east lie the highly distinctive five stars that form the tiny constellation of **Delphinus** (again, one of the few constellations that actually bears some resemblance to the creature after which it is named). Below Aquila, mainly in the star clouds of the Milky Way, lies **Scutum**, most famous for the bright open cluster, **M11** or the ‘Wild Duck Cluster,’ readily visible in binoculars. To the southeast of Aquila lie the two zodiacal constellations of **Capricornus** and **Aquarius**.

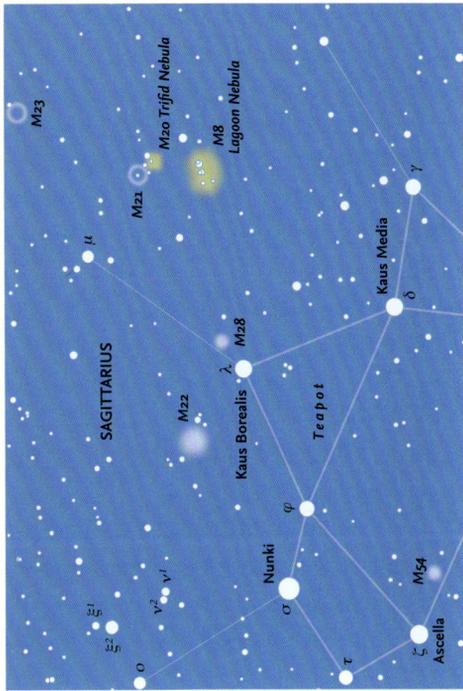

A finder chart for the gaseous nebulae M8 (the Lagoon Nebula), M20 (the Trifid Nebula) and the globular cluster M22, all in Sagittarius. Clusters M21, M23 (open) and M28 (globular) are faint. The chart shows all stars brighter than magnitude 7.5.

The Moon's phases for August 2025

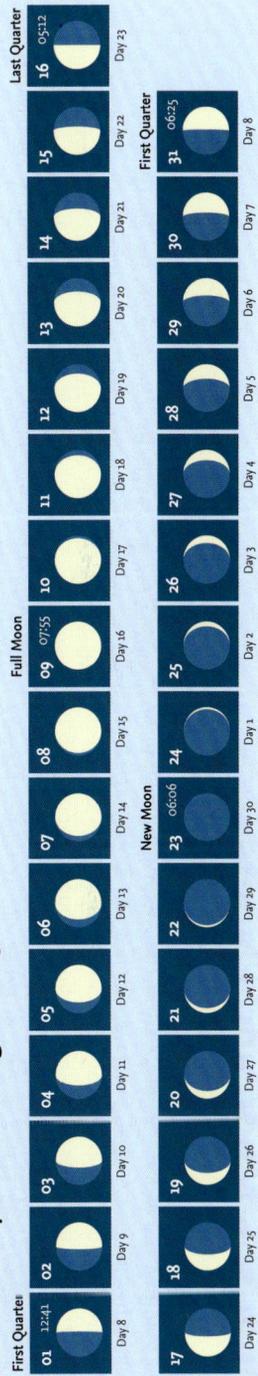

August – Moon and Planets

The Moon

On 1 August the Moon is First Quarter. The Moon passes south of **Antares** by 0.6° on 4 August, five days later it is full. On 12 August the Moon will be 4.0° N of **Saturn** (mag. 0.7). On 16 August the Moon is Last Quarter. Three days later the waning gibbous Moon will appear 4.8° N of **Jupiter** (mag. -2.0). The following day the Moon passes less than 5° from **Venus** (mag. -4.0) and 2.4° S of **Pollux**. On 21 August **Mercury** (mag. -0.3) will be high in the morning sky, 3.7° S of the thin crescent Moon in the dawn sky. Three days after the New Moon **Mars** (mag. 1.6) will appear 2.8° N of the waxing crescent Moon, setting shortly after the sunset. On 27 August the Moon and **Spica** are 1.1° apart and on 31 August the First Quarter Moon will be 0.7° S of **Antares**.

The Planets

Mercury (mag. -0.2) will be at greatest western elongation on 19 August. **Venus** (mag. -4.0) will be at its highest altitude in the morning sky. **Mars** (mag. 1.6) sets earlier in the evening as the month progresses. **Jupiter** (mag. -1.9 to -2.0) will be less than a degree from **Venus**, both in **Gemini**, on the morning of 12 August. **Saturn** (mag. 0.8 to 0.6) will be near **Neptune** (mag. 7.7) at dawn on 6 August in Pisces. **Uranus** (mag. 5.8 to 5.7) is in **Taurus**. Minor planet **(89) Julia** (mag. 8.5) is at opposition close to midnight on 10 August, and on the 26 August **(6) Hebe** (mag. 7.5) will be at opposition.

The path of the Sun and the planets along the ecliptic in August.

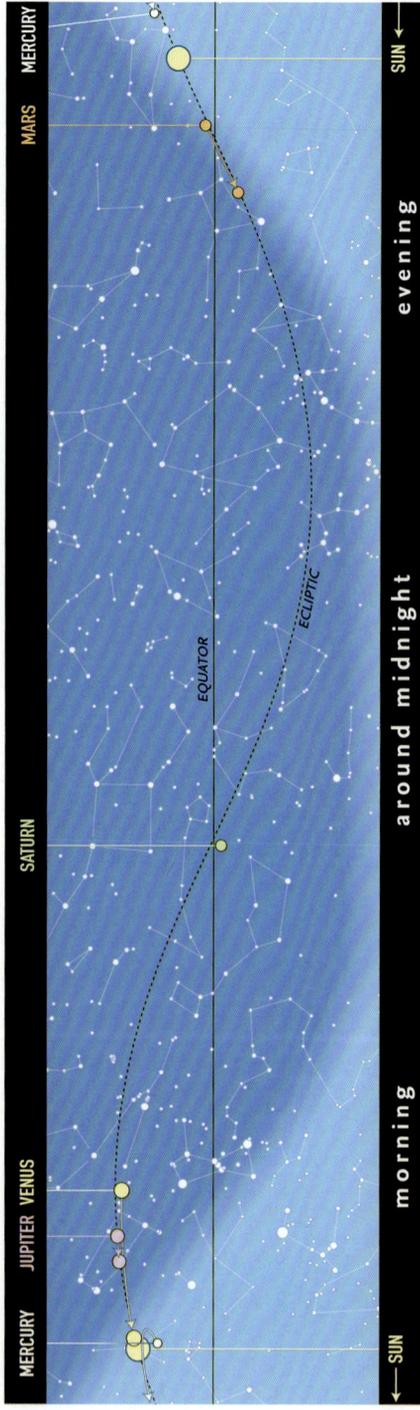

Calendar for August

01	12:41	FIRST QUARTER MOON
01	20:37	Moon at apogee: 404,164 km
04	01:40	Antares 0.6°N of Moon
09	07:55	FULL MOON
10	23:58	Minor planet (89) Julia at opposition (mag. 8.5)
12	07:00	Venus (mag. -4.0) 0.9°S of Jupiter
12	15:05	Saturn (mag. 0.7) 4.0°S of Moon
12		Perseid Meteor Shower maximum
14	18:01	Moon at perigee: 369,287 km
16	05:12	LAST QUARTER MOON
16	16:09	Pleiades 0.9°S of Moon
19	10:00	Mercury at greatest elong.: 18.6°W
19	21:05	Jupiter (mag. -2.0) 4.8°S of Moon
20	12:07	Pollux 2.4°N of Moon
21	16:14	Mercury (mag. -0.3) 3.7°S of Moon
23	06:06	NEW MOON
26	13:53	Minor planet (6) Hebe at opposition (mag. 7.5)
26	16:41	Mars (mag. 1.6) 2.8°N of Moon
27	12:00	Mercury at perihelion
27	13:57	Spica 1.1°N of Moon
29	15:34	Moon at apogee: 404,552 km
31	06:25	FIRST QUARTER MOON
31	09:55	Antares 0.7°N of Moon

AUGUST

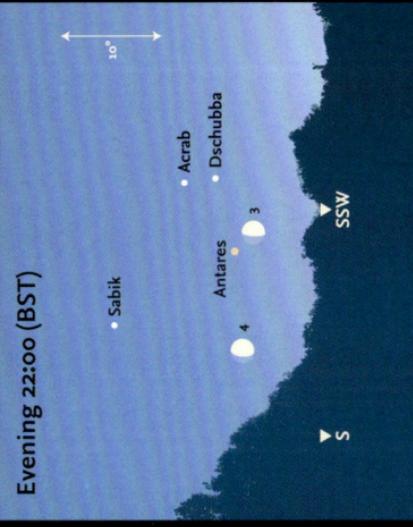

3-4 August • The waxing gibbous Moon passes Antares, low in the south-southwest. Acrab (β Sco), Dschubba (δ Sco) and Sabik (η Oph) are nearby.

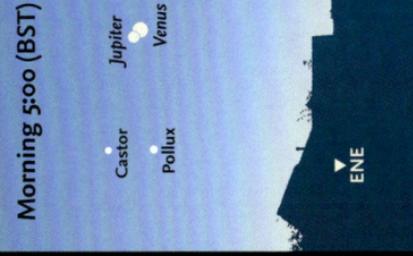

12 August • Venus (mag. -4.0) and Jupiter (mag. -1.9) are close together in the constellation of Gemini, with Betelgeuse (α Ori) a little farther south.

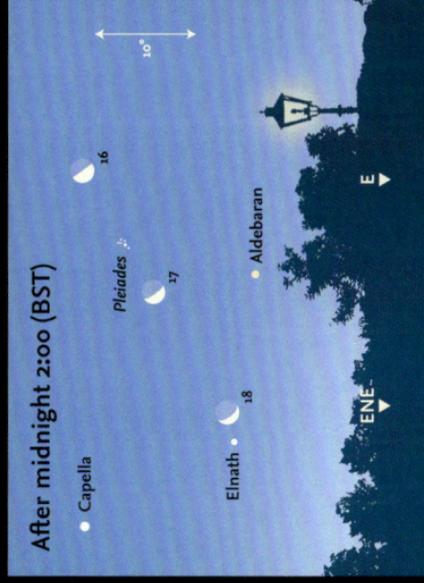

16-18 August • Shortly after Last Quarter, the Moon passes the Pleiades and moves towards Elnath. Aldebaran is closer to

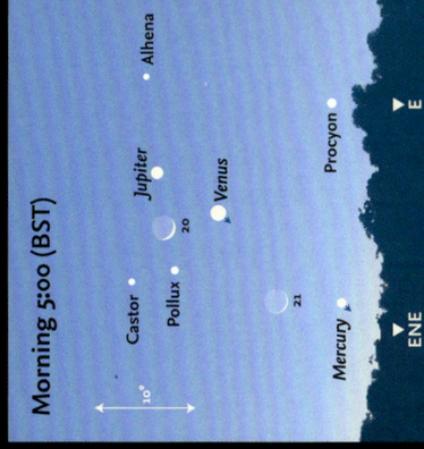

20-21 August • The crescent Moon passes through Gemini, close to Jupiter and Venus.

September – Looking North

The (northern) autumnal equinox occurs on 22 September, when the Sun moves south of the equator in Virgo.

Ursa Major is now low in the north and to the northwest **Arcturus** and much of **Boötes** sink below the horizon later in the night and later in the month. In the northeast, **Auriga** is beginning to climb higher in the sky. Later in the month, **Taurus**, with orange **Aldebaran** (α Tauri), and even **Gemini**, with **Castor** and **Pollux**, become visible in the east and northeast. Due east, **Andromeda** is now clearly visible, with the small constellations of **Triangulum** and **Aries** (the latter a zodiacal constellation) directly below it. Practically the whole of the northern Milky Way is visible, arching across the sky, both in the north and in the south. It is not particularly clear in Auriga, or even **Perseus**, but in **Cassiopeia** and towards **Cygnus** the clouds of stars become easier to see. The **Double Cluster** in Perseus is well placed for observation. **Cepheus** is 'upside-down' near the zenith, and the head of **Draco** and **Hercules** (with the globular cluster **M13**) beyond it are also nicely positioned.

Meteors

After the major Perseid shower in August, there is very little shower activity in September. One minor but very extended shower, known as the **α -Aurigids**, tends to have two peaks of activity. The principal peak occurs on 31 August. In 2025, the Moon will be First Quarter, so conditions are unfavourable until a few hours before midnight – the best time to look for the meteors would be early the following morning. At maximum, however, the hourly rate hardly reaches 10 meteors per hour, although the meteors are bright and relatively easy to photograph. The **Southern Taurid** shower begins this month (on 10 September) and, although rates are low, often produces very bright fireballs. This is a very long shower, lasting until about 20 November. As a slight compensation for the lack of shower activity, however, in September the number of sporadic meteors reaches its highest rate of the year.

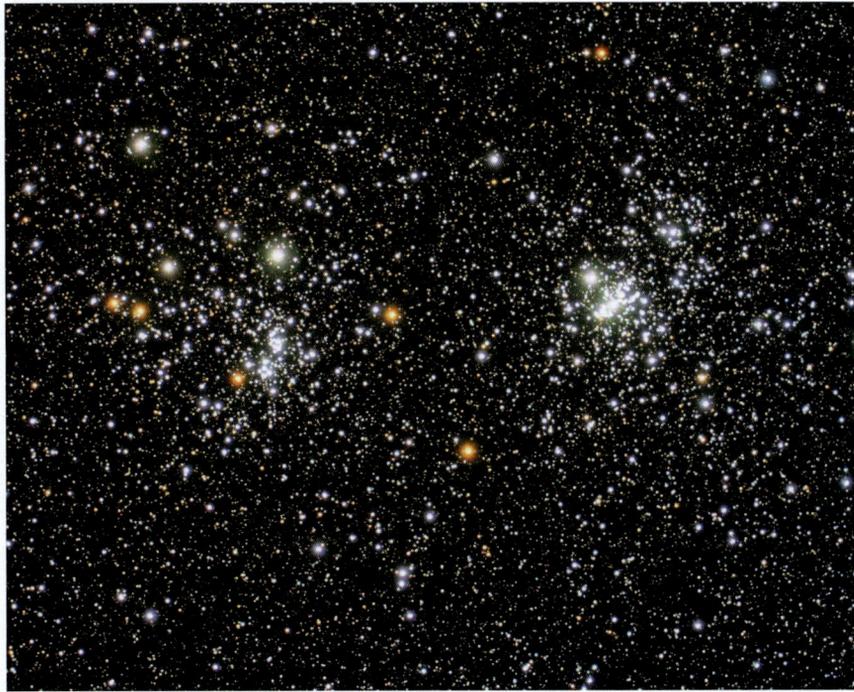

The twin open clusters, known as the Double Cluster, in Perseus (more formally called η and χ Perse) are close to the main portion of the Milky Way.

September – Looking South

The 'Summer Triangle' is now high in the southwest, with the Great Square of *Pegasus* high in the southeast. Below *Pegasus* are the two zodiacal constellations of *Capricornus* and *Aquarius*. In what is otherwise an unremarkable constellation, **Algedi** (α Capricorni) is actually a visual binary, with the two stars (α^1 Cap and α^2 Cap) readily seen with the naked eye. **Dabih** (β Capricorni), just to the south, is also a double star and the components are relatively easy to separate with binoculars. In *Aquarius*, just to the east of **Sadalmeik** (α Aquarii) there is a small asterism consisting of four stars, resembling a tiny letter 'Y', known as the 'Water Jar'. Below *Aquarius* is a sparsely populated area of the sky with just one bright star in the constellation of *Piscis Austrinus*. In classical illustrations, water is shown flowing from the 'Water Jar' towards bright **Fomalhaut** (α Piscis Austrini).

Another zodiacal constellation, *Pisces*, is now clearly visible to the east of *Aquarius*. Although faint, there is a distinctive asterism of stars, known as the 'Circlet', south of the Great Square and another line of faint stars to the east of *Pegasus*. Still farther down towards the horizon is the constellation of *Cetus*, with the famous variable star **Mira** (\omicron Ceti) at its

The constellations of *Pisces* and *Aries*. The 'Circlet' of *Pisces* is bottom right and the three main stars of *Aries*, top left. In 2025, *Uranus* will lie in *Aries* until 2 March.

centre. When *Mira* is at maximum brightness (around mag. 3.5) it is clearly visible to the naked eye, but it disappears as it fades towards minimum (about mag. 9.5 or less). There is a finder chart for *Mira* on page 97.

The Moon's phases for September 2025

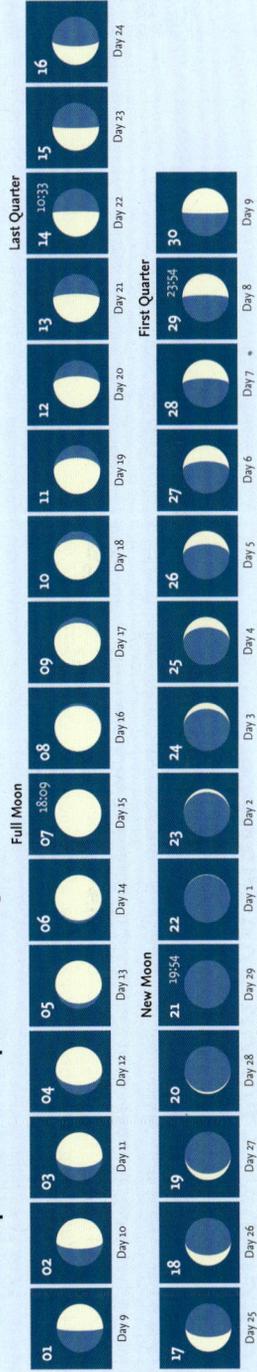

September – Moon and Planets

The Moon

A total lunar eclipse on 7 September will be visible from Asia, Russia, Africa and Europe, although from London the Moon will be below the horizon for part of the eclipse. The following day the Moon will be 4°N of **Saturn** (mag. 0.6), best seen shortly after midnight. On 14 September the Moon will be Last Quarter; two days later the Moon will pass 4.6°N of **Jupiter** (mag. -2.0) and 2.4°S of **Pollux**. On 19 September **Venus** (mag. -3.9) is occulted by the waning crescent Moon, visible from Africa, western Russia, Canada, Asia and Europe including London. The Moon will be 1.3°N of **Regulus** in the dawn sky of the same day. Two days after the New Moon on 23 September, the Moon and **Spica** are 1.1° apart, and the following day the crescent Moon and **Mars** (mag. 1.6) will be 3.9°

apart. On 27 September the Moon will lie 0.6°S of **Antares** in the early evening sky. The First Quarter Moon will occur on 29 September.

The Planets

Mercury (mag. -1.4 to -0.6) sets shortly after the sunset. **Venus** (mag. -3.9) is visible in the morning sky and moves from **Cancer** to **Leo** on 9 September. **Mars** (mag. 1.6) is best seen just after sunset. **Jupiter** (mag. -2.0 to -2.1) in **Gemini** is visible after midnight. **Saturn** (mag. 0.7 to 0.6) is at opposition on 21 September in **Pisces**. Its rings will appear close to edge-on. **Uranus** (mag. 5.7) enters retrograde motion in **Taurus** on 6 September. **Neptune** (mag. 7.7) will reach opposition on 23 September in **Pisces**.

The path of the Sun and the planets along the ecliptic in September.

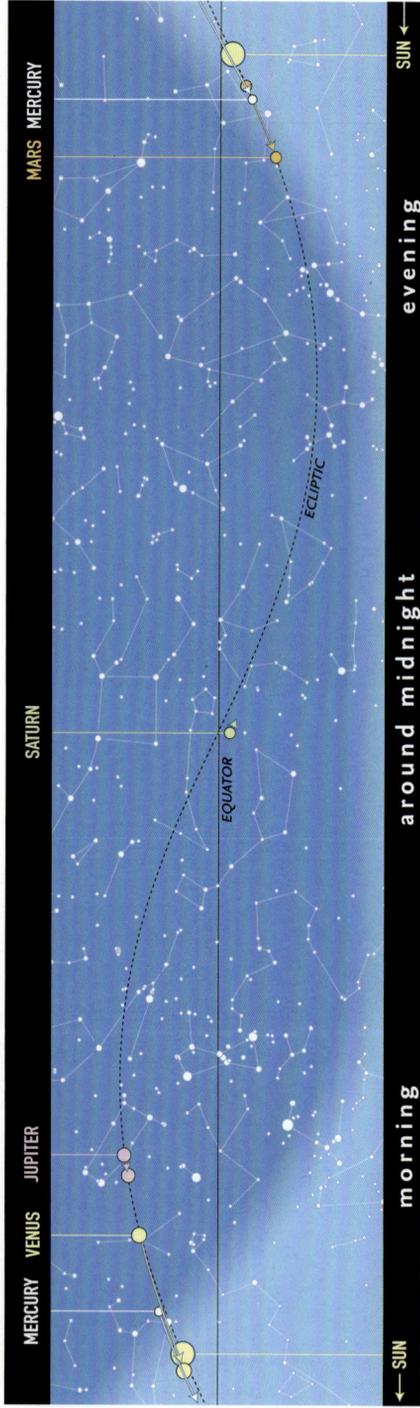

Calendar for September

- 07 18:09 FULL MOON
- 07 18:12 Total lunar eclipse; mag. 1.362
- 08 20:09 Saturn (mag. 0.5) 4.0°S of Moon
- 10 12:09 Moon at perigee: 364,781 km
- 12 21:43 Pleiades 1.0°S of Moon
- 13 03:28 Mars (mag. 1.6) 2.0°N of Spica
- 14 10:33 LAST QUARTER MOON
- 16 11:06 Jupiter (mag. -2.0) 4.6°S of Moon
- 16 17:58 Pollux 2.4°N of Moon
- 19 08:57 Venus (mag. -3.9) 0.4°N of Regulus
- 19 11:11 Regulus 1.3°S of Moon
- 19 11:46 Venus (mag. -3.9) 0.8°S of Moon
An occultation will be visible from Europe
- 21 05:00 Saturn at opposition
- 21 19:42 Partial solar eclipse; mag. 0.855
- 21 19:54 NEW MOON
- 22 18:20 Autumnal Equinox
- 23 11:00 Neptune at opposition (mag. 7.7)
- 23 21:31 Spica 1.1°N of Moon
- 24 14:50 Mars (mag. 1.6) 3.9°N of Moon
- 26 09:46 Moon at apogee: 405,552 km
- 27 17:34 Antares 0.6°N of Moon
- 29 23:54 FIRST QUARTER MOON

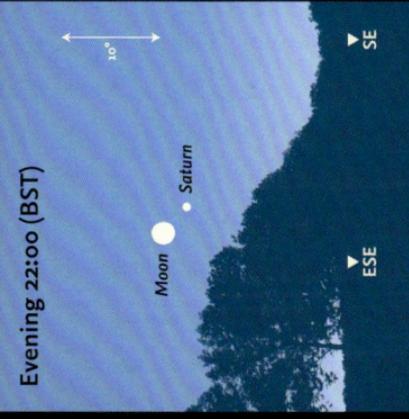

8 September • The Moon meets Saturn (mag. 0.6) in the east-southeast. The Moon is about 20° above the horizon.

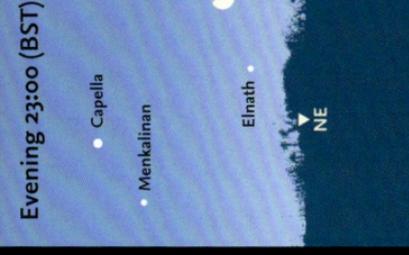

12-13 September • The Moon passes the Pleiades and moves towards Elnath, Capella (α Aur) and Menkalinan (β Aur) are higher in the northeast.

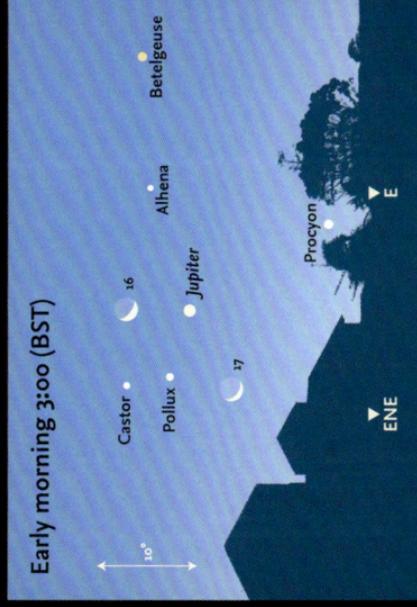

16-17 September • The waning crescent Moon moves between Jupiter (mag. -2.1) and the Twin Stars (Castor and Pollux). Procyon is very close to the horizon and almost due east.

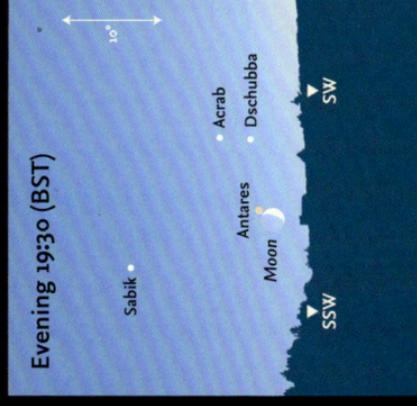

27 September • The Moon and Antares are close to the horizon. Acrab and Dschubba are further west but may not be visible at dusk.

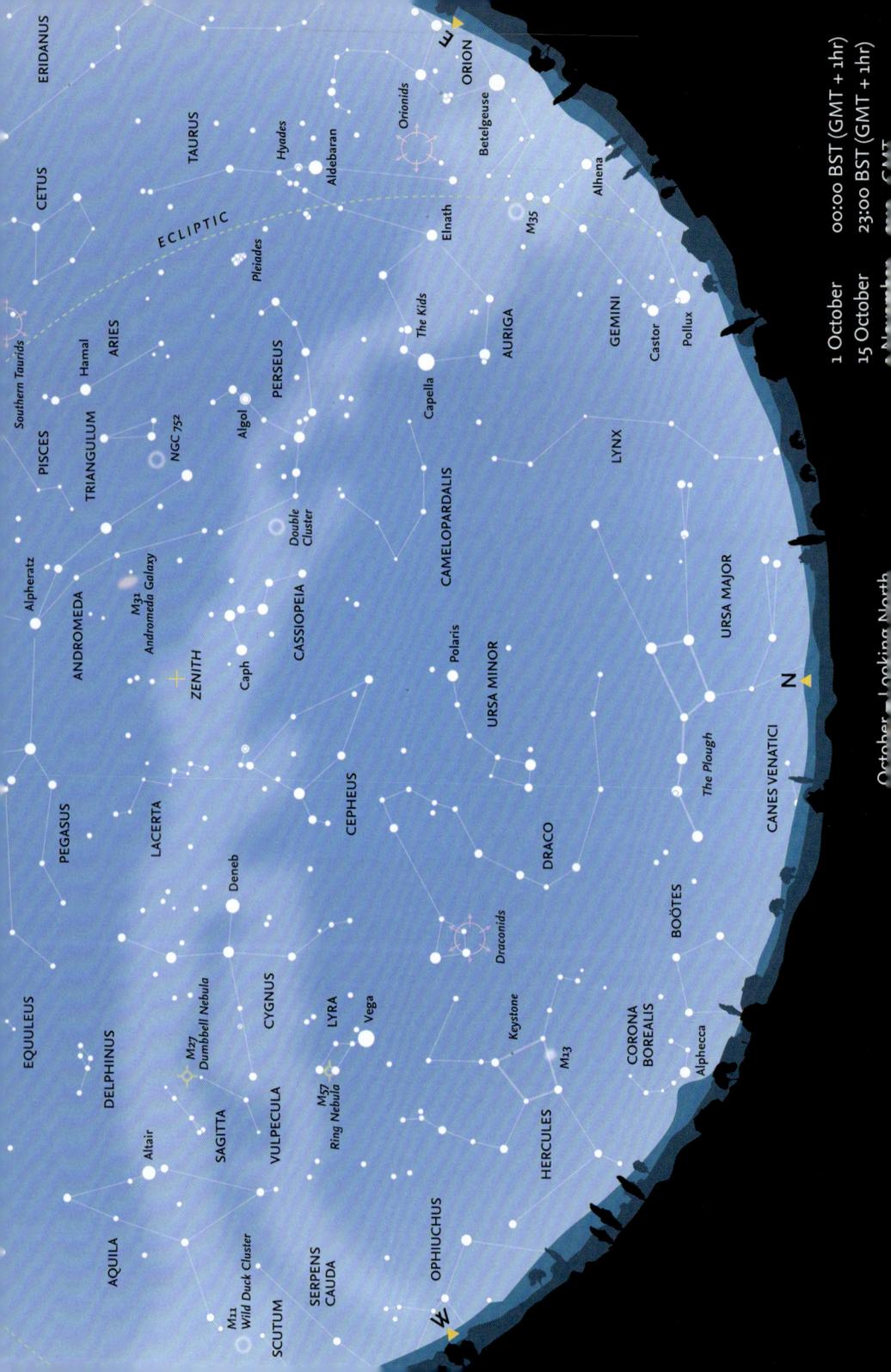

ERIDANUS

CETUS

TAURUS

ARIES

PERSEUS

ORION

LYRA

CEPHEUS

DRACO

BOÖTES

HERCULES

OPHIUCHUS

SERPENS CAUDA

SCUTUM

AQUILA

DELPHINUS

EQUULEUS

PEGASUS

LACERTA

CYGNUS

VULPECULA

SAGITTA

ANDROMEDA

TRIANGULUM

Hamal

NGC 752

Algol

Capella

Double Cluster

Andromeda Galaxy

M31

Caph

ZENITH

Deneb

M27

Dumbbell Nebula

Altair

M11

Wild Duck Cluster

M57

Ring Nebula

LYRA

Vega

M13

Alphecca

Alpheratz

ECLIPTIC

Pleiades

Hyades

Aldebaran

Orionids

Betelgeuse

Rigel

Antares

Alnilam

Saiph

Thetis

Orionids

Alnilam

Rigel

Betelgeuse

Alnilam

Rigel

Alnilam

Hyades

Aldebaran

Orionids

Betelgeuse

Rigel

Antares

Alnilam

Saiph

Thetis

Orionids

Alnilam

Rigel

Betelgeuse

Alnilam

Rigel

Betelgeuse

Alnilam

Rigel

Betelgeuse

Alnilam

Rigel

Alnilam

Rigel

Betelgeuse

October – Looking North

Ursa Major is grazing the horizon in the north, while high overhead are the constellations of *Cepheus*, *Cassiopeia* and *Perseus*, with the Milky Way between *Cepheus* and *Cassiopeia* near the zenith. *Auriga* is now clearly visible in the east, as is *Taurus* with the *Pleiades*, *Hyades* and orange *Aldebaran*. Also in the east, *Orion* and *Gemini* are starting to rise clear of the horizon.

The constellations of *Boötes* and *Corona Borealis* are now essentially lost to view in the northwest, and *Hercules* is also descending towards the western horizon. The three stars of the Summer Triangle are still clearly visible, although *Aquila* and *Altair* are beginning to approach the horizon in the west. Towards the end of the month (26 October) Summer Time ends in Europe, with Britain reverting to Greenwich Mean Time and Europe to Central European Time.

Meteors

The *Orionids* are the major, fairly reliable meteor shower active in October. Like the May *η -Aquariid* shower, the *Orionids* are associated with Comet 1P/Halley. During this second pass through the stream of particles from the comet, slightly fewer meteors are seen than in May, but conditions are more favourable for northern observers. In both showers the meteors are very fast and many leave persistent trains. Although the *Orionid* maximum is quoted as 22 October, in fact there is a very broad maximum, lasting about a week and roughly centred on that date, with hourly rates around 15. In 2025, the Moon is New, resulting in dark skies.

The faint shower of the *Southern Taurids* (often with bright fireballs) peaks on 10 October. The Southern Taurid maximum occurs when the Moon is a waning gibbous, so visibility will be affected by its brightness particularly in the early hours after midnight. Towards the end of the

The constellation of Perseus is not only the location of the radiant of the Perseid meteor shower in August, but is also well known for the pair of open clusters, called the Double Cluster (near the top edge of the image), close to the border with Cassiopeia, and also for Algol (β Persei), the famous variable star (just below the centre of the photograph).

month (around 20 October), another shower (the **Northern Taurids**) begins to show activity, which peaks early in November. The parent comet for both Taurid showers is Comet 2P/Encke. The meteors in both Taurid streams are relatively slow and bright.

A minor shower, the **Draconids**, begins on 6 October and peaks on 8 October.

October – Looking South

The Great Square of *Pegasus* dominates the southern sky, framed by the two chains of stars that form the constellation of *Pisces*, together with *Alrescha* (α Piscium) at the point where the two lines of stars join. Also clearly visible is the constellation of *Cetus*, below *Pegasus* and *Pisces*. Although *Capricornus* is beginning to disappear, *Aquarius* to its east is well placed in the south, with solitary *Fomalhaut* and the constellation of *Piscis Austrinus* beneath it, close to the horizon.

The main band of the Milky Way and the Great Rift runs down from *Cygnus*, through *Vulpecula*, *Sagitta* and *Aquila* towards the western horizon. *Delphinus* and the tiny, unremarkable constellation of *Equuleus* lie between the band of the Milky Way and *Pegasus*. *Andromeda* is clearly visible high in the sky to the southeast, with the small constellation of *Triangulum* and the zodiacal constellation of *Aries* below it. *Perseus* is high in the east, and by now the *Pleiades* and *Taurus* are well clear of the horizon. Later in the night, and later in the month, *Orion* rises in the east, a sign that the autumn season has arrived and winter is approaching.

The constellation of *Aquarius* is one of the constellations that is visible in late summer and early autumn. The four stars forming the 'Y'-shape of the 'Water Jar' may be seen to the east of *Sadalmelik* (α *Aquarii*), the brightest star (top centre).

The Moon's phases for October 2025

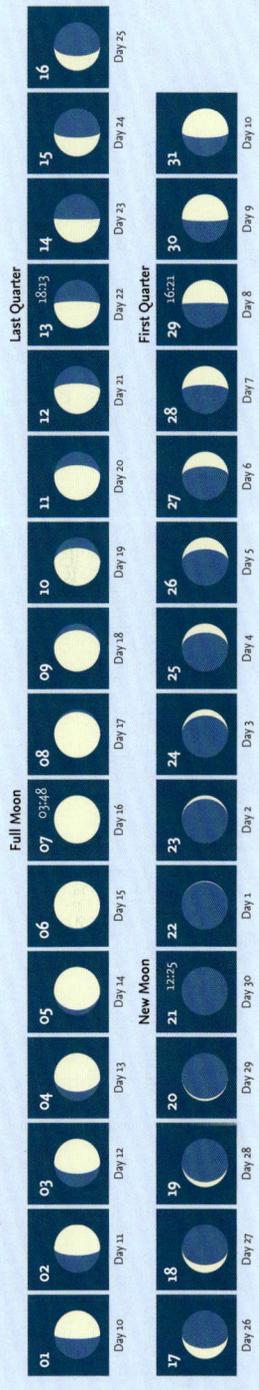

October – Moon and Planets

The Moon

On 6 October the Moon and **Saturn** (mag. 0.6) will be 3.8° apart, a day later the Moon will be full. On the 13th the Moon will be Last Quarter and will lie just over 4°N of **Jupiter** (mag. -2.2) and 2.5°S of **Pollux**. Three days later the Moon is 1.3°N of **Regulus**. On 19 October the waning crescent Moon will pass 3.7°S of **Venus** (mag. -3.9), visible in the dawn sky. After the New Moon on 21 October, the thin crescent Moon will be 4.5°S of **Mars** (mag. 1.4) and two days later it will appear 2.3°S of **Mercury**. On 25 October the Moon moves less than a degree from **Antares** and on 29 October the Moon will be First Quarter.

The planets

Mercury is at greatest eastern elongation on 29 October, at mag. -0.1. In **Libra**, Mercury passes just over 2°S of Mars on 21 October, during the day. **Venus** (mag. -3.9) moves from **Leo** to **Virgo** on 8 October, visible shortly before sunrise. **Mars** (mag. 1.6 to 1.4) sets shortly after the sunset in **Libra**. **Jupiter** (mag. -2.1 to -2.3) is bright in the dawn sky lying in **Gemini**. **Saturn** (mag. 0.6 to 0.8) is visible in **Aquarius** throughout the night. **Uranus** (mag. 5.7 to 5.6) is in **Taurus** and **Neptune** (mag. 7.7) is in **Pisces**. Minor planet (1) **Ceres** (mag. 7.6) is at opposition on 3 October.

The path of the Sun and the planets along the ecliptic in October.

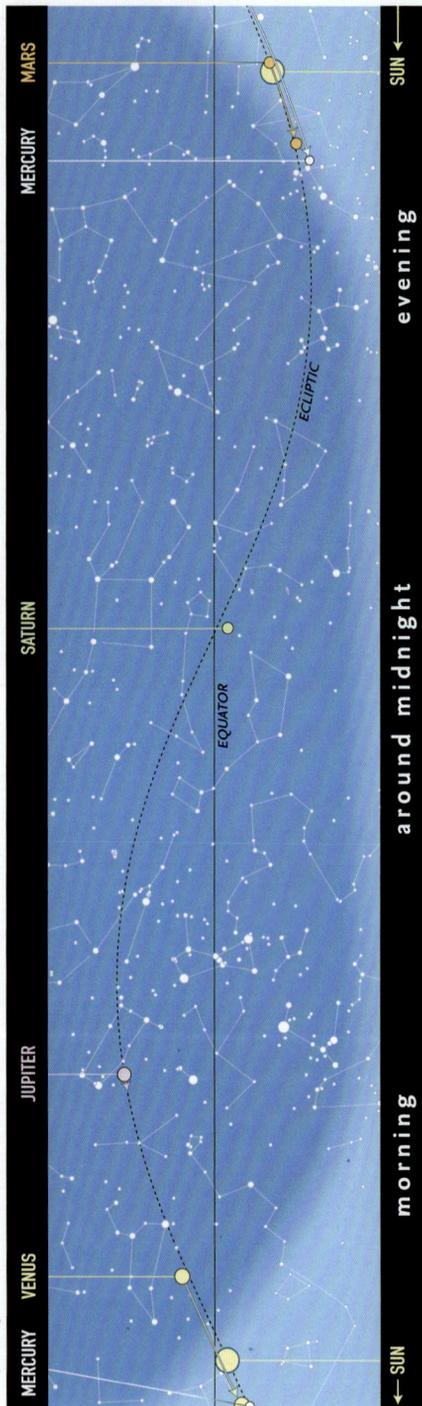

Calendar for October

02	11:00	Venus at perihelion
03	03:23	Dwarf planet (1) Ceres at opposition (mag. 7.6)
06	02:46	Saturn (mag. 0.6) 3.8°S of Moon
07	03:48	FULL MOON
08	12:36	Moon at perigee: 359,819 km
10	05:20	Pleiades 0.9°S of Moon
10		Southern Taurid Meteor Shower maximum
13	18:13	LAST QUARTER MOON
13	22:31	Jupiter (mag. -2.2) 4.3°S of Moon
13	23:31	Pollux 2.5°N of Moon
16	16:56	Regulus 1.3°S of Moon
19	20:00	Mercury (mag. -0.2) 2.0°S of Mars
19	21:37	Venus (mag. -3.5) 3.7°N of Moon
21	12:25	NEW MOON
22		Orionid Meteor Shower maximum
23	16:15	Mercury (mag. -0.2) 2.3°N of Moon
23	23:31	Moon at apogee 406,445 km
25	00:15	Antares 0.5°N of Moon
29	16:21	FIRST QUARTER MOON
29	22:00	Mercury at greatest elong.: 23.9°E

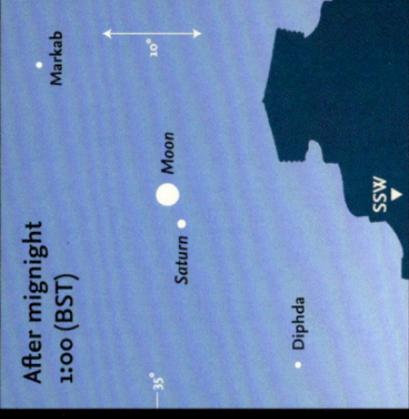

After midnight
1:00 (BST)

6 October • The Moon almost Full, when it meets Saturn (mag. 0.6), halfway between Markab (α Peg) and Diphda (β Cet).

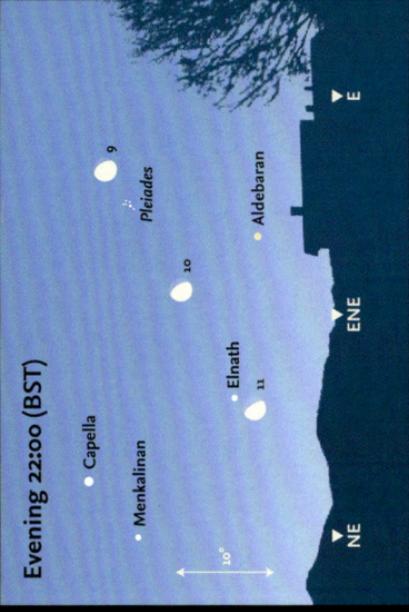

Evening 22:00 (BST)

9-11 October • The Moon passes the Pleiades and Elnath (β Tau). Aldebaran, Capella and Menkaliman (β Aur) are nearby.

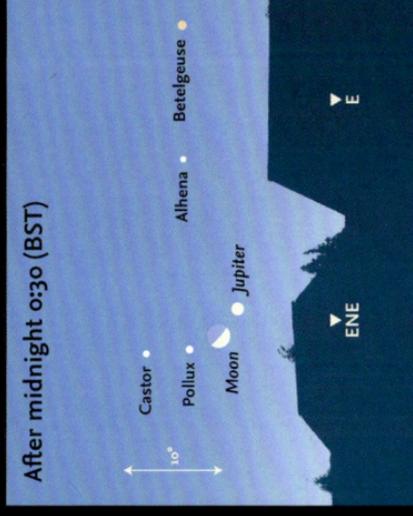

After midnight 0:30 (BST)

14 October • The Last Quarter Moon is between Jupiter (mag. -2.2) and the Twin Stars (Castor and Pollux).

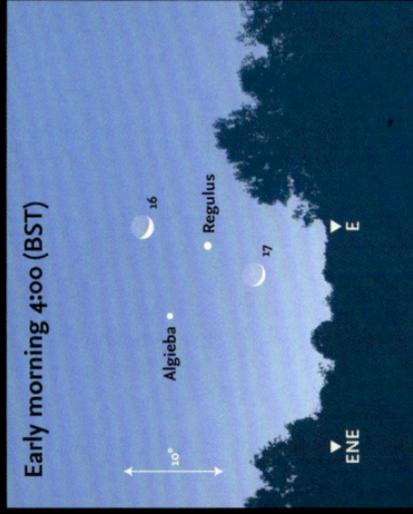

Early morning 4:00 (BST)

16-17 October • In the early morning the crescent Moon passes between Regulus and Algieba (γ Leo), almost due east.

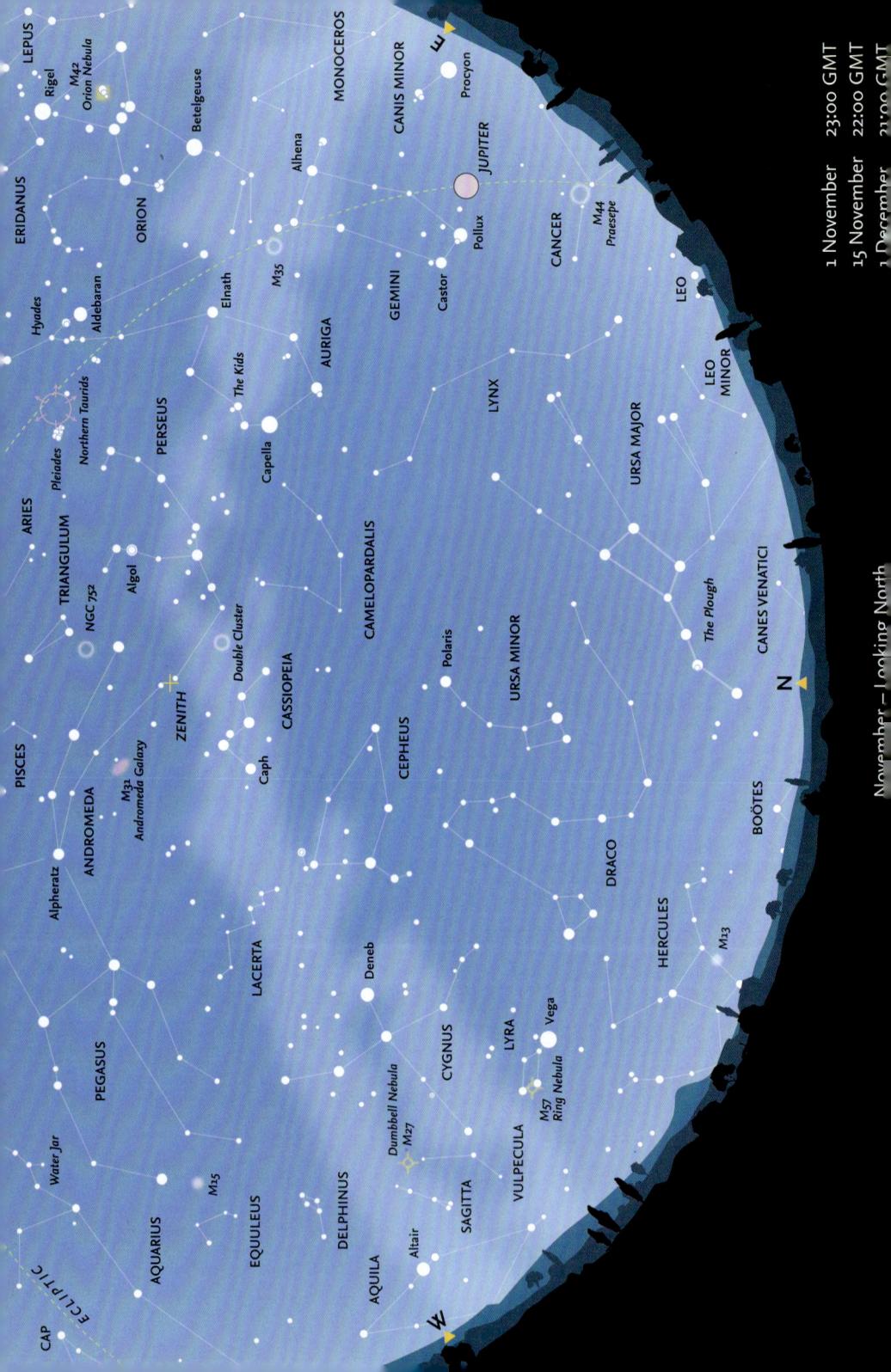

LEPUS
ERIDANIUS
ORION
MONOCEROS
CANIS MINOR
JUPITER
CANCER
LEO
LEO MINOR

Rigel
M42
Orion Nebula
Hyades
Aldebaran
Betelgeuse
Alhena
Pollux
Procyon
M44
Praesepe

PERSEUS
AURIGA
GEMINI
LYNX
URSA MAJOR
URSA MINOR

ARIES
TRIANGULUM
CAMELOPARDALIS
URSA MINOR
URSA MAJOR

PISCES
ANDROMEDA
CASSIOPEIA
URSA MINOR
URSA MAJOR

ANDROMEDA
ZENITH
CASSIOPEIA
URSA MINOR
URSA MAJOR

ANDROMEDA
CASSIOPEIA
URSA MINOR
URSA MAJOR

1 November 23:00 GMT
15 November 22:00 GMT
1 December 21:00 GMT

November - Looking North

N

W

ECLIPHTIC
CAP

ALPHARATZ
M31
ANDROMEDA GALAXY
M35
DOUBLE CLUSTER
M57
RING NEBULA
M52
DUMBBELL NEBULA
M27
VULPECULA
M13
HERCULES
BOOTES
CAMELOPARDALIS
CASSIOPEIA
CANCER
CANIS MINOR
CEPHEUS
CYGNUS
DELPHINUS
EQUULEUS
LACERTA
LYRA
LYNX
MONOCEROS
ORION
PERSEUS
PISCES
PLEIADES
PROCYON
SAGITTA
SAGITTARIUS
SCORPIO
TAURUS
TRIANGULUM
URSA MAJOR
URSA MINOR
VULPECULA
ZENITH

November – Looking North

Most of *Aquila* has now disappeared below the horizon, but two of the stars of the 'Summer Triangle', *Vega* in *Lyra* and *Deneb* in *Cygnus*, are still clearly visible in the west. The head of *Draco* is now low in the northwest and only a small portion of *Hercules* remains above the horizon. The southernmost stars of *Ursa Major* are now coming into view. The Milky Way arches overhead, with the denser star clouds in the west and the less heavily populated region through *Auriga* and *Monoceros* in the east. High overhead, *Cassiopeia* is near the zenith and *Cepheus* has swung round to the northwest, while *Auriga* is now high in the northeast. *Gemini*, with *Castor* and *Pollux*, is well clear of the eastern horizon, and even *Procyon* (α Canis Minoris) is just climbing into view almost due east.

Meteors

The **Northern Taurid** shower, which began in mid-October, reaches maximum – although only with a rate of about five meteors per hour – on 12 November. The Moon is Last Quarter, so conditions are not very favourable. The shower gradually trails off, ending around 10 December. There is an apparent 3- or 7-year periodicity in fireball activity, with a predicted swarm or outburst in 2025. Far more striking, however, are the **Leonids**, which have a relatively short period of activity (6–30 November), with maximum on 17 November. This shower is associated with Comet 55P/Tempel-Tuttle and has shown extraordinary activity on various occasions with many thousands of meteors per hour. High rates were seen in 1999, 2001 and 2002 (reaching about 3,000 meteors per hour) but have fallen dramatically since then. The rate in 2025 is likely to be about 10–15 per hour at peak and, with a waning crescent Moon rising at dawn, conditions will be favourable all night. These meteors are the fastest shower meteors recorded (about 70 km per second) and often leave persistent trails. The shower is very rich in faint meteors.

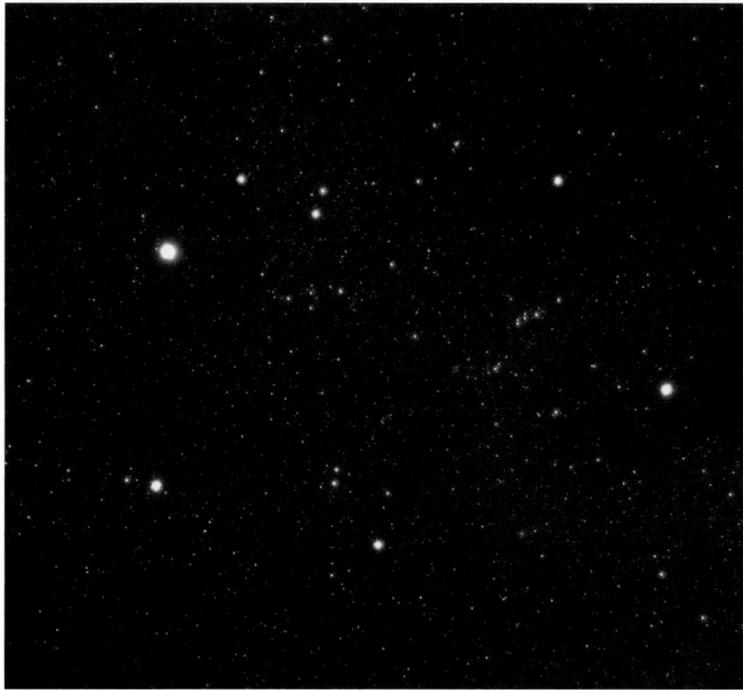

The constellation of Auriga, with brilliant Capella (mag. 0.08), which, although appearing as a single star, is actually a quadruple system, consisting of a pair of yellow giant stars, gravitationally bound to a more distant pair of red dwarfs.

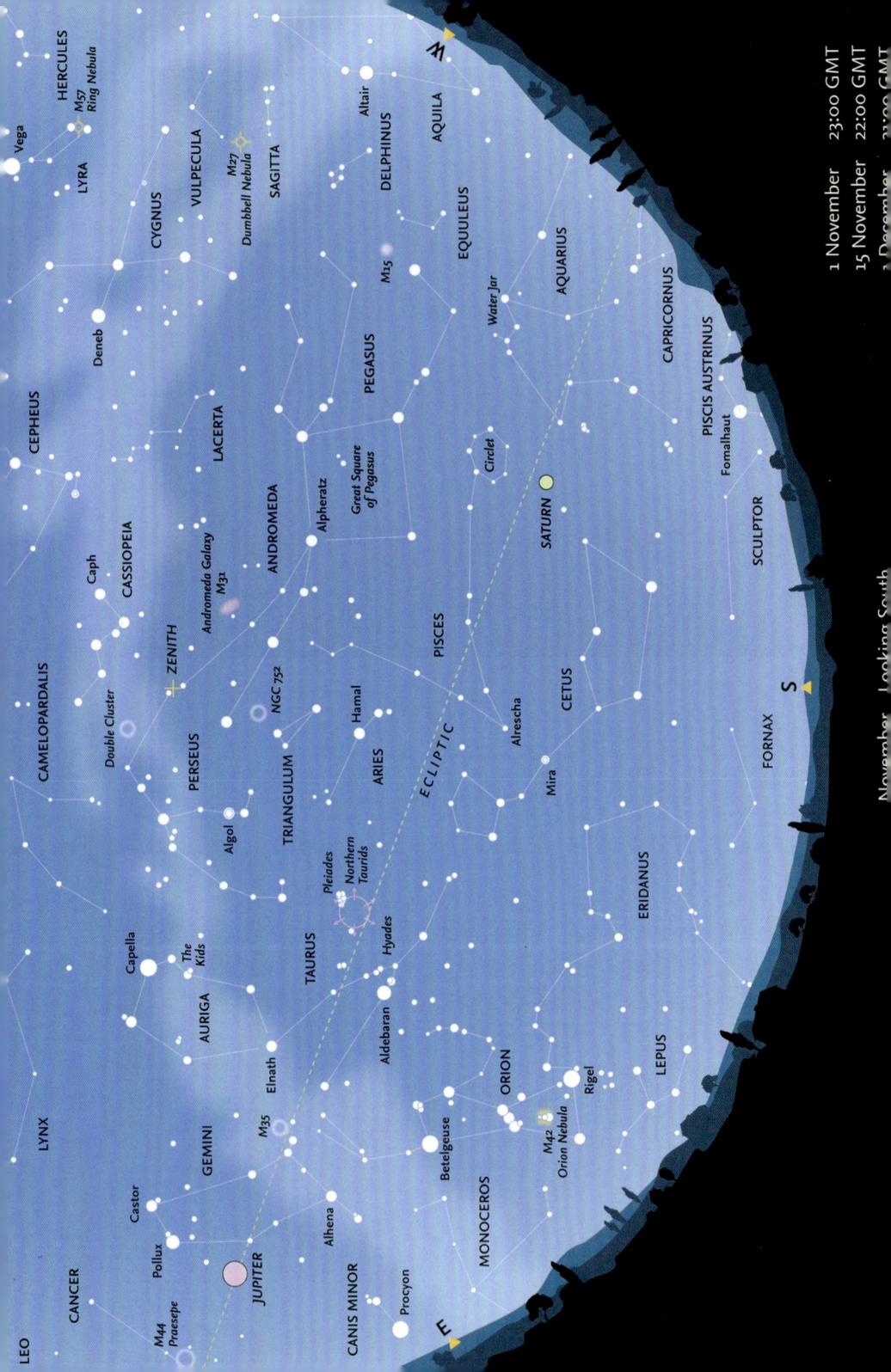

1 November 23:00 GMT
 15 November 22:00 GMT
 1 December 21:00 GMT

November Looking South

S

E

LEO

CANCER

JUPITER

CANIS MINOR

MONOCEROS

ORION

LEPUS

ERIDANUS

FORNAX

S

SCULPTOR

PISCIS AUSTRINUS

CAPRICORNUS

AQUARIUS

SATURN

EQUULEUS

AQUILA

DELPHINUS

SAGITTA

VULPECULA

CYGNUS

LYRA

HERCULES

CEPHEUS

CAMELOPARDALIS

CASSIOPEIA

LACERTA

ANDROMEDA

PEGASUS

PERSEUS

TRIANGULUM

ARIES

ECLIPTIC

PISCES

CETUS

TAURUS

AURIGA

LYNX

GEMINI

M35

Alhena

Betelgeuse

M42 Orion Nebula

Rigel

Mira

Alrescha

Hamal

NGC 752

Alpheratz

Great Square of Pegasus

Water Jar

Circlet

Fomalhaut

Deneb

ZENITH

Double Cluster

Andromeda Galaxy M31

Algol

The Kids

M44 Praesepe

Pollux

Castor

Capella

Pleiades Northern Taurids

Hyades

Aldebaran

Procyon

E

November – Moon and Planets

The Moon

On 2 November the waxing gibbous Moon will lie 3.7°N of **Saturn** (mag. 0.8). On 5 November the Full Moon will be at its closest point to the Earth – its perigee – a distance of 356,833 km. On 10 November the bright waning gibbous Moon will pass within 4°N of **Jupiter** (mag. -2.4), best seen after midnight. **Pollux** will be less than 3° away. Two days later the Moon will be Last Quarter and around 1°S of **Regulus**. On 17 November **Spica** will be 1.2°N of the crescent Moon, both setting before the Sun. On 20 November the New Moon will be at its farthest point – apogee, 406,693 km from Earth. The following day the thin crescent Moon will be 4.5°S of **Mars** (mag. 1.4) during the day. On 29 November, a day after First Quarter, the Moon will appear 3.7°N of **Saturn** (mag. 0.9).

The Planets

Mercury (mag. -0.7 to 0.4) is above the horizon during the day, it passes just over a degree from **Mars** on 13 November during this time. **Venus** (mag. -3.9) appears in the dawn sky, setting just before the Sun. **Mars** (mag. 1.5 to 1.3) is seen just after sunset in **Libra**. **Jupiter** (mag. -2.3 to -2.5) climbs above the horizon late in the night and enters retrograde motion on 11 November, visible in **Gemini**. **Saturn** (mag. 0.8 to 0.9) ends its retrograde motion towards the end of the month in **Aquarius** and starts to move eastward. **Uranus** is at opposition on 21 November (mag. 5.6) in **Taurus** and **Neptune** (mag. 7.7) is in **Pisces**.

The path of the Sun and the planets along the ecliptic in November.

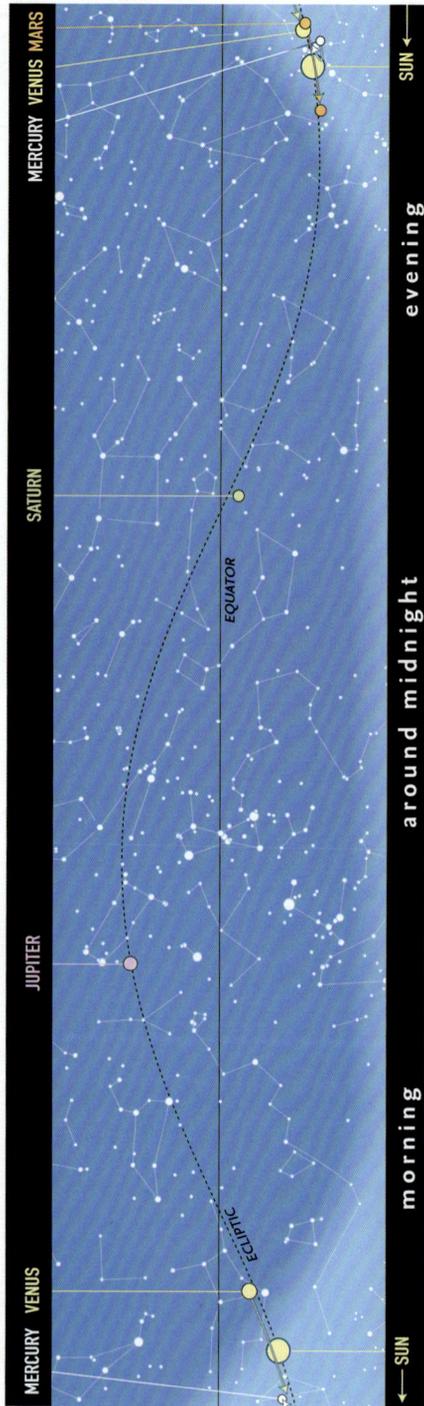

Calendar for November

- 02 01:02 Venus (mag. -3.9) 3.3°N of Spica
- 02 10:46 Saturn (mag. 0.8) 3.7°S of Moon
- 05 13:19 FULL MOON
- 05 22:23 Moon at perigee: 356,833 km
- 06 15:26 Pleiades 0.8°S of Moon
- 09 02:41 Mercury (mag. 0.3) 2.6°N of Antares
- 10 06:40 Pollux 2.7°N of Moon
- 10 07:56 Jupiter (mag. -2.4) 4.0°S of Moon
- 12 05:28 LAST QUARTER MOON
- 12 Northern Taurid Meteor Shower maximum
- 12 22:51 Regulus 1.1°S of Moon
- 13 04:00 Mercury (mag. 1.4) 1.2°S of Mars (mag. 1.5)
- 17 10:11 Spica 1.2°N of Moon
- 17 Leonid Meteor Shower maximum
- 20 02:48 Moon at apogee: 406,693 km
- 20 06:47 NEW MOON
- 21 13:00 Uranus at opposition (mag. 5.6)
- 23 11:00 Mercury at perihelion
- 28 06:59 FIRST QUARTER MOON
- 29 10:08 Saturn (mag. 0.0) 1.7°S of Moon

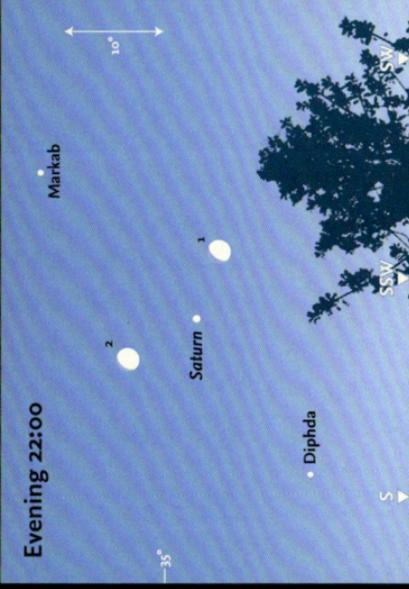

1-2 November • The Moon passes Saturn (mag. 0.8) halfway between Markab (α Peg) and Diphda (β Cet).

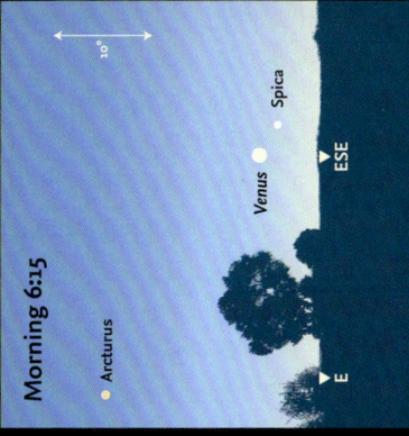

2 November • Venus in the morning sky, just before dawn. Spica (mag. 1.0) will not be easy to spot. Arcturus is higher in the east.

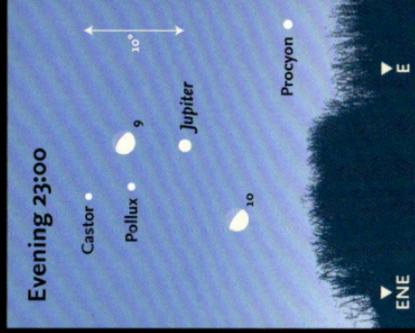

9-10 November • The Moon passes Jupiter (mag. -2.4), Castor and Pollux. Procyon is closer to the horizon.

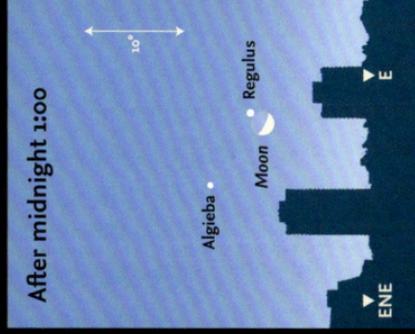

13 November • After midnight, the crescent Moon, with Regulus and Algieba, is low in the east.

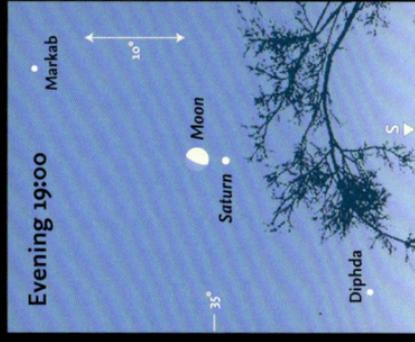

29 November • The Moon lies close to Saturn (mag. 0.9), halfway between Markab and Diphda.

December – Looking North

Ursa Major has now swung around and is starting to 'climb' in the east. The fainter stars in the southern part of the constellation are now fully in view. The other bear, **Ursa Minor**, 'hangs' below **Polaris** in the north. Directly above it is the faint constellation of **Camelopardalis**, with the other inconspicuous circumpolar constellation, **Lynx**, to its east. **Vega** (α Lyrae) is skimming the horizon in the northwest, but **Deneb** (α Cygni) and most of **Cygnus** remain visible farther west. In the east, **Regulus** (α Leonis) and the constellation of **Leo** are beginning to rise above the horizon. **Cancer** stands high in the east, with **Gemini** even higher in the sky. **Perseus** is at the zenith, with **Auriga** and **Capella** between it and Gemini. Because it is so high in the sky, now is a good time to examine the star clouds of the fainter portion of the Milky Way, between **Cassiopeia** in the west to Gemini and **Orion** in the east.

Meteors

There is one significant meteor shower in December (the last major shower of the year). This is the **Geminid** shower, which is visible over the period 4–20 December and comes to maximum on 14 December, when the Moon is a waning crescent, so conditions are reasonably favourable. It is one of the most active showers of the year, and one of the strongest, with a peak rate of around 100 meteors per hour. It is the one major shower that shows good activity before midnight. The meteors have been found to have a much higher density than other meteors (which are derived from cometary material). It was eventually established that the Geminids and the asteroid Phaethon had similar orbits. So the Geminids are assumed to consist of denser, rocky material. They are slower than most other meteors and often appear to last longer. The brightest often break up into numerous luminous fragments that follow similar paths across the sky. There is a second shower: the **Ursids**, active 17–26 December, peaking on the 22nd, with

a rate at maximum of 5–10, occasionally rising to 25 per hour. The peak in 2025 occurs when the Moon is a thin waxing crescent setting early in the evening, so conditions are favourable. The parent body is Comet 8P/Tuttle.

The constellation of Andromeda largely consists of a line of bright stars running northeast from α Andromedae, Alpheratz (bottom right), which is one of the stars forming the Great Square of Pegasus. The small constellation of Triangulum appears on the left-hand (eastern) side, below Andromeda.

December – Looking South

The fine open cluster of the *Pleiades* is due south around 22:00, with the *Hyades* cluster, *Aldebaran* and the rest of *Taurus* clearly visible to the east. *Auriga* (with *Capella*) and *Gemini* (with *Castor* and *Pollux*) are both well-placed for observation. *Orion* has made a welcome return to the winter sky, and both *Canis Minor* (with *Procyon*) and *Canis Major* (with *Sirius*, the brightest star in the sky) are now well above the horizon. The small, poorly known constellation of *Lepus* lies to the south of Orion. In the west, *Aquarius* has now disappeared, and *Cetus* is becoming lower, but *Pisces* is still easily seen, as are the constellations of *Aries*, *Triangulum* and *Andromeda* above it. The Great Square of *Pegasus* is starting to plunge down towards the western horizon and, because of its orientation on the sky, appears more like a large diamond standing on one point than a square.

The constellation of *Taurus* contains two contrasting open clusters: the compact *Pleiades*, with its striking blue-white stars, and the more scattered, 'Y'-shaped *Hyades*, which are much closer to us. Orange *Aldebaran* (α *Tauri*) is not related to the *Hyades*, but lies between it and the Earth.

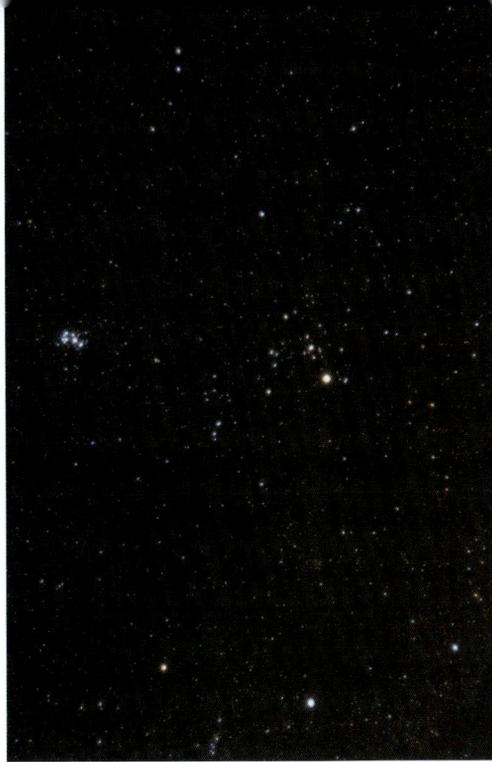

The Moon's phases for December 2025

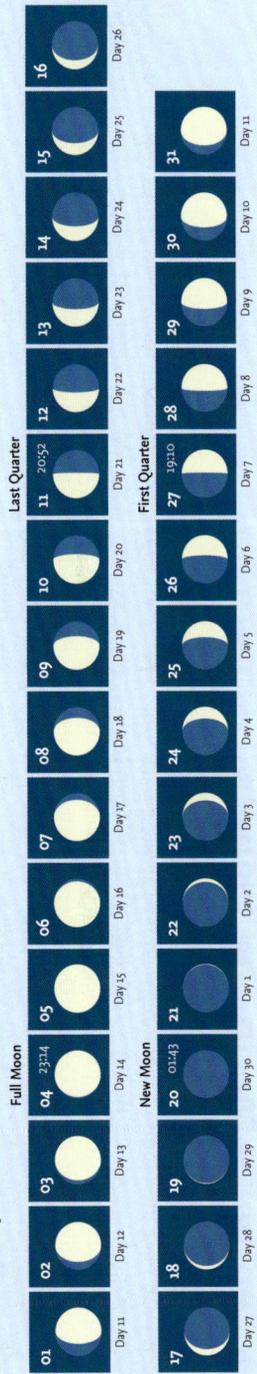

December – Moon and Planets

The Moon

On 4 December the Moon is Full, three days later it will be 3.7°N of **Jupiter** (mag. -2.6) and less than 3°S of **Pollux**. On 10 December the waning gibbous Moon is less than a degree from **Regulus**, and the following day the Moon is Last Quarter. On 14 December the crescent Moon will be 1.4°S of **Spica** and on 20 December it will be a New Moon. On 27 December the First Quarter Moon will lie 4°N of **Saturn** (mag. 1.0), visible in the early evening.

The planets

Mercury increases in apparent brightness as the month progresses (mag. 0.07 to -0.6). On 8 December it will be at greatest western elongation. **Venus** (mag. -3.9) moves into **Virgo** early in the month, visible at dawn. **Mars** (mag. 1.3 to 1.1) moves from **Ophiuchus** to **Sagittarius** around the middle of the month, setting shortly after the Sun. **Jupiter** (mag. -2.5 to -2.7) stays in **Gemini**. **Saturn** (mag. 0.9 to 1.0) continues to move eastward in **Aquarius**, setting earlier over the course of the month. **Uranus** (mag. 5.6) is in **Taurus** and **Neptune** (mag. 7.7 to 7.8) ends its westward retrograde motion in **Pisces** on 10 December.

The path of the Sun and the planets along the ecliptic in December.

Calendar for December

- 04 02:34 Pleiades 0.8°S of Moon
- 04 11:06 Moon at perigee: 356,962 km
- 04 23:14 FULL MOON
- 07 15:48 Jupiter (mag. -2.6) 3.7°S of Moon
- 07 16:21 Pollux 2.9°N of Moon
- 07 21:00 Mercury at greatest elong.: 20.7°W
- 10 06:32 Regulus 0.8°S of Moon
- 11 20:52 LAST QUARTER MOON
- 14 Geminid Meteor Shower maximum
- 14 16:27 Spica 1.4°N of Moon
- 17 06:09 Moon at apogee: 406,324 km
- 18 12:29 Antares 0.4°N of Moon
- 20 01:43 NEW MOON
- 21 15:03 Winter Solstice
- 22 Ursid Meteor Shower maximum
- 27 03:24 Saturn (mag. 1.0) 4.0°S of Moon
- 27 19:10 FIRST QUARTER MOON
- 31 13:21 Pleiades 0.9°S of Moon

6–7 December • The Moon passes close to Alhena, Castor, Pollux and Jupiter (mag. -2.6). Procyon is only 8° above the eastern horizon.

10–11 December • The Moon is nearing Last Quarter, when it passes between Regulus and Algiba. Denebola (β Leo) is only 5° above the eastern horizon.

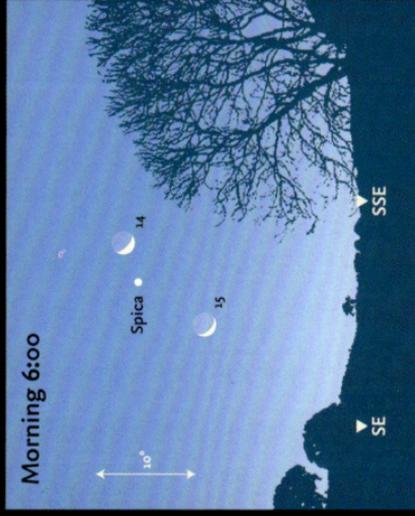

14–15 December • In the early morning the crescent Moon passes Spica in the southeastern sky.

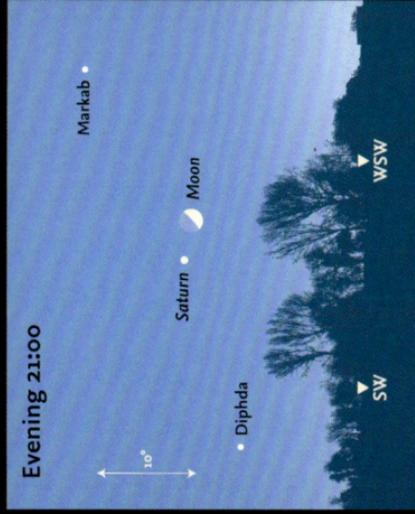

26 December • The Moon meets Saturn in the southwestern sky, halfway between Markab (α Peg) and Diphda (β Cet).

Dark Sky Sites

International Dark-Sky Association Sites

The *International Dark-Sky Association* (IDA) recognizes various categories of sites that offer areas where the sky is dark at night, free from light pollution and particularly suitable for astronomical observing. A number of sites in Great Britain and Ireland have been given specific recognition and are shown on the map. These are:

Parks

- 1 *Bodmin Moor Dark Sky Landscape*
- 2 *Elan Valley Estate*
- 3 *Galloway Forest Park*
- 4 *Mayo Dark Sky Park*
- 5 *Northumberland National Park and Kielder Water & Forest Park*
- 6 *OM Dark Sky Park & Observatory*
- 7 *Tomintoul and Glenlivet – Cairngorms*
- 8 *West Penwith*

Reserves

- 9 *Brecon Beacons National Park*
- 10 *Cranborne Chase*
- 11 *Eryri National Park (Snowdonia)*
- 12 *Exmoor National Park*
- 13 *Kerry*
- 14 *Moore's Reserve South Down National Park*
- 15 *North York Moors National Park*
- 16 *Yorkshire Dales National Park*

Sanctuaries

- 17 *Ynys Enlli (Bardsey Island)*

Communities

- 18 *The island of Coll (Inner Hebrides, Scotland)*
- 19 *Moffat*
- 20 *North Ronaldsay Dark Sky Island (Orkney Islands, Scotland)*
- 21 *The island of Sark (Channel Islands)*

Details of these sites and web links may be found at the IDA website: <https://www.darksky.org/>
Many of these sites have major observatories or other facilities available for public observing (often at specific dates or times).

Dark Sky Discovery Sites

In Britain there is also the *Dark Sky Discovery* organisation. This gives recognition to smaller sites, again free from immediate light pollution, that are open to observing at any time. Some sites are used for specific, public observing sessions. A full listing of sites is at: <https://www.darkskydiscovery.org.uk/> but specific events are publicized locally.

Glossary and Tables

<i>aphelion</i>	The point on an orbit that is farthest from the Sun.
<i>apogee</i>	The point on its orbit at which the Moon is farthest from the Earth.
<i>appulse</i>	The apparently close approach of two celestial objects; two planets, or a planet and star.
<i>astronomical unit</i>	(AU) The mean distance of the Earth from the Sun, 149,597,870 km.
<i>celestial equator</i>	The great circle on the celestial sphere that is in the same plane as the Earth's equator.
<i>celestial sphere</i>	The apparent sphere surrounding the Earth on which all celestial bodies (stars, planets, etc.) seem to be located.
<i>conjunction</i>	The point in time when two celestial objects have the same celestial longitude. In the case of the Sun and a planet, superior conjunction occurs when the planet lies on the far side of the Sun (as seen from Earth). For Mercury and Venus, inferior conjunction occurs when they pass between the Sun and the Earth.
<i>direct motion</i>	Motion from west to east on the sky.
<i>ecliptic</i>	The apparent path of the Sun across the sky throughout the year. Also: the plane of the Earth's orbit in space.
<i>elongation</i>	The point at which an inferior planet has the greatest angular distance from the Sun, as seen from Earth.
<i>equinox</i>	The two points during the year when night and day have equal duration. Also: the points on the sky at which the ecliptic intersects the celestial equator. The vernal (spring) equinox is of particular importance in astronomy.
<i>gibbous</i>	The stage in the sequence of phases at which the illumination of a body lies between half and full. In the case of the Moon, the term is applied to phases between First Quarter and Full, and between Full and Last Quarter.
<i>inferior planet</i>	Either of the planets Mercury or Venus, which have orbits inside that of the Earth.
<i>magnitude</i>	The brightness of a star, planet or other celestial body. It is a logarithmic scale, where larger numbers indicate fainter brightness. A difference of 5 in magnitude indicates a difference of 100 in actual brightness, thus a first-magnitude star is 100 times as bright as one of sixth magnitude.
<i>meridian</i>	The great circle passing through the North and South Poles of a body and the observer's position; or the corresponding great circle on the celestial sphere that passes through the North and South Celestial Poles and also through the observer's zenith.
<i>nadir</i>	The point on the celestial sphere directly beneath the observer's feet, opposite the zenith.
<i>occultation</i>	The disappearance of one celestial body behind another, such as when stars or planets are hidden behind the Moon.
<i>opposition</i>	The point on a superior planet's orbit at which it is directly opposite the Sun in the sky.
<i>perigee</i>	The point on its orbit at which the Moon is closest to the Earth.
<i>perihelion</i>	The point on an orbit that is closest to the Sun.
<i>retrograde motion</i>	Motion from east to west on the sky.
<i>superior planet</i>	A planet that has an orbit outside that of the Earth.
<i>vernal equinox</i>	The point at which the Sun, in its apparent motion along the ecliptic, crosses the celestial equator from south to north. Also known as the First Point of Aries.
<i>zenith</i>	The point directly above the observer's head.
<i>zodiac</i>	A band, stretching 8° on either side of the ecliptic, within which the Moon and planets appear to move. It consists of twelve equal areas, originally named after the constellation that once lay within it.

The Greek Alphabet

α Alpha	ε Epsilon	ι Iota	ν Nu	ρ Rho	φ (ϕ) Phi
β Beta	ζ Zeta	κ Kappa	ξ Xi	σ (ς) Sigma	χ Chi
γ Gamma	η Eta	λ Lambda	ο Omicron	τ Tau	ψ Psi
δ Delta	θ (θ) Theta	μ Mu	π Pi	υ Upsilon	ω Omega

The Constellations

There are 88 constellations covering the whole of the celestial sphere, but 24 of these in the southern hemisphere can never be seen (even in part) from the latitude of Britain and Ireland, so are omitted from this table. The names themselves

are expressed in Latin, and the names of stars are frequently given by Greek letters followed by the genitive of the constellation name. The genitives and English names of the various constellations are included.

Name	Genitive	Abbr.	English name
Andromeda	Andromedae	And	Andromeda
Antlia	Antliae	Ant	Air Pump
Aquarius	Aquarii	Aqr	Water Bearer
Aquila	Aquilae	Aql	Eagle
Aries	Arietis	Ari	Ram
Auriga	Aurigae	Aur	Charioteer
Boötes	Boötis	Boo	Herdsmen
Camelopardalis	Camelopardalis	Cam	Giraffe
Cancer	Cancris	Cnc	Crab
Canes Venatici	Canum Venaticorum	CVn	Hunting Dogs
Canis Major	Canis Majoris	CMa	Big Dog
Canis Minor	Canis Minoris	CMi	Little Dog
Capricornus	Capricorni	Cap	Sea Goat
Cassiopeia	Cassiopeiae	Cas	Cassiopeia
Centaurus	Centauri	Cen	Centaur
Cepheus	Cephei	Cep	Cepheus
Cetus	Ceti	Cet	Whale
Columba	Columbae	Col	Dove
Coma Berenices	Comae Berenices	Com	Berenice's Hair
Corona Australis	Coronae Australis	CrA	Southern Crown
Corona Borealis	Coronae Borealis	CrB	Northern Crown
Corvus	Corvi	Crv	Crow
Crater	Crateris	Crt	Cup
Cygnus	Cygni	Cyg	Swan
Delphinus	Delphini	Del	Dolphin
Draco	Draconis	Dra	Dragon
Equuleus	Equulei	Equ	Little Horse
Eridanus	Eridani	Eri	River Eridanus
Fornax	Fornacis	For	Furnace
Gemini	Geminarum	Gem	Twins
Hercules	Herculis	Her	Hercules
Hydra	Hydrae	Hya	Water Snake

Name	Genitive	Abbr.	English name
Lacerta	Lacertae	Lac	Lizard
Leo	Leonis	Leo	Lion
Leo Minor	Leonis Minoris	LMi	Little Lion
Lepus	Leporis	Lep	Hare
Libra	Librae	Lib	Scales
Lupus	Lupi	Lup	Wolf
Lynx	Lyncis	Lyn	Lynx
Lyra	Lyrae	Lyr	Lyre
Microscopium	Microscopii	Mic	Microscope
Monoceros	Monocerotis	Mon	Unicorn
Ophiuchus	Ophiuchi	Oph	Serpent Bearer
Orion	Orionis	Ori	Orion
Pegasus	Pegasi	Peg	Pegasus
Perseus	Persei	Per	Perseus
Pisces	Piscium	Psc	Fishes
Piscis Austrinus	Piscis Austrini	PsA	Southern Fish
Puppis	Puppis	Pup	Stern
Pyxis	Pyxidis	Pyx	Compass
Sagitta	Sagittae	Sge	Arrow
Sagittarius	Sagittarii	Sgr	Archer
Scorpius	Scorpii	Sco	Scorpion
Sculptor	Sculptoris	Scl	Sculptor
Scutum	Scuti	Sct	Shield
Serpens	Serpentis	Ser	Serpent
Sextans	Sextantis	Sex	Sextant
Taurus	Tauri	Tau	Bull
Triangulum	Trianguli	Tri	Triangle
Ursa Major	Ursae Majoris	UMa	Great Bear
Ursa Minor	Ursae Minoris	UMi	Lesser Bear
Vela	Velorum	Vel	Sails
Virgo	Virginis	Vir	Virgin
Vulpecula	Vulpeculae	Vul	Fox

Some common asterisms

Belt of Orion	δ, ε and ζ Orionis
Big Dipper	α, β, γ, δ, ε, ζ and η Ursae Majoris
Circlet	γ, θ, ι, λ and κ Piscium
Guards (or Guardians)	β and γ Ursae Minoris
Head of Cetus	α, γ, ξ ² , μ and λ Ceti
Head of Draco	β, γ, ξ and ν Draconis
Head of Hydra	δ, ε, ζ, η, ρ and σ Hydrae
Keystone	ε, ζ, η and π Herculis
Kids	ζ and η Aurigae
Little Dipper	β, γ, η, ζ, ε, δ and α Ursae Minoris
Lozenge	= Head of Draco
Milk Dipper	ζ, γ, σ, φ and λ Sagittarii
Plough or Big Dipper	α, β, γ, δ, ε, ζ and η Ursae Majoris
Pointers	α and β Ursae Majoris
Sickle	α, η, γ, ζ, μ and ε Leonis
Square of Pegasus	α, β and γ Pegasi with α Andromedae
Sword of Orion	θ and ι Orionis
Teapot	γ, ε, δ, λ, φ, σ, τ and ζ Sagittarii
Wain (or Charles' Wain)	= Plough
Water Jar	γ, η, κ and ζ Aquarii
Y of Aquarius	= Water Jar

Acknowledgements

Denis Buczynski, Portmahomack, Ross-shire – p.32 (Fireball), p.35 (Quadrantid fireball)

Stephen Edberg – pp.35, 53, 89, 91, 103 (Constellation photographs)

Akira Fuji – p.21 (Lunar eclipse)

Jens Hackmann, Bad Mergentheim, Germany – p.77 (Perseid fireball)

Bernhard Hubl – pp.49, 53, 55, 71, 85, 95 (Constellation photographs)

Nick James – p.28 (Comet NEOWISE)

peresanz/Shutterstock – p.37 (Orion)

Ken Sperber, California – p.83 (Double Cluster)

Wil Tirion, Capelle aan den IJssel, The Netherlands – p.43, 67, 101 (Constellation photographs)

Alan Tough, Nairn, Highland, Scotland – p.65 (noctilucent clouds)

For the 2025 Guide, the editorial support was provided by Edward Bloomer, Senior Astronomy Manager: Digital & Data.

Further Information

Books

- Bone, Neil (1993), *Observer's Handbook: Meteors*, George Philip, London & Sky Publ. Corp., Cambridge, Mass.
- Chu, A (2012), *The Cambridge Photographic Moon Atlas*, Cambridge University Press, Cambridge
- Dunlop, Storm (1999), *Wild Guide to the Night Sky*, HarperCollins, London
- Dunlop, Storm (2012), *Practical Astronomy*, 3rd edn, Philip's, London
- Dunlop, Storm, Rükl, Antonin & Tirion, Wil (2005), *Collins Atlas of the Night Sky*, HarperCollins, London
- Heifetz, Milton & Tirion, Wil (2017), *A Walk through the Heavens*, 4th edn, Cambridge University Press, Cambridge
- National Geographic & Wei-Haas, Maya (2023), *Stargazer's Atlas: The Ultimate Guide to the Night Sky*, National Geographic
- O'Meara, Stephen J. (2008), *Observing the Night Sky with Binoculars*, Cambridge University Press, Cambridge
- Ridpath, Ian (2018), *Star Tales*, 2nd edn, Lutterworth Press, Cambridge, UK
- Ridpath, Ian, ed. (2003), *Oxford Dictionary of Astronomy*, 2nd edn, Oxford University Press, Oxford
- Ridpath, Ian, ed. (2004), *Norton's Star Atlas*, 20th edn, Pi Press, New York
- Ridpath, Ian & Tirion, Wil (2004), *Collins Gem – Stars*, HarperCollins, London
- Ridpath, Ian & Tirion, Wil (2017), *Collins Pocket Guide Stars and Planets*, 5th edn, HarperCollins, London
- Ridpath, Ian & Tirion, Wil (2019), *The Monthly Sky Guide*, 10th edn, Dover Publications, New York
- Rükl, Antonín (1990), *Hamlyn Atlas of the Moon*, Hamlyn, London & Astro Media Inc., Milwaukee
- Scagell, Robin (2000), *Philip's Stargazing with a Telescope*, George Philip, London
- Stimac, Valerie (2019), *A Practical Guide to Astrotourism*, Lonely Planet, Franklin, TN
- Tirion, Wil (2011), *Cambridge Star Atlas*, 4th edn, Cambridge University Press, Cambridge
- Topalovic, Radmila & Keress, Tom (2016), *Stargazing: Beginner's Guide to Astronomy*, HarperCollins, London

Journals

- Astronomy*, Astro Media Corp., 21027 Crossroads Circle, P.O. Box 1612, Waukesha, WI 53187-1612 USA. <http://astronomy.com>
- Astronomy Now*, Pole Star Publications, PO Box 175, Tonbridge, Kent TN10 4QX UK. <http://astronomynow.com>
- Sky at Night Magazine*, BBC publications, London. <http://skyatnightmagazine.com>
- Sky & Telescope*, Sky Publishing Corp., Cambridge, MA 02138-1200 USA. <http://www.skyandtelescope.org/>

Societies

- British Astronomical Association*, Burlington House, Piccadilly, London W1J 0DU. <http://www.britastro.org/>
- The principal British organization for amateur astronomers (with some professional members), particularly for those interested in carrying out observational programmes. Its membership is, however, worldwide. It publishes fully refereed, scientific papers and other material in its well-regarded journal.
- Federation of Astronomical Societies*, Secretary: Ken Sheldon, Whitehaven, Maytree Road, Lower Moor, Pershore, Worcs. WR10 2NY. <http://www.fedastro.org.uk/fas/>
- An organization that is able to provide contact information for local astronomical societies in the United Kingdom.

Royal Astronomical Society, Burlington House, Piccadilly, London W1J 0BQ. <http://www.ras.org.uk/>

The premier astronomical society, with membership primarily drawn from professionals and experienced amateurs. It has an exceptional library and is a designated centre for the retention of certain classes of astronomical data. Its publications are the standard medium for dissemination of astronomical research.

Society for Popular Astronomy, 36 Fairway, Keyworth, Nottingham NG12 5DU.

<http://www.popastro.com/>

A society for astronomical beginners of all ages, which concentrates on increasing members' understanding and enjoyment, but which does have some observational programmes. Its journal is entitled *Popular Astronomy*.

Software

Planetary, Stellar and Lunar Visibility (planetary and eclipse freeware): Alcyone Software, Germany.

<http://www.alcyone.de>

Redshift, Redshift-Live

<http://www.redshift-live.com/en/>

Starry Night & Starry Night Pro, Sienna Software Inc., Toronto, Canada. <http://www.starrynight.com>

Stellarium, <https://stellarium.org/>

Internet sources

There are numerous sites with information about all aspects of astronomy, and all of those have numerous links. Although many amateur sites are excellent, treat any statements and data with caution. The sites listed below offer accurate information. Please note that the URLs may change. If so, use a good search engine, such as Google, to locate the information source.

Information

Astronomical data (inc. eclipses) HM Nautical Almanac Office: <http://astro.ukho.gov.uk>

Auroral information Michigan Tech: <http://www.geo.mtu.edu/weather/aurora/>

Comets JPL Solar System Dynamics: <http://ssd.jpl.nasa.gov/>

American Meteor Society: <http://amsmeteors.org/>

Deep-sky objects Saguario Astronomy Club Database: <http://www.virtualcolony.com/sac/>

Eclipses NASA Eclipse Page: <http://eclipse.gsfc.nasa.gov/eclipse.html>

Moon (inc. Atlas) Lunar and Planetary Institute (LPI): <https://www.lpi.usra.edu/resources/cla/>

Planets Planetary Fact Sheets: <http://nssdc.gsfc.nasa.gov/planetary/planetfact.html>

Satellites (inc. International Space Station)

Heavens Above: <http://www.heavens-above.com/>

Visual Satellite Observer: <http://www.satobs.org/>

Star Chart: <http://www.skyandtelescope.com/observing/interactive-sky-watching-tools/interactive-sky-chart/>

What's Visible

Skyhound: <http://www.skyhound.com/sh/skyhound.html>

Skyview Cafe: <http://www.skyviewcafe.com>

Institutes and Organizations

European Space Agency: <http://www.esa.int/>

International Dark-Sky Association: <http://www.darksky.org/>

RASC Dark Sky: <https://rasc.ca/lpa/dark-sky-sites/>

Jet Propulsion Laboratory: <http://www.jpl.nasa.gov/>

Lunar and Planetary Institute: <http://www.lpi.usra.edu/>

National Aeronautics and Space Administration: <http://www.hq.nasa.gov/>

Solar Data Analysis Center: <http://umbra.gsfc.nasa.gov/>

Space Telescope Science Institute: <http://www.stsci.edu/>